BEHIND THE COLONNADE

BEHIND THE COLONNADE

COLONNADE

THIRTY-SEVEN YEARS
AT THE BRITISH MUSEUM

NORMAN JACOBS

First published 2010

The History Press
The Mill, Brimscombe Port
Stroud, Gloucestershire, GL5 2QG
www.thehistorypress.co.uk

British Library Cataloguing in Publication Data.
A catalogue record for this book is available from the British Library.

ISBN 978 0 7524 5279 1

Typesetting and origination by The History Press
Printed in Great Britain

CONTENTS

Foreword 7

Acknowledgements 11

1. First Impressions 13

2. Life Beyond the Director's Office 31

3. Life-Changing Events 45

4. Not Where I Wanted to Work 60

5. Back Home 71

6. Birth of the British Library & BM Publications Ltd 89

7. Real Museum Work 110

8. 'Hypocrisy at the Top' 128

9. Journey of a Lifetime 141

10. Invisible Green Railings 155

11. Financial Difficulties & Redundancies 175

12. 'An Awe-Inspiring Triumph': The Great Court 188

13. Last Impressions 198

FOREWORD

By Dr Robert G.W. Anderson, Director of the British Museum, 1992–2002

Surprisingly few memoirs or autobiographies have been written by those who have spent their working lives in museums and art galleries. Of those accounts which do exist, most have been compiled by scholars who have attained the uppermost ranks of their profession, mostly directors and senior curators. As museums and art galleries are complex organisations, employing a range of professional expertise at a range of grades, the view which these books offer is a partial one. In *Behind the Colonnade*, we are offered a glimpse of a rather different kind. Norman Jacobs worked for the whole of his career as a middle-ranking administrator, starting at a modest level as a stationery clerk, and finishing, thirty-seven years later, as manager of Human Resources to the Museum's 1,100 employees. He had also had experience working as a clerical officer in the Department of Medieval & Later Antiquities ('Real Museum Work', as he refers to it in a chapter heading). In addition to these roles, he was actively involved in the trade union affairs of the Museum's staff. The kind of information we are able to obtain from Norman's forthright memoir would be very difficult to gain from any other available source.

It is normal to imagine that institutional change occurs at an unprecedented rate whilst one is in the midst of it. However, in this case, an external, objective observer would probably concur with Norman Jacobs' feeling that the work

culture of the British Museum was indeed shifting rapidly over the period 1967–2004. Gentlemanly, hierarchical Civil Service attitudes at the beginning of the period gave way to increasingly managerial, though equally inflexible, styles of operation; styles which had been developed for entirely different kinds of bodies, usually commercial organisations. Employees had to adapt to imposed changes, even when they personally felt these to be inappropriate and that they offered a less effective *modus operandi* for the work they were employed to undertake.

Many museums around the world would like to boast of themselves as being the oldest, the biggest or the best in their particular fields. If the British Museum was ever to make such claims, it is likely they would be truer than most. There is a feeling amongst those employed in Bloomsbury that their museum has added something very special to cultural life, both nationally and internationally. Certainly, the place is indisputably very old and large. Quite a number of staff remained in the Museum for their entire careers, and there are stories of dynasties in which grandfather, father and son all spent their lives in Bloomsbury. Until the Second World War, the British Museum was even home for a number of staff and their families, who lived in the purpose-built residences designed by Robert Smirke behind the Great Russell Street railings.

Norman Jacobs feels these attitudes strongly, his final sentence starting: 'I have nothing but affection for the old place and the people who worked and still work in it …' That is not to say that the Museum has ever had a trouble-free existence or has been exempt from criticism. In 2002 the former director, Sir David Wilson, published a new account, *The British Museum: A History*, in which various vicissitudes suffered by the institution over its quarter-millennium of existence were brought to light. In 1885, for example, a trustee, Lord Salisbury, complained about the reduction in grant, saying that the Treasury 'look upon the arts and the sciences as so many

excuses for extravagance'; while in 1923 another trustee, Lord Crawford, complained that the board's meeting agenda was 'congested with every kind of trumpery report about messengers and window-cleaning'. Somewhat earlier, a secretary to the trustees, Josiah Forshall, actually managed to keep the director excluded from board meetings; he was eventually retired on grounds of insanity. In the light of these examples, Norman Jacobs' time at the Museum might even be seen as one of relative calm!

One of the major perturbations over the period discussed in the memoir is the construction of the Great Court at the heart of Smirke's museum. Building took place over the period March 1998 to December 2000, though there was significant activity leading up to this; the brief had to be drawn up, discussions held with architects, and a large-scale fund-raising programme put in place (the total cost of the Court and its immediate surroundings was £110 million, of which £35 million was from lottery sources, the remainder coming from private donations). Unsurprisingly, this put the Museum under considerable strain: whole departments had to move their accommodation, objects had to be protected from dangerous conditions and visitors had to be re-routed through the galleries. With pride, the author states that the Museum never once closed to the public. Moreover, the British Library moved its entire stock of books and manuscripts from Bloomsbury to its new St Pancras building. All the while, the battle of charging versus non-charging for admission to the public raged. As Norman Jacobs tells us, the Museum held firm under great pressure, while others in the public service were either not so resolute in rejecting a charging regime, or even seemed to welcome it. The Great Court having been opened, not only was no provision made by the government for the additional costs in running the enlarged museum operation, there was actually a significant reduction in the funding it provided.

There is no doubt that the functioning of a complex organisation such as the British Museum will be interpreted differently by staff who observe it from its different viewpoints and who hold different levels of responsibility. Norman Jacobs is acutely aware of this. He shows regard, even sympathy, for those whom he considers endeavouring to provide high levels of service under difficult circumstances. He has a powerful sense of right and wrong, and has not avoided making judgements, both of his immediate colleagues and of those who occupy positions senior to himself. He is unflinching in pouring criticism on those whom he feels are not pulling their weight. Other authors might have avoided his outspokenness, but their account would not have offered so vivid a picture.

The impression we are left with is that of an employee who has developed the strongest empathy with the organisation he has come to love. His memoir has added a new dimension to the historical record, and he must be admired for having decided to set down his thoughts so others can gauge what it was like, in his particular case, to have given over a significant part of his life to the service of the British Museum.

ACKNOWLEDGEMENTS

Firstly I should like to acknowledge the support of the British Museum itself in this project, especially in allowing me access to its photographic archive, and to the trustees of the British Museum for kind permission to reproduce illustrations: nos 1, 2, 4–7, 9, 10, 12, 14, 15, 20, 21, 26, 28, 31–33, 39 and the plan on page 12.

In addition I would like to thank a number of members of staff, past and present, including the deputy director, Andrew Burnett; the archivist, Stephanie Clarke; and her senior administrator, Lyn Rees. I owe a big thank you to Chris Lazenby who has supported me throughout in various ways, most notably in reading my drafts and making valuable comments on each chapter as we went along. I would also like to thank Chris Down, Chris Jones, Erwin Quistorff (Olly), Brian Smith, David Wraight, Tonia Noussia, Ian (and Val) Jacobs, Peter Clennel and Don Adams for help in jogging the old memory and for providing further information, as well as Jane Newson for her initial encouragement for the project; and last, but most certainly not least, Dr Robert Anderson, for his valuable comments on the text and for writing the foreword.

Of the non-Museum people who have helped me, I would like to say a big thank you to 'Perdita' for her continued support and encouragement, and for reading through the manuscript and giving me very constructive feedback.

And finally my wife, Linda, for all her support and for coming up with the title of the book.

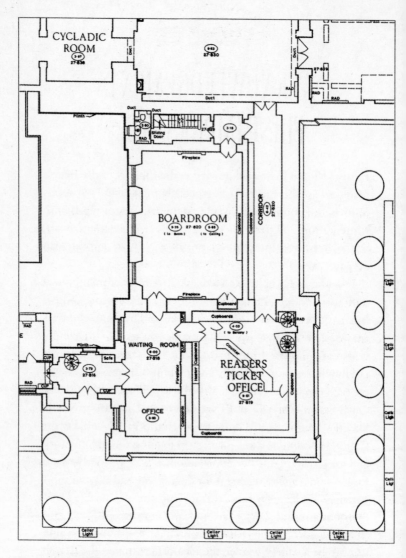

My first office at the British Museum, the Readers' Ticket Office. This area was completely refurbished when the New Wing was built. The boardroom became the New Wing Gallery, where temporary exhibitions were held until recently; my old office is now a bookshop and toilets. The circles round the outside edge show the columns on the colonnade.

I

FIRST IMPRESSIONS

'Hello, my name's Tom Punter. I've got four years, two months and three days to go before I retire and I can't wait!'

And that was my introduction to the British Museum. Tom Punter was to be my first boss and those were his first words to me. I must admit it wasn't the best of starts; the first person I met couldn't wait to get out! It didn't augur well ...

I had left Keswick Hall Teacher Training College in January 1967 as, after two teaching practices, I realised that teaching wasn't the life for me. My main interest ever since I could remember was history and, after leaving college, I didn't really know what to do. I went to my local Labour Exchange (as they were called in those days) and said, 'Have you got a job?' The reply was, 'Yes, here. How would you like to work behind the counter?' Well, I didn't really think much of the idea, but a job's a job, so I said yes.

About a month later I saw an advert in the newspaper for gallery warders at the British Museum and, although I didn't want to be a gallery warder, the idea of working at the British Museum struck me as perfect for someone whose main interest in life was history, so I wrote and asked for a job. Shortly afterwards I went for an interview and then waited for about three months before I heard again. This was in the form of a

telephone call on a Thursday afternoon asking me if I could start work the following Monday. Little did I realise then the significance of that phone call to the rest of my life.

I arrived at 9 a.m. on 1 May 1967 and was taken to meet the assistant security officer who gave me my staff pass and the key that let me get through the doors into the backroom areas that are locked to the public. He told me to make sure I kept my key safe and then patted an area just below his stomach, uttering the immortal words, 'I keep mine here.' To my great relief I realised that what he meant was that he kept his key on a chain tied round his waist, but I must admit it threw me at first.

I was then taken to meet the welfare officer, who told me a bit about the Museum and its staff facilities, which consisted of a staff restaurant, commonly known as the canteen, and ... er ... well, that was about it, really. She took me to meet Tom Punter, my new boss, who greeted me with the words already stated.

My job was to assist him as clerk of stationery for the whole museum. The Museum, although not technically part of the Civil Service, was governed by Estacode, the official Civil Service rules and regulations. I was graded at clerical officer (CO); my boss was an executive officer (EO). His remit was quite strange as he had two completely different jobs: one as EO in charge of stationery; the other as EO in charge of Reading Room Admissions. This was in the days, of course, before the British Library, when the famous round Reading Room was an integral part of the British Museum.

Although officially my job was to help out with the stationery, I was also drafted in from time to time to help on Reading Room Admissions, which was a much more interesting job as I got to meet members of the public. Our office was at the end of a long corridor behind a door off the main galleries on the ground floor. Applicants for tickets would be let into the corridor by a warder on duty at the door. They would then take their long walk, at the end of which was a counter where the

three clerical officers, whose job it was to interrogate applicants to make sure they really needed a ticket, sat. The British Museum Reading Room was not open to any old Tom, Dick or Harry; it was designated as a library of last resort and could only be used if the material you were searching for could not be found anywhere else. In effect, the Reading Room was really for postgraduate students, academics, authors and journalists.

The three clerical officers in question were Jack Bennett, Bernard Lynch and Sylvia Anne Harper-Reekie. Jack and Bernard had been at the Museum for over thirty years, as indeed had many members of staff. In those days people didn't change jobs much and the BM was stuffed full of people who had started work there in the 1920s and '30s. In fact, the two most senior members of staff when I started had been there since 1919 – a different era.

Probably because of this, and because of the sort of institution it was, the BM maintained an air of staid respectability that Harold Wilson's white-hot technological revolution had somehow passed by. But I was soon to learn that all was not as it seemed.

Jack and Bernard were both in their fifties and they had been passed over so many times for promotion that they were now resigned to the fact that they would finish up their days at the BM as clerical officers, and they were both somewhat bitter about it. As people they were as different as chalk and cheese. Jack was a gruff old cockney, wiv accent to match. He was very down to earth and I had visions of him going home each night to his plate of pie and mash or fish and chips. He always wore an old check jacket with grey flannels and a woollen pullover. He turned up each morning wearing his cloth cap which he threw over the hook on the coat stand.

Bernard, on the other hand, gave off an air of suave sophistication. He always wore a black or dark-blue suit with an immaculately ironed white shirt. His choice of headgear was a

brown trilby, which he placed gently on the hook each morning. He arrived every morning with a neatly rolled-up copy of *The Times* under his arm. He had a very cultured accent, as though he had been to Eton and Oxford, and he lived in Hampstead Garden Suburb. He also seemed to be very well connected. One day he came over to me when no one else was around and whispered conspiratorially in my ear: 'My old friend, Prince Michael of Romania, is coming in today but don't tell anyone, he doesn't want everyone to know.' The only thing that let Bernard down was the dandruff in his hair which fell like snowflakes everywhere.

They also didn't get on with each other. Although they had known each other for over thirty years there was a great rivalry between them and they were always trying to outdo each other and put the other down.

Because of his sophisticated air, Bernard sometimes gave the impression to visitors that he was actually the director of the Museum, an image he did nothing to dispel. Reading Room Admissions (and, for that matter, the Stationery Department) were part of the department known as the 'Director's Office'. When people arrived at the Information Desk in the Front Hall wanting a Reading Room ticket, they were told to go along to the warder in the gallery at the end of our corridor and ask for the Director's Office. On arriving at our counter some visitors would ask for the director. Jack would always ask what they wanted and then explain that they didn't actually need to see the director and that he, Jack, would sort out their Reading Room ticket for them. Bernard, however, would reply in somewhat vague terms to leave the impression that he was the director. When someone asked for the director he would reply, 'Yes, how can I help you?'

Bernard's delusions of grandeur and Jack's desire to get one over on him led one day to the following exchange between Jack and a visitor when Bernard had gone off for a break:

Visitor:	Can I see the director?
Jack:	What do you want to see him for?
Visitor:	He gave me an application form for a Reading Room ticket a couple of days ago. I've filled it in and I've brought it back.
Jack:	The director gave it to you?
Visitor:	Yes, he was sitting at the other end of the counter.
Jack:	Was he wearing a dark suit?
Visitor:	Yes
Jack:	(barely able to suppress his laughter) What, ol' four eyes? That's old Lynchy. 'E's not the director! 'E's just the tea boy!

There was one person who could unite Jack and Bernard and that was their common enemy, Ellen Bennett (no relation to Jack), who was the executive officer in charge of the Publications Department. She too was in her fifties and an inveterate practical joker. She had no favourites and used to go for Jack and Bernard in equal measures. One day she stapled up Bernard's beloved *Times*, stapling pages 3 & 4 to 5 & 6, 7 & 8 to 9 & 10, and so on. Bernard was absolutely livid when he discovered what she'd done. However, to make things equal she poured a packet of confetti inside Jack's rolled-up umbrella, so that as soon as he opened it, the bits showered down on top of him. Mrs Bennett gave me my first clue that perhaps the institution wasn't quite so staid after all!

I soon realised that the rules and regulations weren't too strictly enforced either. At the time we used to have to sign in a book when we arrived in the morning and sign out in the evening so that our bosses could see we had worked our correct number of hours. My starting time was 9 a.m., but I used to arrive at about 9.05 most mornings. Nevertheless, I wrote in 9.00 and thought I'd got away with something. During my second week, I arrived one morning with Bernard at about

9.10. As I was with Bernard I thought I'd better be honest and write down 9.10. Before I could get to the book, which was on our counter, Bernard picked up the pen and wrote in his space, with a large flourish, 8.30. So, I thought I'd be safe in writing 9.00!

As I said earlier, the British Museum Reading Room was a library of last resort. Jack, Bernard and Sylvia were supposed to question applicants to find out if they really needed the Reading Room or could find what they wanted elsewhere. To help in this task, we had a book in the office which listed all the specialist collections in London, as well as all the public libraries that specialised in a particular subject. I was told that Sylvia's predecessor, Edward Telesford, who had now moved on to the photographic service, had memorised the whole book so that as soon as an applicant said 'I'm studying mid-eighteenth-century philosophy', Edward would say, 'New Cross Library' (or whatever it was). This system generally worked well except for two things. The first was that Bernard was a Roman Catholic, so any nun or priest who asked him for a ticket automatically got one whatever they were studying; the second was that Tom was too soft, so anyone who appealed to him over the heads of Jack or Bernard got let in.

There was one memorable occasion when the peace of our office was suddenly shattered by Jack turning round and bellowing, 'Mr Punter, this gentleman refuses to go to Westminster Public Library!' Apparently the 'gentleman' was studying a subject in which Westminster specialised. Tom looked up and came over to the counter, saying, 'It's all right Jack, give the gentleman a ticket.' Jack was most put out.

Although the BM was not perhaps quite as staid as I had first imagined it to be, it was, nevertheless, very hierarchical. You were allowed to call your boss by his or her first name, but above that it was Mr/Mrs or Miss someone. The senior executive officer (SEO) in charge of us, for example, was always Mrs

Ding. No one would ever dare refer to her as Elsie, a fact I was to reflect on many years later when I found myself in her position as the SEO in charge of Human Resources. Everyone called me Norman, from the cleaners and labourers upwards.

Despite the fact she was in charge of us, I hardly ever saw Mrs Ding. She was always in before me and seemed to spend all day in her office. Sometimes I had to go and see her to get something signed – an urgent stationery order, for example – but apart from that we never saw each other. What little I did see of her always gave me the impression that she was a career Civil Servant who took her job very seriously. She was not one for the fripperies of life. I could never see her taking part in office banter or cracking jokes in the canteen. She would certainly never have stapled up Bernard's *Times*. Her only extravagance was her fur coat. So it came as something of a shock to me one day when she phoned down to me and said: 'If my husband phones, could you tell him I've just gone out to Marks and Spencer's to buy some knickers.' This phone call was the talk of the canteen for some days afterwards.

Above her was the Museum's assistant secretary, a man called George Morris. Like Mrs Ding he had a very sober personality. He always wore a dark suit to work and spoke in a dull monotone. Again like Mrs Ding, he gave the impression that his work was everything and that he took it all very seriously. However, as with Mrs Ding, there was a moment when I realised that perhaps he did have a lighter side after all, although in his case I wasn't quite sure. The Reading Room had played host in its past to many famous readers, none more so than Karl Marx and Lenin. Members of the public were always asking where Karl Marx had sat. Of course, like any other reader, he had sat where there was a space, but people became so insistent on seeing his actual seat that the Museum decided to designate quite arbitrarily a particular seat as his, and pointed it out to anyone who asked. Anyway, back to George Morris … Some time after

I started work at the Museum, the Soviet Union asked if they could borrow the volume of the Reading Room Admissions register with Lenin's signature for an exhibition on the life of Lenin they were mounting in Moscow. The book was duly lent. Its return to the Museum came one evening when I was on my own in Reading Room Admissions. George Morris brought it in and handed it to me to put back on the shelf. As he gave it to me, he said: 'You'd better check that the signature is still there and that the Russians haven't stolen it.' I began to open the pages and he walked off with a half-smile on his face. I later learnt that, in fact, the staid and respectable George Morris actually had a very dry – and funny – sense of humour.

Our office was lined with oak cupboards in which were all the Reading Room registers going back to the eighteenth century. There were also a number of other volumes relevant to the work of the Reading Room. My favourite for a browse every now and then was the 'Banned Readers' book. This contained the names of people who were forbidden from holding a Reading Room ticket, and better still contained the reasons why. Many were banned for being 'mentally deranged' or 'certified lunatic'; there were also a number of criminals amongst the ranks of those banned, 'convicted for picking pockets', 'criminal assault', with perhaps the most exotic of this type being the reader who was banned because he was 'imprisoned for conspiracy against Czar of Russia' and 'Prince Abdullah Cetywayo, charged with fraud'.

There was a significant number banned for their personal hygiene, including those who were 'verminous', 'dirty' and had 'offensive uncleanliness'. Another regular category was reserved for those who had had some problem in the Reading Room itself; for example, 'lighting matches in the Reading Room', 'drunk in the Reading Room'. And those who managed to combine two categories, including the person who was banned for a 'disturbance in the Reading Room – loss

of mental balance', and another who was banned for 'stealing clothing in the Reading Room. Sentenced and recommended for deportation.' A number of readers fell foul of the authorities for their lifestyle, 'excessively long periods in cloak room. Dirty habits', and 'Dress-Reformer', while one poor woman was banned for being a 'suffragette'. But my two all-time favourites from the book were the two people who were banned, the first because he 'said Superintendent might be damned and blew his nose in a Reading Room book ticket' and, best of all, the poor unfortunate soul who, in 1908, was banned for 'strange behaviour at King's Lynn'.

To get to the rest of the Director's Office, which included the Staff Office (as Human Resources was then called), the General Office and Registry, the Photographic Service, Security, Welfare, oh yes, and the director's own personal office itself, you had to go to the end of our counter, through a little swing door and on through a maze of corridors and narrow, winding staircases which led you into the West Residence, an additional wing of the Museum where all these offices were situated, only accessible through this corridor. The fact that everyone had to come past our office meant that we saw all the comings and goings of staff and visitors.

Apart from Tom, Jack, Bernard, Sylvia and me, we also had stationed in our office, behind a very large table, the three messengers for the Director's Office. As well as collecting our post, their job was to ferry visitors to the director or anyone else behind the scenes. These visitors would usually present themselves at our counter and ask for whoever it was they wanted to see. As Jack was the nearest to the end of the long corridor it usually fell to him to call for a messenger to help a visitor. He would shout out, 'Kay!' (the senior messenger), 'Kay!' On getting no response the second time, he would turn his head to find no messengers. Then came his most commonly heard plaintiff cry: 'Cor! Never 'ere when you wan'em.'

My own job, as I said above, was as assistant to the clerk of stationery, Tom Punter. Tom was another life-long Civil Servant, although in his case he had only been at the BM for seventeen years, having transferred from the Foreign Office in 1950. Just like Mrs Ding and Mr Morris, I had a revelatory moment with him as well. Although he wasn't quite as serious as either of them, the thought of him taking part in office japes or banter seemed totally out of the question. However, one day a middle-aged woman came to our office and walked through the swing doors. I asked Tom who she was. He said, 'Oh, that's Miss Adcock – but whether she has or not I couldn't say.'

In those days practically all of our stationery, along with that of every other government department, was supplied by Her Majesty's Stationery Office (HMSO) free of charge. This method of supplying stationery was later changed by the Thatcher government, which broke up HMSO and sold it off. Every government department then had to buy its own stationery. For the BM this was taken one step further when every department of the Museum had to buy its own and there wasn't even a central stationery store. I never understood how this could possibly help save money. The HMSO, of course, had enormous buying power and could get supplies very cheaply, whereas by breaking it down to individual departments it meant they had to go out and buy supplies from local shops at full retail price.

The job was not especially difficult or demanding. I received requests from departments and either sent down requisitions to our own stationery store or, if the order was for something we didn't stock, sent it off either to HMSO or a specialist supplier. There was a bit more to it than that, but not much. Our own stationery store, which was at the bottom of an old iron, spiral staircase just beyond the swing doors, was looked after by a man called Bob Sinclair. Bob was in his sixties and had a bit of a hunchback, but he was very strong and able to haul

quite heavy boxes of stationery up and down the stairs with seemingly very little effort. He was also meticulous with his record keeping and would always keep the stationery store well stocked.

The downside of Bob was that he was a real 'jobsworth'. If someone had made even the tiniest mistake on their requisition he would send it back, even if it was obvious what was meant. His only saving grace in this respect was that he applied it to everyone, whatever their position at the Museum. Once, the director's secretary, Enid Roberts, came rushing in to me and said the director urgently needed a pen. He was just about to go to a meeting and his pen had run out. So I went down to see Bob and repeated the message. Bob was unimpressed. 'Where's his requisition?' he said. I replied that he hadn't sent a requisition. Bob looked at me and said, 'If he hasn't got a requisition I can't let him have a pen.'

'It's the director,' I pleaded, 'and he needs it urgently.' Bob absolutely refused. So I took a requisition form, filled it in myself and gave it to Bob. 'Put it at the bottom of the pile,' he said. Containing the urge to strangle him, I picked up a pen and just left. I didn't hear the end of this heresy from him for some time afterwards.

Bob retired not long after I arrived and his place was taken by Albert Beaver, who suffered from MS and, it seemed, every other illness known to mankind. He would regale us for hours with his tales of all the hospitals he had visited and his various operations. But for all that he was a lively character with a very animated choice of language, as well as being a bit of a practical joker.

Sometimes I helped out on the Admissions desk when there was a particular rush or we were short-staffed. This was much more interesting as I got to meet the public and also some well-known 'celebrities', although the word wasn't used the same way in those days. The most famous people I attended

to were the film star Terence Stamp, who reeked of some perfume or other, and Bamber Gascoigne, who was then well known as the quizmaster on *University Challenge*. I met him again in 2000 at the opening of the Great Court. I reminded him that I had once given him a Reading Room ticket, but he said he couldn't remember me. I was most put out.

I also saw a number of folk singers who came in to research the origins of folk music. At that time folk singing was going through something of a revival and was very popular. I was well into it myself and had been half of a folk duo when at college – the Norman half of Robin and Norman. So I knew all these folk singers that came in. Three I remember in particular were Sydney Carter, who had actually written a song about the Reading Room, Sandra Kerr, who later became famous as the voice of the mice in *Bagpuss* and Shirley Collins. I particularly liked Shirley Collins as she had a beautiful voice and I loved her interpretation of traditional songs. When I saw her approach the desk my knees started to buckle. I told her I had a number of her records at home and asked if she would sign them for me if I brought them in. Much to my astonishment and delight, she said yes. The next day I brought them in and we even went for a coffee together in the canteen, where we had a chat about folk music. She was lovely.

There was a great flurry of activity one day when we were told by Buckingham Palace that Prince Charles would be coming in to obtain a Reading Room ticket. It was decided that he wouldn't be made to come to our office but would sign the register and be given his ticket in the Reading Room superintendent's office, just off the Reading Room itself. He was to be met at the front entrance and escorted in. Because he didn't arrive with a great entourage no one actually recognised him when he did come, and by the time anyone realised what had happened he had completely bypassed the waiting party and had almost made it to the Reading Room.

The waiting Museum dignitaries just managed to stop him in time and took him to get his ticket. Of course, while this palaver was going on in the Front Hall, no one else could get a Reading Room ticket as the register was not available. When it eventually came back to our office, I noticed that no one had put their initials next to his name, something that was part of the recognised procedure – so I did it. And that is why my initials will be forever next to Prince Charles' signature in the Reading Room register, even though I didn't actually see him.

There were a number of other interesting people who came in for tickets. One I remember in particular was Francis Ridley. He was in his seventies and had been a leading Trotskyist all his life. He had even known Trotsky himself and would entertain me with tales about the history of the socialist movement. Despite his beliefs, he had a good sense of humour and was not above making jokes about his own views. The one I remember best was: 'Where you have two Trotskyists you have a struggle for power.' Francis was always working away on some great tome or other which he was convinced would lead to the downfall of capitalism and the rise of socialism throughout the world. Sadly for him, it never happened.

The one person I absolutely refused to speak to was Enoch Powell. Shortly after he made his infamous 'Rivers of Blood' speech he came in for a Reading Room ticket and I just left the desk.

We also used to do overtime on Reading Room Admissions as the Reading Room was open until 9 p.m. on Tuesday, Wednesday and Thursday, as well as on Saturday mornings. As Tom put it to me when he asked me if I'd like to volunteer, 'It's money for old rope.' And so it was. We very rarely had more than two or three visitors in the evening and not many more on Saturday mornings. There was one Saturday morning duty, however, which I will never forget. The trustees used to meet about eight times a year and always on a Saturday morning.

One of my Saturday duties coincided with a trustees' meeting. I was sitting at the counter when the swing door flew open and Dr Michael Ramsey, the Archbishop of Canterbury, came rushing out. Between the swing doors and the corridor there were a couple of oak cupboards and he began tugging furiously at the handles on one of these cupboards. I said, 'Can I help you?'

He turned to me and said, almost pleadingly, 'Yes, how do I get out of here?' Incidentally, Dr Ramsey was the last Archbishop of Canterbury to be a trustee of the British Museum. By not appointing his successor it broke a tradition going back to 1753, when the BM was founded.

I particularly liked doing evening overtime as there was a great atmosphere about the place. I'd get a break at about 7.30 and go to the canteen for fifteen minutes or so. The Museum itself was very quiet as there were no visitors and very few staff around. Although, of course, it was always good during the day to see the Museum very busy, the air of tranquillity and peace seemed to add to the aura of the BM, something I found very inspiring and uplifting, and it added to the feeling that had been growing strongly inside me that this was definitely the place where I wanted to spend the rest of my working life.

Even when I was not on duty I would sometimes stay on in the evenings to go to the Reading Room. In those days, because the Reading Room was part of the BM, we were allowed to go into the book stacks and borrow books and take them back to our offices. At the time I was particularly interested in eighteenth- and nineteenth-century boxing (one of my ancestors, Aby Belasco, was a prominent boxer in the early 1800s) and I would go and search out contemporary literature. The boxing books were mainly held in the 'Ironworks', which was attached to the round Reading Room. As the name suggests, this part of the book stacks was made of iron. Again, there was a wonderfully peaceful atmosphere amongst all those

books that only the privileged few were allowed to access. And I did consider it a great privilege.

As I have mentioned, there were a number of offices behind those swing doors. Beyond the Board Room was the Security Office, where I had received my pass and key on that first day. The chief security officer was a man called Ron Saunders. Mr Saunders was another of those who had been at the Museum for more than thirty years. Most of this time had been spent in the Director's Office. If you ever spoke to him about it you would soon come to the conclusion that, in fact, he used to run the Museum almost single-handed, along with his side-kick, Cliff Standing. Mention the Photographic Service and Mr Saunders would say, 'Oh yes, I used to be in charge of that. Me and Cliff Standing. Isn't that right, Cliff?'

Cliff would nod and say, 'That's right.'

Talk about the General Office and it would be the same: 'Me and Cliff Standing used to run that. Isn't that right, Cliff?' The same with the Staff Office. In fact, the same with every office.

By 1967, however, the dynamic duo of Saunders and Standing had been split up, with Cliff now the executive officer in the Staff Office. Now I'm not suggesting that Cliff was a bit of a skiver or anything, but he had this clever little trick. When he arrived in the morning, he would take off his jacket and leave it on the coat stand that stood in the lobby outside the Board Room. When he got to his office, which was on the second floor, he would put on another jacket which he had left on the back of his chair overnight. By leaving his jacket on the chair it looked as though he had got in long before anyone else, as when the first person arrived they would see his coat already there. In the afternoon, at about four o'clock, he would always find an excuse to leave the office, come downstairs and get his jacket off the stand and go home. By leaving his jacket in the office it would look

as though he was still there. The ridiculous thing about this was that all his staff – those who worked under him – knew exactly what was going on, but somehow he managed to fool his bosses for years.

The General Office was on the first floor and was presided over by a fierce Amazon of a woman called Miss Oldfield. She seemed about 7ft tall and was not to be messed with. In typical career Civil Servant fashion, she wore her glasses on a chain around her neck. Poor Albert Beaver felt the full force of her wrath one day. Normally, the only people who went down to the stationery stores, apart from Jack and Bernard (who both had their afternoon tea down there for some reason), Tom and me, were the messengers from other departments to collect their stationery orders. As I said earlier, Albert was a bit of a practical joker and one day he rigged up a toy spider on a string above the door to the stationery store, and when anyone rang the bell he would let it down on top of them. Mostly the people that suffered from this were the messengers. However, one morning, for some reason, Miss Oldfield had decided to go down to the stationery store herself to collect her own stationery rather than send a messenger. She rang the bell and this hairy rubber spider descended on her head. She was not amused. When Albert opened the door she let fly at him, and even without using any of the language that Albert himself was noted for she managed to convey her displeasure in no uncertain terms.

In spite of her fearsome nature and her reputation, she did meet her match one day in the guise of none other than mild-mannered Tom Punter, of all people. Tom was very keen that departments should not keep their own stocks of stationery. In particular he was very reluctant to supply pens for some reason. We used to have standard issue ball-point pens at the time which could easily be refilled. Refills came in boxes of twenty-five. So if anyone asked for a pen, they had to prove to

Tom that it was either for a new member of staff or that their old one had actually broken, otherwise they had to use a refill. He was very strict about this.

One day I saw him looking at a stationery requisition. A deep frown came over his face and he picked up the phone. 'Miss Oldfield,' he began, for it was she who had sent the requisition in question. 'You've asked for five pens. Why?'

Of course I couldn't hear the response. But this conversation went on for several minutes with Tom getting redder and redder, and shouting down the phone louder and louder about how she was being profligate, wasting money, keeping her own store, making his job worthless and so on and so forth. What she was saying I could only imagine, but from what I knew of her I knew she would not be taking this sort of talk lying down. In the end, Tom slammed the phone down, took out a red pen and scribbled furiously on the requisition. He then passed it over to me and calmly said, 'Take this down to Albert, would you?' He had scored out the request for five pens completely. When I told Albert what had happened he was absolutely delighted that Tom had got one over on her.

I was part of an influx of new younger recruits at the Museum which had the general effect of further ending the old staid image of the institution. Sylvia Anne Harper-Reekie left after a few months and her place was taken by a vivacious young blonde woman in her early twenties by the name of Louise Thomas. Louise always wore very short miniskirts and was the very antithesis of staid. She was down to earth, extravert and very loud. She made her first big impression not long after her arrival. Above our office was a balcony which went all the way round. Off the balcony, straight in front of the counter, was a door leading to the Accounts Office. In those days many members of staff were still paid in cash and those who weren't were paid by cheque. There was no paying straight into your bank account, no BACS transfers. Everyone,

therefore, received an envelope at the end of the month with their payslip and either cash or a cheque in it.

About a month after Louise's arrival, the Accounts door opened one day and a member of the staff, Derek Cole, came out with a box in his hands. He stood on the balcony and shouted down that he had our pay envelopes in the box and asked if we wanted him to bring them down. Louise shouted up to him, 'No, just chuck the box down.'

'Okay,' replied the man from Accounts, doing as he was told. Louise went to catch it and it hit her full on the chest. In full earshot of several members of the public who were getting their Reading Room tickets, she looked up at Derek and shouted, 'Oi! Mind me tits!'

I realised then that the staid old Museum had definitely disappeared for ever.

LIFE BEYOND THE DIRECTOR'S OFFICE

Outside the confines of the Director's Office there was a whole museum to explore. For me the most interesting place was the canteen. There you met a whole range of characters from around the Museum, some interesting, some eccentric, some just plain mad.

My introduction to this new world came about two or three days after my arrival. One of the boys from the Staff Office, Geoff Barker, who I was to get to know quite well over the next thirty years – well, as well as anyone could get to know Geoff – stopped by my desk at about 10.30 one morning and said, 'Are you the new chap?' I replied in the affirmative and he said, 'Mrs Burns suggested we take you to tea.'

Mrs Burns was the welfare officer and apparently she had suggested to some of the Staff Office lads that they should help me integrate into what passed for the social life of the Museum. Geoff was with his friend Paul Brown and together they took me off to the canteen. Although the canteen was to change its location and nature many times over the next thirty-seven years, it was a place I was going to get to know very well and where I would spend many happy hours.

At that time it was a reasonable-sized hut tacked on to the west side of the Museum. It was divided into two parts: the

public restaurant and the staff canteen. Both sections were managed by a family called the Corbetts. As far as the staff canteen went they were answerable to a committee partly appointed by the director and partly elected by the staff.

The canteen consisted of two rooms. There was the main eating room that contained a servery and a number of tables and chairs, and a more relaxed inner room that had a series of easy chairs round the wall, which mostly served as a reading room for curators, who could usually be seen ploughing through the latest specialist tome on their particular subject; a few tables, used mostly for playing chess, on and a snooker table. Given the quiet nature of the readers and the chess players, the snooker table was a rather incongruous addition to the room, as every now and then there would be a piercing, strangulated cry coming from the direction of the green baize, usually something to the effect of 'you jammy bastard', as the latest fluke went in. The readers and chess players never seemed to bat an eyelid but continued in their own world. The only other sound to penetrate the silence of the room was Jack Bennett's snores after lunch.

For the first few weeks I went for my breaks with the lads from the Staff Office, but gradually, as I started to make my own friends, I abandoned them, except for Geoff, who I remained friends with – in a manner of speaking – for the next thirty years or so. Apart from him, the two people I went to tea with most were Louise and another young newcomer to the Director's Office, Chris Down, who worked in the General Office with Miss Oldfield. Chris was a dab hand at mimicry and we would get his impersonations of all the senior museum staff and other characters.

One of the regulars in the canteen was a man called Matthew Arnold. Not *the* Matthew Arnold, of course, but a research assistant who worked in the State Papers Room. He used to roll in at about 10.30 each morning, not having yet

been to his office as he felt he needed some sustenance before facing the rigours of the day. He would arrive wearing a black beret with a brown shoulder bag slung over his arm and would hold court for anyone wishing to listen. We used to love sitting with him as he made pronouncements on any and every subject under the sun, whether he knew anything about it or not. We used to pretend to be very impressed while he was still with us, but after he left the table I believe the word 'wanker' cropped up in the conversation on more than one occasion.

I can remember one day he stated with absolute certainty that it was a fact that nobody ever moved from North London to South London. Louise said, 'Well I did.' Quickly recovering from this body blow, Matthew said, 'You are the exception that proves the rule, my dear. You must be the only person ever to do this.' He also told us once how he had a deep understanding of Vietnam (this was the period of the Vietnam war, of course) and had studied Vietnamese so he could read up on the subject with native textbooks. Chris asked him to speak a few words of the language, but, sadly, he declined, saying he could read it but not speak it.

Apart from his pronouncements he also had a fund of funny stories about incidents that had happened to him personally in the Museum. His best one was the time he had been sent as a young boy to deliver a message to the legendary Wallis Budge. Budge had been keeper of the Department of Egyptian and Assyrian Antiquities and was a world-renowned Egyptologist at a time when Egyptian antiquities were all the rage – the discovery of Tutankhamen's tomb and all that. He had written dozens of books on the subject and had even had a book dedicated to him by the famous author H. Rider Haggard. This was the stature of the man to whom the young Matthew Arnold had been sent to take a message. On arriving at his office, Arnold knocked on the door and heard a muffled 'come in'. He was greeted by the sight of Budge's buttocks leaning

over the window sill with Budge himself peering out the window. Arnold coughed to gain attention and Budge turned round. He held a peashooter in his hand, which he had been using to shoot peas at the public in the front courtyard.

We found this highly amusing, of course, but there was one problem with the story. Budge retired from the BM in 1924 and Arnold didn't start work there until 1938. Maybe he had just repeated someone else's story, or maybe he had just made it up. But it would be nice to think it was true.

Another canteen character in those early days was Adrian Digby, keeper of the Department of Ethnography. In spite of being head of a department – or keeper, as they are known in the Museum – he would turn up in a dishevelled state wearing very old and ill-fitting clothes, looking more like a tramp than a well-respected senior curator. He would also hold court and expound his views on various subjects, though mostly his thoughts would turn out to be incoherent ramblings with a good smattering of the word 'blasted' in them; for example, 'The blasted director has no idea what he's blasted well doing. He expects all the blasted keepers to fall in line. Well, he's got another blasted thing coming!'

One time we were commenting on the fact that the canteen we were in was supposed to have been a temporary building put up just after the war and yet it was still here. Digby leaned over and said, 'Temporary in the blasted Museum means anything upwards of fifty years.'

His incoherence and tramp-like appearance gave rise for some concern to the trustees and they eventually managed to ease him out of his job and he was retired. For many years afterwards, however, his thoughts on various subjects frequently appeared in *The Times* letter column in perfectly well-constructed, coherent and cogently expressed opinions.

The head of the British Museum Publications Department, Henry Jacob, was another frequent visitor to the canteen.

Although he had a very thick Eastern European accent, he demanded to be known as Jacob with a J. If anyone mistakenly said Mr Yacob, he would go into a paroxysm of anger and shout 'Jacob. Jacob. The name is Jacob!'

Henry Jacob was a keen chess player and seemed to spend all his time in the canteen either playing chess or reading books about it. He knew all the moves of the Grand Masters and would frequently ascribe your moves to this same in-depth knowledge. I used to play chess occasionally, mostly with Geoff, who was a keen member of the Museum's chess club. On one occasion I was playing him and Henry Jacob was looking on. I moved my pawn somewhere and he immediately said, 'Ah, so you are using the Botvinik defence, the one he used to win the 1948 World Championship', or some such remark. All I had done was to move my pawn. I had no idea what Botvinik had done in 1948.

The one person to avoid at all costs in the canteen was Alma Munns, or Mrs Munns as she was known to everyone. She was a typist in her mid- to late fifties with a very pronounced German accent. Once she had you in her clutches you were a gonner. She would talk incessantly without drawing breath for the whole time you were down there. If I was really unlucky I sometimes met her coming down the stairs from the typing pool just as I was leaving my office. She would then walk with me, talking all the way, sit down with me, talking all the time, and walk back with me, still talking. And, what was worse, her monologue was just complete gibberish. It was a stream of consciousness whose middle and end bore no relation to its beginning, and she would skip from subject to subject with no attempt at any sort of link between them. For example, she might say: 'Oh dear, I had a terrible night last night, my hus-band vas so unvell and he said to me, Alma he said, I don't feel vell, did you see zat new programme on ze television zat eve-ryone's talking about, zis cheese sandwich seems a bit off today.

I saw ze director zis morning, he valked in to ze typing pool, zat vas nice of him, did you see anyone interesting today, my bus vas on time zis morning, sometimes it's late but it's usually a good service, zat new exhibition in ze Egyptian Gallery looks good don't you sink, my friend Dolly has a new coat, I must remember to buy some aspirin for my husband, in my last job before coming to ze Museum we didn't get a tea break ... etc.'

Another character was the manager of the canteen himself, the Corbetts' son, Les. He managed the canteen and the public restaurant on behalf of his parents, because, nice as they were and without being too dismissive of their capabilities, they would have struggled to run the proverbial whelk stall without Les. He was an affable, tall young man with flowing blonde hair who liked to spend time with his 'customers', playing chess and snooker or just talking. He certainly made his presence felt and was not exactly a shrinking violet. I remember one occasion when he was watching a chess match. One of the players made what Les thought was a good move and he thumped the table hard and started singing, 'I've never seen anything like it. I've never seen anything like it. I've never seen anything like it in my life.'

In spite of the fact that Les was the brains behind the outfit, it was Mrs Corbett who used to attend the quarterly staff canteen committee meetings on behalf of the Corbetts, and it was here that she would talk about any problems they were encountering and listen to suggestions from the committee on how to improve the canteen. She saw her role in these discussions as one of trying to maximise profits for the Corbetts, not really one of trying to improve the service. When I first started going to the canteen I noticed there was no cash register on the counter, just a member of staff taking money and putting it into a tin. Apparently the committee had for some time been trying to get the Corbetts to buy a proper cash register, but Mrs Corbett had been putting up a stout rearguard action

against this revolutionary proposal. Finally, the committee managed to get their way, but, with an awe-inspiring attention to fiscal trivia, which many felt would make her a millionaire one day, she announced to the assembled committee that the paper rolls used in the machine were too expensive so she had decided to use odd scraps of paper instead.

This lack of investment permeated everything the Corbetts did and was probably the main motivation behind Les obtaining a seemingly endless supply of 15-year-old Irish girls who were all his relations – or so he said – to work in both the staff and public restaurants.

The cost cutting also gave rise to suspicions about what was going on behind the scenes and I think we all felt it was probably a good thing that Camden Council never sent an environmental health inspector to look at the state of the kitchens; we were prepared to take our chances with the hygienic arrangements rather than have the canteen closed down altogether, as it surely would have been. Maybe the food in the canteen was not, perhaps, what you might expect in an establishment catering for the academic elite of the museum world, but it was better than nothing.

The public restaurant fared no better. About this time, the famous food critic Egon Ronay wrote a series of articles in the *London Evening News* called 'A guide to catering facilities at London's Tourist Centres'. This was his review of the BM's facilities: 'When we emerged from the trials of the self-service counter at the British Museum (e.g. a girl lifting up four cups ready for tea, her four fingers reaching deep down towards the milk in them) and navigated with our dirty trays to a table, I felt slightly sick because of the filth ground in to the floor everywhere ...'

Outside the canteen people were working quietly away in all corners of the Museum. The public only get to see the galleries, but behind them are vast areas of rooms, corridors,

stairways, basements and so on, where the staff spend their time. So complex is the Museum that even after thirty-seven years I still never got to know my way round everywhere.

I suppose the late '60s, when I started at the Museum, was really the tail end of the era of the gentleman academic. Certainly before the Second World War the British Museum was noted for them. Although they were true experts in their field, the curatorial departments exuded an air very much of the Edwardian gentleman's club, which lasted until just after the war. When the first female curators were appointed in the early '60s it did cause something of a stir. Some of the 'old timers' felt that this would somehow destroy the quiet academic atmosphere, jeopardise their long lunch hours with the chaps and make conversation in the department more difficult. Some reacted to this by engaging in polite conversation only when absolutely necessary, others with outright hostility and no conversation at all. By and large, however, with the appointment of more female curators, males straight from university and the retirement of the older generation, there was a general relaxation and acceptance of the 'modern world'.

By the time I arrived on the scene in 1967 the old gentleman's club ambience had largely disappeared and along with it the old-style gentleman academic. Perhaps the last of these was Soames Jenyns, the deputy keeper of Oriental Antiquities. He would often be seen arriving at the Museum in the company of one or more of the trustees late in the morning, wearing his Saville Row suit and a large, wide, homburg hat. In fact, many junior members of staff who had no reason to know any different did, I am sure, think he was a trustee. He managed not to let work get in the way of his social life, which was carried out in his office and out at lunch. It has to be said, his keeper, Basil Gray, was not too happy with the way he conducted himself and his lack of departmental output, but there was little he could do about it given Soames' powerful friends.

My first introduction to the wider Museum came with my job as assistant to the clerk of stationery, as now and then I would go round and drop off orders to people. This was really the messengers' job but sometimes I volunteered to go myself as it got me out of the office and I did get to see parts of the Museum I would never otherwise have seen.

Because it was such a large department most of my contacts were in Printed Books. Their main office was behind a door disguised as a bookcase in the King's Library and was known as the anteroom. Many years before I worked at the BM, when I was about 9 or 10, my mother and I had brought an old book up to the Museum to get an expert's opinion on its rarity. Sad to say it wasn't very rare, even though it was a mid-nineteenth-century tome. However, we had been directed by the warder to ring the bell in the middle of the King's Library and we were waiting for someone to arrive to see us when suddenly the bookcase, which we hadn't realised was false, opened and out stepped our expert. My mum never got over this and would tell everyone about it for years to come. It was with some amusement, therefore, that as a Museum employee many years later I was able to use my key to open up this bookcase and walk through to the anteroom myself.

The two people I dealt with most in the anteroom were the two clerical officers, Susan Willsdon and Frances Duck. They were both very attractive young women; Susan was about my age and Frances was probably a couple of years older. Given that most of the people I dealt with around the Museum were middle-aged men who had been there since the 1930s, I did tend to favour Printed Books when it came to delivering stationery personally!

Sadly, neither of them stayed very long and both were gone within the year, though I did hear of Frances again a few years later in 1970, when she was involved in the famous Dawson's Field hijackings. After leaving the BM she had got a job as an

air hostess with BOAC and was on duty on flight 775 from Bahrain, which became the fourth plane to be hijacked by the Popular Front for the Liberation of Palestine. The hijacking aimed to pressurise the British government into releasing Leila Khalid, who had been captured while unsuccessfully trying to hijack another plane earlier. Frances was held hostage in the desert for a while but fortunately was eventually released without harm and became something of a heroine. When news of her role in the hijacking broke, I felt I was somehow able to bask in her reflected glory, as I still had in my possession some notes this celebrity had once sent me signed 'Fanny Quack'.

Printed Books had plenty of other sub-divisions which I managed to get round. The one that fascinated me most was the Copyright Receipt Office. By law, a copy of every publication in the United Kingdom had to be deposited with the British Museum, where they were received and registered in the Copyright Receipt Office. The man in charge of this office was called Ben Damery. When you walked into his office all you could see was a desk piled almost to the ceiling with books. It was impossible to see Ben sitting behind the desk and we used to carry on any conversation without actually setting eyes on one another.

Elsewhere in Printed Books there were executive officers and higher executive officers (HEO), like Ron Pick, Frank Fletcher and Jimmy Etherington, who presumably were doing something but no one ever seemed to know what. In charge of all of them was Jimmy Norton, the senior executive officer. Being new and young I was keen to know what work was being undertaken in the darker recesses of the Museum so I would sometimes ask Susan or Frances what Jimmy Norton or Ron Pick, for example, did. But they always just shrugged their shoulders. I also asked Tom, Jack and Bernard in our office but they didn't seem to know either. The one thing I did

learn about them was that they seemed to spend an inordinate amount of time in the canteen.

Talking of Jimmy Etherington, he was a bit of a character in his own right. He would often be seen in the company of his friend, Ted Albertiri. The two of them would walk around the Museum at a very sedate pace side by side. Ted always had his hands clasped behind his back with his stomach sticking out. Jimmy had a very conspiratorial way of speaking to anyone. He would go up to them very close, put his hand on their shoulder and look round furtively to make sure no one could overhear, and then speak very quietly into their ear. Normally what he said was completely inconsequential and you wondered why he'd gone to all the bother of not being overheard. He did, however, have a good line in punchy jokes, so you sort of looked forward to one of Jimmy's visits.

Another pair who could always be seen going round together was Alf Spiller and Jack Port. Alf was the higher executive officer in charge of the Manuscripts Department and Jack was the executive officer in Oriental Printed Books and Manuscripts. I always found it a bit strange that Alf was an HEO when no other department outside the Director's Office and Printed Books had anyone higher than an EO in charge. I was told some years later that this happened just after the Second World War, when the grading structure was reorganised. Until then there had been a myriad of different grades and the idea was to streamline it all. The people that eventually became the clerical officers, executive officers and higher executive officers were mostly, before restructuring, attendants, assistant clerks and second division clerks. Alf was the trade union chairman and, as such, was consulted about the regrading. Apparently he put a lot of effort into getting his own post upgraded to HEO, while letting the others be regraded to CO and EO. I don't know whether this was true or not, but his grade was certainly a bit out of kilter with everyone else's.

Leaving that aside, Alf was good company. He had a sort of jolly uncle personality; always good for a few quips and always there with good advice for us youngsters. One of his little witticisms that I remember occurred when I was standing on the colonnade out the front of the Museum with him and an ambulance pulled into the yard. I said, 'I wonder what's happened.' He replied quick as a flash: 'Someone did a bit of work in the Museum.'

His friend, Jack Port, was an entirely different kettle of fish, and how they managed to be such good friends I'll never know. It's not that Jack was unpleasant or anything, he was just dour. I don't think I ever saw him smile, no jokes ever crossed his lips and advice was in short supply. What was not in short supply was Jack's description of all his many ailments and operations, not just once but repeatedly about the same operation or the same illness. He could talk for hours on the subject if you let him. I don't know how many times I saw his scar where he had his appendix out. It seemed like a daily occurrence that Jack would lift up his shirt and reveal his mutilated flesh.

Another Printed Books man was Reg Goode. He was a short, rotund fellow who looked most ungainly, but it was said that in his youth he had been an excellent ice skater. We youngsters couldn't see it, but those who had known him for years swore it was true. While looking for photographs to accompany this book I came across illustration no 6. It is possible to see from this that Reg might well have been more lithe in his youth, and perhaps we scoffing youngsters had it all wrong. If so, I belatedly apologise, Reg, on all our behalves for the sniggering that went on behind your back.

There is no doubt that the BM's major character of this period was Bexley Hocombe. He was always dressed immaculately with a full three-piece suit, and arrived at work in typical Civil Service fashion, complete with bowler hat and rolled-up copy of *The Times* under his arm while carrying a briefcase

in his hand. He was the quintessential Civil Servant, or probably more realistically, the quintessential caricature of a Civil Servant. Judging by appearance he looked as though he was someone very high up indeed, but he was, in fact, a clerical officer like myself.

His main task seemed to be to entertain the younger members of staff with his outspoken political opinions on everything under the sun. Wherever you bumped into him he would start ranting on in a very loud voice on the topic of the day in a broad Northern Irish accent, even in the quiet of the Reading Room. His views on all subjects were an eccentric mix of very right wing and just pure nonsense. But as youngsters we loved him, because all you had to say to him was something like, 'Hello Bexley, I see Harold Wilson is …' And before you could even say what it was you had seen Harold Wilson doing, he would be off on one of his perorations about the evils of the Labour government, Harold Wilson and everyone and everything else. If you dared to interrupt him by saying something like 'Well, I think the Labour government is right …', he would go red in the face and shout even louder. We all took great delight in winding him up and letting him go.

The year 1967 was, of course, before the Northern Ireland troubles started up in earnest, so his remarks at this time were usually directed at the 'absolute uselessness' of the Labour government, but later, when the IRA hit the headlines, he would rail forcefully for hours against the nationalists and those who wanted a united Ireland. Bizarrely, Bexley himself was actually a Catholic, and in later years his main opponent in these impromptu debates around the Museum was an IRA supporter called Jeremy Newson, who was a Protestant. It all got very confusing! In fact, Bexley was a member of the Orange Order and, unlike some of his colleagues in the department of Printed Books, everyone knew exactly what he was working away at as he was responsible for cataloguing all the Orange

Order material that was available in the Reading Room. I never found out whether his passion for Northern Ireland Protestantism came from cataloguing Orange Order material, or whether he was given the job of cataloguing Orange Order material because of his obsession with the subject, but that was what he did for about thirty years.

LIFE-CHANGING EVENTS

And so after a few months I had got to know my way round a bit, was familiar with some of the characters and the work that was being carried out (or not in some cases) around the Museum. My early impressions of the staid institution were not wholly borne out by what I had seen and heard, but it was certainly true that a large number of the staff had been working at the BM since before the war and, of course, that 'olde worlde' atmosphere was still around. But this was being more and more challenged by the number of new young arrivals who were coming to work at the Museum. Two other new arrivals that I palled up with were Ron Wallom and Richard Ellingsworth.

Ron told me that he knew he was going to like working at the Museum when, on the day of his job interview, he walked past the Reading Room Admissions desk and saw me trying to sort out five readers' tickets into two equal piles. He said this sort of eccentricity appealed to him. Personally, I don't remember the incident and think he made it up.

He always maintained that he could have been a big rock star if only he hadn't 'bottled out' of playing at a gig in Hamburg in the early 1960s with his band, the Jakes. Because, for some reason which I never discovered, he decided not to go, the agents booked another local band instead, all of whom

came from the same town and went to the same school as Ron. And that is how it came about that Mick Jagger and the Rolling Stones became one of the most famous bands of all time, while Ron Wallom and the Jakes faded into obscurity. At least, that was what Ron always said.

I got to know Ron very well and apart from making up stories about me, and his flight of fancy about his rightful place in the annals of rock history, I always found him to be very down to earth and sensible and I was to remain friends with him for the next thirty-four years, until he retired from the Museum in 2001.

Richard, on the other hand, was a bit of a strange character who loved American comic books and was often to be seen writing fantasy stories which he hoped would one day be published. They never were while I knew him, but perhaps they were later on. I'd like to think so.

Richard was the cause of my first run-in with authority. As in most places, we used to have reports written about us by our immediate boss and countersigned by our boss' boss. In my case this was Tom Punter and Mrs Ding. The reports in those days were completely secret and reportees had no sight of what was being said about them. Normally they were written annually, but there was also a six-monthly report for new staff to check on progress and see if they should be kept on. When the reports were completed they were sent to the Staff Office for filing away. One day I received a call from Richard, who worked in the Staff Office, saying he had my six-monthly report and would I like to see it.

Naturally I was very curious and went up to have a look. I was very pleased with the report as Tom had marked me as 'very good' with 'high intelligence and sound common sense'. The only criticism of me was my handwriting which, he said, was 'untidy'. While I was reading it, one of the Staff Office executive officers, Daphne White, came into the room and saw

me. She was horrified that I should be looking at my report and learning what my boss thought of me. I left the office quickly, but later that day I received a call to go and see the Museum secretary, Bentley Bridgewater. Mr Bridgewater was a real gentleman and in my admittedly limited dealings with him so far he had always seemed very fair, and although in a very senior position, in fact number two only to the director, he always took time to talk to junior members of staff, which is more than many senior members did. This did not stop me feeling very worried and the thought crossed my mind that, in spite of my report being a very good one and recommending me for retention, this crime might be seen as so heinous that I would soon be out on my ear.

When I went into the room, Mr Bridgewater was, as always, the perfect gentleman. He kindly asked me to sit down and said that Mrs White had told him what I had done but he felt he should give me the chance to explain myself before he decided what to do about it. I asked him what Mrs White had said and he told me that she had caught me reading my own report. I decided the only way out of this was to lie. So I told him that I had certainly been in the Staff Office and couldn't help but notice my report which was out on the table, but I had picked it up and given it to Mr Ellingsworth to put away. Whether he believed this or not I really don't know, but he nodded and just said, 'Thank you. You may go now.'

At that point, of course, I didn't know whether he had already asked Richard what had happened, so I raced up to the Staff Office to see him. Fortunately Mrs White wasn't there and I told him what had just occurred. He said that Mr Bridgewater had not spoken to him yet. While I was in the office Richard received a call from Mr Bridgewater asking him to go downstairs to see him. I said, 'Tell him the same thing. I'll see you in the canteen later.' About half an hour later I met Richard in the canteen. He said Mr Bridgewater

had asked him why he had left my report out on his desk and Richard said he had a few out as he was filing them away. Mr Bridgewater seemed satisfied with this and we never heard any more about it. I often wondered what Mrs White thought!

Shortly after this I found myself involved in another incident with Mr Bridgewater that could also have had dire consequences. I was in the General Office talking to Chris Down and yet another young newcomer, Susan Hayes, when we started talking about Mr Bridgewater. As I said earlier, Chris was a dab hand at mimicry and Mr Bridgewater had a way of speaking, with mannerisms to match, that cried out to be impersonated. He had quite a high-pitched voice with a very posh accent and used to say words like 'lawks'. Also, in true Civil Service senior administrator fashion, he was always very concerned to find precedents before deciding what action to take with regard to any problem which came his way. His main mannerism was to hold his hands up by the side of his face and twiddle his fingers in mid-air while speaking. So on this particular day, Chris did exactly that; he said in a posh, high-pitched voice, 'Oh, lawks, is there a precedent?' while twiddling his fingers just as Mr Bridgewater would have done. Susan and I joined in and we walked round the office, all three of us, twiddling our fingers and saying, 'Lawks, is there a precedent?' As we were in mid-flow, the door opened and in walked Mr Bridgewater. He just looked at us and said, 'Don't let me spoil your fun.' Well of course his entry did spoil our fun and we stopped immediately. For his part, he didn't say any more about it, though he must have known what we were doing. As I have already pointed out, he was a true gentleman.

A few days after this incident I was in my office when Tom Webb, who I knew as a CO in the Photographic Service, approached me and said, 'I don't suppose you want to join the union?' It turned out that he was the branch secretary of the Civil Service Clerical Association (CSCA). I thought, if this

is how he goes about recruiting people there can't be many people in the union at the BM. He had seen me at least a couple of times a day, practically every day for the past six months, on his way to and from his office without trying to sign me up, and then when he did finally get round to it, it was such a negative invitation that I think I could have been forgiven for turning him down. However, I didn't turn him down but agreed to join the CSCA – a decision that was to play as big a part in my life as the phone call telling me I had got the job.

The year 1968 saw some big changes at the British Museum, as first the director, Sir Frank Francis, retired, and secondly, the trustees decided to appoint, for the first time ever, a deputy director.

Sir Frank had worked at the British Museum since 1926. He had been promoted to keeper of the Department of Printed Books in 1948 and was appointed director in 1959. He had revolutionised the cataloguing procedures while keeper and was a key figure in the British Museum Act of 1963, which separated the British Museum from the Natural History Museum and set the terms and conditions under which BM employees still work, insofar as their governance and relationship with the main Civil Service goes.

With the departure of Sir Frank, the trustees appointed Basil Gray, keeper of Oriental Antiquities, as temporary director while they considered the future direction of the Museum. This was the last time that a lifelong British Museum employee was to be promoted through the ranks to take the top position.

In place of the devoted career museum person, the trustees, in their wisdom, decided to appoint a public figure to head up the BM, the choice falling on Sir John Wolfenden, well known at the time for being the author of the Wolfenden Report, which, for the first time in British history, had recommended that consenting sex between homosexual adults

'in private' should no longer be a criminal offence. By profession he was a teacher and had been headmaster of Uppingham and Shrewsbury schools and vice chancellor of Reading University. He had had no real connection with the museum world at all. His first major achievement at the Museum was to allow his office to become a smoking area as he was himself a pipe smoker. Until his reign, smoking had been banned everywhere in the BM because of the risk of fire.

Even the new deputy director, Maysie Webb, although a current Museum employee, had only been in the post of keeper of the National Reference Library of Science and Invention (NRLSI) since 1966. She was actually the trustees' third choice for the post, but the first two had turned down the opportunity. This didn't stop her from making her mark immediately by throwing the well-respected Bentley Bridgewater out of his large office and taking it over herself – a move that didn't go down too well with many of the staff, both junior and senior.

One of her first appointments, I remember, was her assistant from NRLSI, Barbara Youngman. As there was nothing really for her to do she was given the arduous task of finding out which doors in the Museum opened to the left and which to the right. I'm not sure if anyone ever saw the outcome of this critical and essential survey.

Meanwhile, my life in the Stationery Department, with the odd spell on Reading Room Admissions, continued on its merry way. I enjoyed the job and was very happy there. There was a bit of sadness when old Ted the warder retired. Ted was the warder at the entrance door from the gallery to our office. His job was to let the public in and deal with any emergencies that might arise. In the year and a bit that he stood outside the door I was never aware of any emergencies, which was probably just as well because old Ted was well into his seventies, wore a hearing aid and walked with the help of a stick. What would have happened had there been an emergency I dread to

think. But he was a nice old boy and we often passed the time of day when I was on my way in or out of the office.

So everything was going swimmingly, if a little predictably, when one day Fred Crees walked into my life. Fred was yet another of the new breed of teenagers and early twenty-somethings flooding into the Museum to take the place of the pre-war breed. Like Geoff, Richard and Ron, he started Museum life in the Staff Office but he was a bundle of nervous energy, never happy unless he was rushing around somewhere and talking at the speed of light.

One day I met him in the King's Library. I can't remember what I was doing exactly, but I expect I was taking some stationery to someone while he was flying along at his usual million miles an hour. When he saw me, he stopped and said, 'Would you like to be branch secretary?'

'Branch secretary of what?' I replied.

'The union,' he said. He explained that all three of the current officers, including Tom Webb, were going to resign because they felt they had done it long enough and it was time for new blood to take over. He told me they were going to call a special meeting for all members to vote in a new committee and new officers and he thought I would make a good branch secretary. Why he should have thought that I have no idea. Anyway, after some reflection I said I would do it, as I was a committed trade unionist and I felt it might stretch me a bit and give me something a bit more interesting to do than just compile stationery orders.

My impression from talking to Fred was that we would struggle to find enough people willing to join the committee, but at the meeting a couple of weeks later I discovered there was going to be an election, as something like twelve people had been put forward for the nine places. Most of those present at the meeting were the old timers, and as I was not very well known to them I failed to make it on to the committee,

gaining the tenth highest number of votes. Fred himself was elected and became branch chairman, while my offered place as secretary was taken by Geoff Bayliss, who worked at the Holborn Branch of the NRLSI. He defeated a man called Mick Martin in the election for the post.

After the meeting, Fred came up to me and told me not to worry, he would sort it out. I wasn't too sure what that meant at the time but just three days later he came and told me that Geoff had resigned as branch secretary and the committee had elected me to fill both the vacant committee place and the branch secretary post. I had no idea why Geoff had resigned and Fred didn't tell me, but I got the distinct impression that somehow Tammany Hall had arrived at the Museum.

My first committee meeting was a nightmare because Mick Martin declared he should have been offered the post of secretary as he had been the runner-up to Geoff in the first election. Mick was a wily old bird and had been around the union for a long time. In fact, he had been on the National Executive Committee in the early '60s so he knew all the rules and all the full-time officers at union headquarters. He told us he was taking over as secretary whatever we said, and would get headquarters to confirm the decision. He then got up and left the room, taking the union's portable typewriter with him.

A vague air of unease settled over the rest of us and we decided we had to find out if Mick was right and whether he should have been offered the job. So Fred rang up headquarters and spoke to the full-time officer responsible for the Museum, Roy Footman, who, I learned later, was an old friend of Mick's. Roy said it was up to the branch to decide who it wanted to have as its secretary and, even though it was customary, there was no rule about the runner-up having to be offered the job, so in his opinion I was the legitimate branch secretary if that's what the committee had decided.

Someone now had the unenviable task of telling Mick Martin this; something made even more difficult by the fact that he worked at the Newspaper Library out at Colindale in North London. In the end, with the help of Roy Footman, we did manage to persuade Mick that I was now the branch secretary and that he should not only hand over the branch typewriter, but also all the other papers he had managed to walk off with.

I found some of the documents I was handed fascinating, particularly the minutes' books as they went back to 1919, and I found it really interesting looking back at what had been exercising the minds of the union branch committee in those far-off days. The main issues always seemed to centre on grading and job demarcation, particularly in the Reading Room, a subject which was still live in 1968 when I took over, fifty years on.

In spite of this interesting glimpse into the past, I have to say that I found the immediate past secretary's minutes the most entertaining, especially the reports of the committee meetings held on 7 August and 4 September 1967, which read: 'The minutes of the above meetings were taken on separate sheets of paper which were subsequently consumed with great relish by the secretary's dog. Hence there are no recorded minutes of the meetings.'

I was plunged almost immediately into an industrial dispute as our members at NRLSI Holborn were unhappy about overtime arrangements for covering their Reading Room. Fred and I went over to see them and they explained the problem, which was that sometimes managers would give them very short notice of the need to cover the Reading Room out of normal hours, and that the overtime was being made compulsory. They felt the overtime should be voluntary with more notice being given. We then went and saw the local management who refused to budge on the issue, so we went back to

see the members and told them the outcome of our meeting. Fred told them that it would strengthen our hand if they were prepared to take industrial action, which could mean anything from refusing to cover the Reading Room to possible strikes. The members, however, demurred at this and said they were not prepared to take any form of action. We agreed to take the case back to central management at the BM itself and see what we could do.

On our way back to the Museum, I said to Fred that it seemed as though we weren't going to win this one. He said, 'When we see Mr Bridgewater, let me do all the talking.' On arriving back we went straight to Mr Bridgewater's office and Fred began by outlining the problem. He then said, much to my utter astonishment, that we had not long returned from a meeting with our members at the NRLSI, and such was the strength of their feelings over this that they were all for going on strike immediately, but we – Fred and I – had managed to stop them. But, he continued, he didn't think we could contain them much longer.

My jaw metaphorically dropped; I had to consciously force myself not to let it drop literally as that might have given the game away. Mr Bridgewater starting flipping his fingers and saying, 'Oh, lawks!' Having delivered this bombshell, Fred just sat back and waited for a response. Mr Bridgewater eventually said, 'Leave it with me. I'll get back to you later.'

Later that same day, he called Fred and me back into his office and said he had had a word with Michael Hill, the new keeper at NRLSI following Maysie Webb's promotion, and he had agreed firstly to try and give at least two days' notice of overtime and secondly, as far as possible, to ask for volunteers, although he said he wanted to retain the right to make it compulsory if absolutely necessary. I thought this was probably the best we could hope for but Fred shook his head and said, 'I don't know. We'll have to consult our members.'

The outcome was, of course, that we accepted Mr Hill's proposal but not without letting a few days go by and Fred letting it be known that the members were still minded to strike over the issue but that he had personally managed to persuade them to accept what was on offer.

Fred's next masterstroke was to introduce a branch newsletter. Although the newsletter had very small beginnings, being distributed to our members only, it was to grow into a museum-wide publication. Under Fred it was quite frankly very dull, consisting mainly of the latest union news and notices about meetings. It was after Fred's departure that the newsletter took on a life of its own, eventually becoming compulsive and almost compulsory reading for all staff lasting for something like thirty years.

Fred left the Museum after about six months in charge of the union. He was a committed Evangelical Christian and found a new job with an Evangelical organisation whose main purpose in life seemed to be smuggling Bibles into the godless country of Czechoslovakia for the betterment of the people, or so he said. With Fred gone, I took over editorship of the newsletter and decided to revamp it into something more readable, interspersing the union material with other articles, some thought-provoking, some of a lighter nature and some about the Museum itself. Coincidentally with my assuming the editorial reins, an old school friend of mine, Herbert Tyler, came to work at the Museum. We had previously worked on a couple of projects together: an unpublished novel called *Lilo Schlieberger Down South* and a book of poems, *Gaam*, which had been published. So, knowing he was a good writer, I immediately appointed him assistant editor and together we worked on the next few issues of the newsletter.

In those far-off pre-computer and pre-photocopier days the newsletter had to be typed out on to a 'skin', as they were called, and run off on a duplicator. If you made a mistake you

had to put a dab of correcting fluid over the error and retype it. The correcting fluid we used was red in colour. I used to make copious mistakes so the whole skin had plenty of red dots all over it. I remember on one of her rare visits to my office, Mrs Ding saw me typing out the newsletter after work one evening. She looked at it and remarked, 'It looks as though it's got measles.'

My first 'scoop' was to get an interview with Sir John Wolfenden himself. This former teacher's big idea seemed to be that the BM should involve schoolchildren more, which in itself was a laudable aim, but when pressed he seemed to have no idea how to carry this out. It is true to say, however, that the Education Department was founded under his steward-ship and over the years this was to provide much support for schools and children generally.

It was our second interview that caused something of a mini-sensation around the Museum. I sent Herbert off to interview a recent arrival at the Museum, Bevis Hillier. Bevis was a highly respected art historian and journalist, who popu-larised the term art deco, making it the definitive term for that style of art. He had been appointed to a sort of public relations role by the chairman of the trustees, Lord Eccles.

When his interview was published it created waves all round the Museum for several reasons. The first was that he had said in the interview that he had been appointed directly by Lord Eccles to take on the job. The post was not a complemented one and he had had no formal interview; he was not on a Civil Service grade and therefore not tied to any particular pay scale as everyone else, including the director, was. No one knew, therefore, what sort of money Bevis was being paid. The second was that his appointment had not been officially announced anywhere and many people were actually unaware of him or his role until our interview appeared. And the third was that until this time, curatorial departments were responsible

for their own public relations as they knew their market best. Bevis Hillier's appointment muddied this and many of the keepers were now unsure of whether to continue as before or whether they were supposed to defer to the new public relations man. The matter was raised at keepers' meetings and the director given something of a hard time over the whole saga. For his part, Bevis was called in to Lord Eccles' office and told never to give interviews to the press again without his authority. This injunction didn't matter too much, however, as Bevis Hillier left shortly afterwards.

It was the November 1969 issue that was to change my life. I had been thinking about writing an article on how junior staff at the Museum were sometimes treated as though they were still at school, and I was going through some examples I could use when I realised that actually all the examples I could think of emanated from one man, Gordon Barber, the HEO in charge of the Photographic Service. As well as treating his staff like kids, he had also been involved in a couple of unsavoury episodes, so I decided to change the article into a thinly veiled attack on him by writing it as a moral fairy story with the names of those involved changed. The first unsavoury episode was when he had made a racist remark, overheard by several people, about his executive officer, Edward Telesford, who was black. The second concerned the promotion board when he was elevated to his current position. He had been the executive officer in the Photographic Service the previous year when a management report was commissioned by the Museum on the future organisation and administration of the service. One of the report's findings was that the EO post should be upgraded to HEO, hence the promotion board. However, because Gordon Barber was the EO in the service he was given sight of the full report before the board, something the other candidates were denied, so when he was questioned on the board about how he saw the future of the Photographic

Service etc., he already knew the official recommendations, giving him an unfair advantage over everyone else.

Using these two episodes, along with a number of other things he had been guilty of (as I saw it) in the treatment of his staff, I wrote up the story and put it on the front page of the newsletter. Of course he read it and put in an official complaint to the director. He threatened to sue me and the union for libel and demanded my sacking. He also consulted the branch officers from his own union, Alf Spiller and Jack Port. As no real names had been mentioned in the story they asked him how he could be sure it was about him. He thereupon pointed at all the incidents in the story, saying, 'That was me' or 'I did that' and so on. Alf's advice to him was: 'If you really did all those things I'd keep quiet about it if I were you!'

Shortly after the newsletter was published, Herbert and I were summoned separately to see Alan Gray, the HEO in charge of the Staff Office, and the man who had originally interviewed me for the job at the BM. We were both told that the Museum was instituting a new training policy which involved moving clerical officers around different departments to gain wider experience of the Museum. I was being moved to NRLSI Holborn and Herbert was being moved to the NRLSI branch at Bayswater. I asked if this had anything to do with my article in the newsletter and he flatly denied it. How strange that shortly after the article came out, the editor and deputy editor should be moved as far away from the Museum, and from each other, as possible, and how strange that we were the only two clerical officers ever to take part in this training scheme.

Gordon Barber never did sue us but we didn't speak for about thirty years until we were forced into a position where we had to work together, but that's for a later chapter.

Just after the announcement was made that I was to go to NRLSI, Frances Fletcher, the assistant welfare officer, stormed

up to the Staff Office and proclaimed, 'We must start a Save Norman Jacobs campaign!' Sadly, the campaign never got off the ground and, although Herbert resigned altogether rather than go to Bayswater, on 10 November 1969 I left the stationery department to start my new life at NRLSI Holborn.

4

NOT WHERE I WANTED TO WORK

The National Reference Library of Science and Invention (Holborn Division), or NRLSI for short, was the old Patent Office Library which had been transferred from the Board of Trade to the British Museum in 1966. It was situated just off Chancery Lane, about a mile or so away from the main museum building. The Reading Room was open to the public and contained a large part of the Museum's collection of scientific books and periodicals. The building itself was a rambling old Victorian building with plenty of corridors and offices. It was a soulless place with none of the splendour of either the architecture or the objects I had come to accept as part of my working life at the British Museum. It seemed, for the most part, just like another Civil Service department and not the sort of place I wanted to work in at all.

My job was in the quaintly named Roneodex section, so called because the job of the section was to record all incoming scientific journals and periodicals on a Roneodex visible card index system. By law we had to ensure that all incoming periodicals were stamped and placed on the public shelves on the same day as they were received, in case of any future disputes about patents and queries about when something had become public knowledge. The section was divided alphabetically,

with four COs working on their part of the alphabet. I was L–R. Mostly it was a very routine job and hardly required any thought at all. A messenger would arrive a couple of times a day and dump a large pile of pre-sorted journals on to the desk and I then had to record them on the Roneodex and place them in the out-tray for the messenger to take them to the Reading Room. As my L–R section contained all the main photographic magazines it was also my unofficial job to let the rest of the all-male office know when they arrived, so they could quickly scan through for the photos of naked or half-naked women!

The only vaguely interesting part of the job was when a journal arrived which didn't seem to be on the index. Sometimes this was because they were new, sometimes because they had changed their name and sometimes the title on the front of the magazine was not its officially catalogued title. For example, we might receive a journal entitled *Up and Down* which was actually catalogued under the title *Journal of the Lift Engineers Association*. It was our job to track it down. If it was an entirely new magazine or journal we had to pass it over to a research assistant who would make a new catalogue entry for it.

There were two other members of the Roneodex section: the EO in charge and another CO whose job it was to help out with the searches for unknown magazines. They occupied a small office next to the main Roneodex room. The EO was a man called Walter Beeby, who was an Anglo-Indian with a slight Indian accent. Either his command of the English language was not great or he was very forgetful, because he would forever be falling back on the words, 'this thing'. For instance, he might bring in a magazine and say, 'this thing needs a this thing', which translated as 'this journal needs a stamp'. The CO who worked with him was Brian Smith, who I already knew as he was on the union branch committee. Brian and I became good friends at Holborn and it was due in large measure to

him that I was able to get through the excruciating boredom and mind-numbing job of a Roneodex clerk.

Poor Brian had a very sad story of missed fame and fortune to tell, just like Ron Wallom. He was really an actor but had missed out on his big break a few years previously because another actor with a similar name had been given the part that he should have had, and subsequently went on to bigger and better things as Brian would surely have done had he had the opportunity. Because Brian Smith was quite a common name he had adopted the stage name of Paul Eden, and the part he was supposed to play went by mistake to Mark Eden who went on to appear in a number of well-known films such as *The Password is Courage*, *Séance on a Wet Afternoon* and *Doctor Zhivago*. Later on he was to take the part of Alan Bradley in *Coronation Street* for five years. Following this tragic mistake, the nearest Brian got to being a big star was a bit part in *Eastenders*.

One of my other colleagues was Jacob Adams, which was a strange coincidence because when I went to NRLSI I had not long become an uncle to a little boy called Adam Jacobs. Although Jacob was as keen as any of the others to take a look at my photographic journals, he was a devout Christian. One day he noticed my fingernails, which I kept short on my left hand and long on my right hand, as this helped with playing the guitar. He asked me if this was something to do with my religion, so I explained why I cut them like this. He burst out laughing and said, 'It's all right, you don't have to tell me what your religion is. I understand it's a very personal matter.' I said, 'No, really, I keep them like this for playing the guitar.' He just shook his head and said, 'We'll say no more about it.'

Above Walter Beeby was the HEO in charge of the administration at Holborn, Arthur Keyte. I already knew Arthur fairly well as he was a frequent visitor to the Director's Office, where he often stopped for a word with Jack Bennett. Arthur's

father had worked at the Museum before the war and Jack's opening line was always, 'How's your old dad?' Arthur's dad always seemed to be doing fine. Arthur was a decent enough sort with a cheery manner. His main characteristic was that he never used anyone's name when he spoke to them but referred to them as 'old lad' or 'old chap'.

A few days after I arrived at Holborn I was called into his office and he said to me, 'Hello, old lad, I know you didn't particularly want to come here but we're not that bad you know. I hope you get to like us.' Then he asked me if I was still the union branch secretary. I had no idea of his views on active trade unionists, and I wondered why he asked me. However, I replied that I was and to my great surprise he said, 'Well, I believe it's a Museum rule that union branch secretaries are allowed a half-day off each week to get on with their union business, so which half-day would you like?'

I had never heard of this rule before and none of the branch secretaries I knew (there were seven different union branches at the Museum) were allowed any time off. But not wishing to look a gift horse in the mouth, I said, 'Friday afternoon would probably suit me best.' So he said, 'Fine, I'll tell Mr Beeby.'

I discovered later that Arthur was a keen supporter of the unions and had been an active branch officer in his younger days. I also think he was quite sympathetic to my plight and knew the real reason I had been sent there – and it wasn't for training! It was because of Brian and Arthur Keyte that I didn't follow my friend Herbert and pack the job in. They both kept me going and I was very grateful to both of them.

The two research assistants we had to refer new journals to were Margaret Seager and Doris Crews. Both they and their office looked like a throwback to the worst excesses of a Dickensian novel. These two elderly spinsters occupied a poorly lit office with paint flaking off the walls and bars on the windows. To my youthful eye they looked as though they must

have been in that same office wearing the same dowdy clothes since the Victorian era. They were very school ma'amish in manner and you half expected them to take out the cane if they found you had made a mistake. It also wouldn't have been a great surprise if I'd seen them making their catalogue entries on parchment with a quill pen. Their office was not the place to try and lighten the mood with a little banter.

Outside of my own office I got to know several of the other staff. Apart from Brian, the person I got to know best was the same Geoff Bayliss whose place as branch secretary I had taken. I took the opportunity of asking him why he had resigned and he said he hadn't wanted to be branch secretary in the first place but that Fred had asked him to stand, assuring him he wouldn't have to do the job for longer than a week. That Fred was some operator. I am sure that Czechoslovakia must very soon have become awash with Bibles.

In another office was a man called Hugh Walters who was a frustrated journalist. He often used to tell me about how in his youth he had wanted to go into journalism but somehow it had never quite happened. He was telling me his sorry tale in his office one day when the phone rang. He picked it up and said: 'City Desk … oh, I'm sorry, I mean it's Hugh Walters here.' He left not long after I arrived at Holborn, but whether he at last achieved his ambition and got a job on one of the big national newspapers, I never found out.

Although Brian Smith was on the union branch committee, it was Peter Risdon, a clerical officer on the Reading Room Enquiry Desk, who was my main support at Holborn in all things union because he was the branch vice chairman. Peter was the union equivalent to George Morris, very serious on the outside but with a dry sense of humour. One day a reader complained to him that he'd got a splinter in his hand from one of the bookshelves. Without missing a beat, Peter replied, 'Well, you'd better put it back then.'

As my actual paid job was boring in the extreme, I looked around for issues I could take up to keep my mind active. The first idea I had was to see if we could abolish the signing-in book as I felt it showed a lack of faith and treated staff as though they couldn't be trusted to do their proper hours. The signing-in book was not just a Museum phenomenon as all Civil Service departments had them at the time, so it was going to be a bit of an uphill struggle, but I thought it was worth pursuing.

I spoke to Peter about it and we decided to go for a local Holborn agreement rather than a Museum-wide one and then use it, if we were successful, as a precedent for the rest of the BM. We arranged an appointment to see Dr Hill and, as we sat in his secretary's office waiting to go in to see him, I noticed Peter getting very tense. He was clenching and unclenching his hands and had almost started to shake. He turned to me and said, 'Be calm. Don't be nervous.' Personally, I wasn't in the least nervous and thought he should heed his own advice.

Dr Hill was surprisingly quite receptive to our arguments and, although it took a couple of meetings, he agreed to do away with signing-in books at Holborn. As far as I know, the staff at NRLSI Holborn were the first Civil Servants in the whole country not to have to sign in and out. As planned, we used this agreement as a precedent and after a couple of months it was widened to include the whole of the Museum. I was amused later in the year when our renamed union, the Civil and Public Services Association (CPSA), discussed this very issue at its annual conference and instructed the National Executive Committee to negotiate with the Civil Service Department to abolish the books in all government departments. By the end of 1970 they were gone from everywhere – but we were first!

Just after this, the Museum created a new post of chief executive officer in charge of administration. The new person

would sit under the deputy director in the Museum hierarchy with poor old Bentley Bridgewater being even more sidelined. There were two applicants for the job: Elsie Ding and Jack Ryde, the SEO in charge of the Accounts Department and yet another survivor from the pre-war cadre of assistant clerks and attendants who had worked their way up through the ranks. Much to our surprise it was Mr Ryde who was appointed to the post.

After I had been at Holborn for about two months, in January 1970, Brenda Miller, the executive officer in Greek and Roman Antiquities phoned me and asked if I'd like to transfer to her department as there was a vacancy. I jumped at the chance and she said she would speak to Alan Gray about it. He refused to allow it as he thought I should spend more time at Holborn before being considered for a transfer back. But the incident gave me an idea for my next negotiation. Most COs at the Museum were working in administration in the Director's Office or the Department of Printed Books (which included NRLSI), but the plum positions for our grade were the ones in antiquities departments, where the 'real' work of the Museum was carried out and why most people, myself included, had applied for a job at the BM in the first place. Most antiquities departments only had one or, at the most, two COs in them so they weren't easy to get in to, and it was just a matter of luck where the vacancies were when you applied to work at the Museum as to which post you were assigned to.

So I hit on the idea of arguing that when a CO post became available in an antiquities department it should be put up for internal transfer first before being advertised outside the Museum. With the new branch chairman, Alan Brookes, I arranged to see Alan Gray to discuss this. On the day of the appointment, I arrived at the Museum a bit early so I could go and see my old friends up in the newly titled Establishments Office, formerly the Staff Office. But when I got to the door,

David Jones, a new CO there, said, 'You can't come in here.' I said, 'Why not?' He replied that, on taking up his new position, Jack Ryde had issued instructions to the Establishments Office staff that I was not allowed to set foot in the office. It seemed to me to be a very petty start for a newly promoted CEO in such a senior position to take as one of his first actions. I also thought it didn't auger too well in getting the Museum management to agree to anything I might put forward.

The meeting with Alan Gray went well, however, and he said he would consider what we had said and get back to us. A few days later he called and said that Mr Ryde and he had agreed with our position and thought it would be good for staff morale if they knew they had the chance of applying for one of these much sought-after posts. From now on any CO post that became vacant in an antiquities department would be advertised for internal transfer, but this would only apply to such posts – others would be filled in the normal way. We accepted this and everyone went away happy. In fact, I didn't know it then, but this successful negotiation was very soon to make me even happier.

Life at NRLSI went on and I was getting more and more bored with the job, which the longer I did it and the easier it became, the more it became screamingly mind-numbing and repetitive. Some time in May 1970, after about six months in the post, Mr Beeby went on three weeks' leave and I was asked to substitute for him, so I became acting EO. This meant working in the same office as Brian. While I was there, Brian asked me if I'd like to swap jobs with him when I reverted to CO. I said I would but reminded him that that decision was really up to Mr Beeby. Brian said, 'Oh, don't worry about him. We'll just present it as a fait accompli.' Which is exactly what we did and Mr Beeby didn't say anything about it – something which seemed very odd to me. But at least I now had a slightly more interesting job.

Just after I took up this new position, an office notice came round advertising a CO post in the Department of Medieval & Later Antiquities (M&LA). This was the first of the antiquities posts to be advertised under our new agreement. I leapt at the chance and put in my application immediately. As predicted, several COs applied for the post and a board was arranged for 8 June. The two interviewers were Alan Gray and the acting keeper of M&LA, Hugh Tait. With Alan Gray on the board I didn't think much of my chances, but I wasn't going to give up the chance without a fight.

The main issue which I felt was going to prevent me from getting back to the Museum proper was that the Gordon Barber saga had continued to rumble on. During the six months or so I had been at Holborn, I had fought off several demands from BM management and my own union headquarters to print an apology to him in the newsletter. I had continually refused to do this and, every time I did, Gordon threatened to sue us again. Fortunately I had the full support of the Museum's CPSA branch members as they knew that what I had printed had been the truth and, indeed, was written as a result of complaints from some of them about his behaviour. However, I felt that this stubbornness on my part was not exactly calculated to put me in Alan Gray's good books and would seriously affect my chances of success on the board.

As it happened, my annual report had just been written and a couple of days before the interview, Arthur Keyte called me into his office to wish me good luck at my interview. He told me that Mr Beeby had given me a 'thundering good report' and he had endorsed it, so this should go down well with the interviewing panel. I thanked Arthur and my spirits rose a little about my chances.

I thought the interview went well, even though Alan Gray did ask a couple of questions about my union involvement and the time I spent on such work. This was aimed, I thought at the

time, at creating an impression in Mr Tait's mind that I was a bit of a troublemaker and that I would be away from my desk too often on union business. But this didn't seem to faze Mr Tait and he even said at one point in the interview that he could forsee no problems with me being a union representative.

Two days later, on 10 June, I received the following letter:

Dear Mr Jacobs,
I am pleased to be able to tell you that following your interview you have been selected for transfer to the vacant Clerical Officer post in the Department of Medieval and Later Antiquities.
Yours sincerely,
Alan Gray.

I later discovered from Mr Tait that when they were discussing the merits of the candidates after the interviews, Alan Gray had been very fair and had not tried to influence him against me at all. They both felt that the good reports I had always received and my youth were just what the department was looking for. Mr Tait told me he thought I was 'easily the best candidate'.

In retrospect I feel that Alan Gray was not actually out of sympathy with me. He had been a member of the Communist Party in his youth and was now a member of the Labour Party, where his political views found a natural home on the left of the party. He was under orders from higher up to deal with me in the way he had done, but when he had the chance to help me out he did so by supporting my transfer back to the Museum almost at the earliest opportunity – the Greek and Roman vacancy had been just a shade too early for him to justify. I think his questioning of my union position at the interview was only an attempt to be fair to Mr Tait, to let him know that he would have to accept my going off on union work as part of the deal, and was not part of a 'Keep Jacobs out'

conspiracy after all. After my return to the Museum I got on well with Alan Gray, though it took many years before I was to get on well with Jack Ryde.

My last day at NRLSI Holborn was 10 July 1970, eight months to the day since I had started there. My nightmare was at last over and I was to return to the Museum to the post that I had always coveted right from the time I first saw the advert for gallery warders way back in February 1967. The Department of Medieval & Later Antiquities was to become my 'home' at the Museum for the next sixteen and a half years.

BACK HOME

At nine o'clock on the morning of Monday 13 July 1970, I returned to the British Museum. This time, instead of turning left immediately inside the main doors to the Director's Office, I walked across the Front Hall almost to where the old Information Desk stood and turned right through the Grenville Library and the Manuscript Saloon and into the door at the end of the gallery. Out of sight of the public I now had to walk down a long corridor lined with bound volumes of manuscript letters, written by such towering British political figures as William Gladstone and Lord Palmerston, and up two flights of stairs, at the top of which was the door into the Department of Medieval & Later Antiquities – my new workplace. And how good it felt.

There was another corridor inside the department itself which I had to negotiate to get to the general office, which was where the two EOs and two COs were stationed. It was a very large room almost completely divided down the centre by floor-to-ceiling racking containing the departmental photographic negatives. On the left-hand side were the four desks with the two EOs facing each other and the two COs likewise. On the right-hand side was a very large table where the two departmental messengers sat and sorted the post, and another

desk in the window bay at which one of the museum assistants (MA) sat.

I was greeted by one of the EOs, Peter Stocks, and the other CO, Stella Lyne. Unfortunately George Collins, the EO under whom I would actually be working, was having two days' annual leave. I already knew Peter from my previous museum days. He was then a CO in the Department of Oriental Printed Books and Manuscripts (OPB & MSS) but had recently been promoted to the EO post in M&LA. Even before starting his new job Peter had regretted ever putting in for it. Although he was not a curator and had no academic qualifications to speak of, he was an expert on Egyptian history, which was his real passion. He had converted to Islam and was learning Arabic. He would soon co-author *The Blue Guide to Egypt* and be much in demand on the writing and speaking circuit. He told me that he had continually turned down the chance of promotion and had not applied for any EO vacancy that came up, preferring instead to stay where he was. However, Alan Gray had convinced him he ought to put in for the M&LA post on the grounds that he should get some experience of a promotion board before he went for the job he really wanted – the EO in charge of the OPB & MSS Reading Room. Alan had told him that no one ever gained promotion at their first attempt. Sadly for Peter, he was to be the exception that proved the rule.

I did not know Stella at all as she had only been at the Museum about three months. She was an extremely attractive young woman, about one year older than me, slim with long dark hair and the most sensitive and wistful brown eyes. But in spite of her good looks, the first thing that endeared me to Stella was her habit of packing up work dead on going-home time. As soon as the clock reached 5 p.m. she would immediately stop what she was doing, even if she was in the middle of something, put her coat on and leave. No clean desk policy for her.

The two messengers were Winnie Kennell and May Seals. I knew both of them as they had often been down to the stationery stores collecting stationery for the department. Winnie was always good for a laugh. She was in her fifties and had been at the Museum for about five years. She had a strong cockney accent and always pretended to be shocked by some of the things Peter and I said to her: 'You boys!' But secretly – or not so secretly really – she loved all the office gossip and banter. May was also in her fifties but was much more reserved. She was a good sort but kept herself to herself for the most part and always seemed quite melancholy. We always felt that she had suffered some great tragedy in her life. Although there was no evidence to go on, we felt she must have been jilted when she was younger and had decided on permanent spinsterhood. I say no evidence, but what led Peter and I to this conclusion was that we, along with Winnie, used to hold impromptu singsongs in the department every now and then when there was no one else about, and twice, when we started singing the Frank Sinatra song *Love and Marriage*, she burst into tears.

The museum assistant who sat in the window bay was Jack Roomes. Jack was yet another of the pre-war breed who had worked his way up to his present position through a succession of more manual-type jobs. His job in the office was to parcel up objects that members of the public had sent in to us for an opinion and return them.

George Collins wasn't there on my first two days and I had absolutely nothing to do, so I tried to get round meeting other members of the department, some of whom I already knew but others I didn't know at all. The head of the department was Hugh Tait who was the acting keeper. The actual keeper was Rupert Bruce-Mitford, but he was working full time on getting the Sutton Hoo collection published.

The Sutton Hoo treasure had been discovered just before the war and bequeathed to the Museum in 1942. Although

excavations had stopped during the war, they had been car-
rying on in fits and starts ever since. Rupert Bruce-Mitford
began work at the British Museum in 1938, and, as the Anglo-
Saxon specialist, was put in charge of leading the Sutton Hoo
project to study and publish the find. By the late 1960s, the
trustees were getting very concerned that, thirty years since its
discovery, nothing had been published.

One of the trustees in particular was getting quite exas-
perated with him. Sir Mortimer Wheeler had become well
known through his books and appearances on television and
radio, helping to bring archaeology to a mass audience. He
believed strongly that archaeology needed public support, and
was assiduous in using the media to promote it. He played a
prominent part in three television series that aimed to bring
archaeology to the public: *Animal, Vegetable, Mineral?* (1952–60),
Buried Treasure (1954–59) and *Chronicle* (1966), and was named
British TV Personality of the Year in 1954. He was also secre-
tary of the British Academy and president of the Society of
Antiquaries. As part of his mission to bring archaeology to
the people he strongly believed that the British Museum had
a duty to make available everything it was holding in public
trust, both by displaying as much as possible in the Museum
itself and also by publishing the results of its archaeological
digs and other research. This was why he was so frustrated by
the fact that the Museum had been sitting on this enormously
important discovery for over twenty-five years with nothing
of any significance being published.

While I was still working in the Director's Office, Bruce-
Mitford had been summoned to a meeting of the trustees to
explain the lack of progress. Before he was actually called in
he sat in the little anteroom outside the Board Room, slouch-
ing back in a chair with his feet up on the little coffee table,
seemingly without a care in the world. The result of the sum-
mons and the trustees' deliberations was that Bruce-Mitford

should be removed as keeper of Medieval & Later Antiquities and seconded to head up a new sub-section of the department dealing solely with Sutton Hoo. By the time I arrived in Medieval & Later Antiquities, this section consisted of eight full-time members of staff working exclusively on this one excavation and its discoveries, and was situated on the upper floors of 1a Montague Street, the building immediately next door to the Museum on the east side.

With Bruce-Mitford's departure, the senior assistant keeper, Hugh Tait, was promoted to the substantive grade of deputy keeper and the acting grade of keeper. Not to put too fine a point on it, Mr Tait had the reputation of being a bit of a bastard in his dealings with his staff and I was a bit concerned by some of the stories I had heard. However, I have to say I found him excellent to work for and I personally got on very well with him. What really impressed me early on was his enthusiasm for his subject, which was the post-medieval period, and his willingness to share this with everyone. The best example I can give of this is that, as one of the COs, I was often asked by the assistant keepers to do little jobs for them, one of which was to photocopy articles from journals that they needed for their research. All the other AKs would just come in and say, 'Can you photocopy pages 4–10 from this journal for me, please?' But Mr Tait would always tell you why he wanted it photocopied. For example, after asking me to copy pages 4–10, he would say something like, 'I'm giving a lecture next week on Wedgwood Porcelain and this article has some important facts about the dating of certain pieces of Wedgwood … etc.' I felt he always treated me like a human being and not a skivvy who was there just to do the photocopying. It made the job itself far more interesting to be involved in some way.

Peter did not share my view of Mr Tait, but this jaundiced view may have been the result of an incident when he was accused of breaking one of the department's precious teapots,

for which Mr Tait was responsible, in the storeroom behind the Iron Age Gallery. Peter had gone there with Sandy Davison, one of our conservation officers, who had shown him the teapot. While Peter was holding it the lid fell off and broke. Peter said the lid was already broken and not sitting properly on the top, which is why it fell. Mr Tait would have none of this and asked for an incident report. When he read Peter's version he immediately called him into his office and said he wanted the truth. Peter said that was the truth. Mr Tait said, 'We'll sit here all night if we have to till you tell me what happened.' Peter just shrugged his shoulders. After a few moments of silence, he said, 'Can I phone home?' Mr Tait looked a bit puzzled and asked him why he wanted to do that. Peter replied, 'I'd better tell them I'm not coming home tonight.' The interview ended shortly afterwards.

Peter was keen on spreading the idea that Mr Tait's accent – he had a very posh Eton-style accent – was all put on and that he had only adopted it after he'd got his degree from the Courtauld Institute. Really he was a working-class boy who had been a motorcycle dispatch rider before studying at evening classes for his degree. I don't know whether any of that was true because although he did get a degree from the Courtauld Institute, he was also a graduate of Cambridge University. But what did give Peter's story some credence was that whenever Mr Tait's wife came in to take part in a social occasion – Christmas party, leaving dos, etc. – she would often berate him for the way he talked. She would say things like, 'Come off it, Gerry, where'd you learn to speak like that?'

Whatever the truth of it all – and did it matter anyway? – I admired him for the way his enthusiasm infected every part of his work and that he was so willing to explain to the junior staff what he was doing and how it fitted in with everything.

The AKs were all very affable and good-natured, in general, even if a bit thoughtless. The most senior AK was John Cherry,

but even he had only been in the department for six years. He spoke with a sort of stammer, though I think it was more to do with pausing while he was thinking what to say rather than an actual speech impediment. If you asked him what time he was going to lunch, he might reply, 'I-I-I-I-I think I'll be going at about twelve o'clock today.' There was one time when I found this stammer rather amusing. I forget what I had asked him now, but his reply was to give me an alternative as in, 'You can either do this or do that', but he got stuck at the beginning of 'either' and said, 'You can ei-ei-ei, you can ei-ei-ei ...' It sounded just like the beginning of a dance routine.

He was followed into the department two weeks later by Leslie Webster, who, in spite of the spelling of 'Leslie', was one of those early female curators who so upset the old-school type. She was an Anglo-Saxon specialist and took over Bruce-Mitford's specialism in the main department.

The third AK was Richard Camber, who had arrived just a few months earlier. His predecessor was Michael Taylor, who had become famous throughout the Museum for being pictured on the front page of *The Times* in 1968 at a 'Legalise Pot' rally in Hyde Park, much to the director's displeasure. Michael was, at heart, a hippy, and he left soon after this incident to take up crofting and self-sufficiency somewhere in the wilds of Scotland.

Richard seemed, in many ways, the complete opposite of Michael. He was very suave and wore only the best suits, but, on getting to know him, I discovered that his political views were very left wing. He was actually a member of the Labour Party and a supporter of the left-leaning Tribune Group. Not long after he started at the BM he married the daughter of Baroness Birk, who was to become a minister in the 1974–79 Labour government. During that period he would often come into our office and say things like, 'As I was saying to the Home Secretary over dinner last night' or 'The Lord Chancellor said to me on

Sunday …' What was so likeable about Richard was that this was all done without any pretention at all; it just seemed to trip naturally off his tongue and we sometimes got to hear some juicy titbits straight from the government horses' mouths.

Hugh Tait's office was at the near end of the long corridor to our office; then there was a very large room in which the three AKs sat, and finally at the far end of the corridor was the keeper's room, unoccupied of course. Opposite his room was the keeper's secretary, one of the greatest characters of all time at the BM. Her name was Gena Kingsford. She was a lovely woman and I have no doubt was very efficient at her job, but she had two very frustrating traits, both related to the fact that she was always in a hurry and tore around everywhere. The first was that she would always leap in and try to finish your sentences for you, usually wrongly. Conversations with her would take at least three times as long as they would have done if she'd just kept quiet. For example, a conversation might go like this:

Me: Oh, Gena, could I …?

Gena: Could you speak to Mr Tait?

Me: No, could I …?

Gena: Could you give me a letter to type?

Me: No, could I …?

Gena: Could you borrow some milk?

And so on, until she hit on what it was I'd actually come to ask her.

Her other 'endearing' trait was to keep getting names wrong, both of people and objects. Once, she came rushing into our office at her normal speed and said, 'The keeper wants to know if Lancelot Green's in today.' As we had no one by the name of Lancelot Green working in our department we were all at a bit of a loss. After some questioning, it turned out that

the person the keeper was looking for was Jeremy Evans, who did work in our department.

Part of my job as the admin CO was to look after the stationery supplies in the department. These were kept in a cupboard in our room. One day, Gena came flying into our office and exclaimed, 'My polliwog's dried up!' To say I was nonplussed is an understatement. All I could come up with by way of reply was, 'Your what's dried up, Gena?'

'My polliwog. It's dried up. It's unusable.' I could see out of the corner of my eye that Peter was in hysterics while trying to hide his face. Once again the situation called for some careful questioning and it turned out that it was her Tippex correcting fluid that had dried up. Fortunately I had another one in the cupboard to give her.

Along the corridor there was a small booth in one of the window bays, with a chair and a desk with a typewriter on it. I was told this was where the departmental typist, Esther Ochonogor, sat. She was off sick when I arrived and remained off sick for a whole year before she resigned from the Museum, so in spite of working in the same department as Esther for twelve months, I never saw her once.

Downstairs, in the basement, were the Conservation Workshop, the Horological Students' Room and the Museum Assistants' Workshop. The Conservation Workshop was headed by Peter Van Geersdaele, who had, in a former life, been a professional footballer with Queens Park Rangers and Hull City. This was to come in very useful for us when we later formed a British Museum football team. Beresford Hutchinson was in charge of the Horological Students' Room, although as this was one of Mr Tait's interests, he didn't actually get much say in how it was run.

The senior museum assistant (SMA) was Harry Pavitt. He was a woodworker by trade, having worked for some of the big furniture companies like Lebus and Beautility before coming

to the Museum fairly late in life. He was a practical MA, as most were in those days. The main function of an MA was to help out with exhibitions, making mounts, packing up objects for loans and taking them to the Photographic Studio if they needed to be photographed. By the time I left the Museum, the MA grade had become more a training ground for would-be curators. All the MAs had history or archaeology degrees rather than any practical experience in a trade that might be useful to what they actually had to do. Harry himself was a master at cutting Perspex and his object mounts were things of beauty in their own right.

Surrounding these three rooms were cupboards with shelves full of objects unable to be displayed in the galleries due to lack of space, with a special room set aside containing numerous boxes of Anglo-Saxon material with hundreds and hundreds of pottery shards. For me it was wonderful actually getting in amongst the Museum's objects. This is why I had applied for a job here in the first place, not to enter an endless succession of magazines on a Roneodex.

My EO, George Collins, returned on the Wednesday and explained my duties to me, which was pretty much general admin of the department, looking after the stationery and ordering specialist supplies for the MAs and conservators, and photocopying material for the curators as I have already said. The other main parts of my job were, firstly, to keep the departmental library in order, buying books on instruction from the keepers, stamping them as they came in and placing them on the shelves in the correct place; and secondly, to monitor the auction catalogues as they came in. We received all the Sotheby's and Christie's sales catalogues and my job was to scan each one briefly and pass it on to whichever curator I thought it would be of most interest to, as each, of course, had their own specialism, and then to file it for future reference once it was returned to me.

There was one other aspect to my job which was seeing the public when they brought in an object for an opinion. George explained to me that members of the public were let in to the department by the warder and would ring the bell at the top of the stairs. It was up to any of us, the two COs and two EOs, to answer the door. There was no rota as such but as far as possible, George told me, the aim was to share this out, although it depended on who was doing what at the time.

One thing he did warn me about was that if Jack Roomes was in the office we were to try and beat him to the door at all costs. Although Jack was stationed at the desk by the window, he wasn't often there as he was helping out the other museum assistants in their workshop or in the galleries. He would, however, most often come in to eat his sandwiches at lunchtime and this was the danger time. Jack's favourite was jam sandwiches and he wasn't too careful about not letting the jam shoot out on to his shirt as he took a bite. The problem was that sandwiches or no sandwiches, as soon as that bell rang, Jack was up off his chair like an Olympic sprinter. He would open the door still munching on his sandwich, most likely with a blob of jam on his shirt. With his free hand he was usually twanging his red braces which he always wore.

Although Jack was very enthusiastic and loved meeting the public, he sadly did not give a very good impression. George asked him time and again not to answer the door, but Jack always seemed to get hold of the wrong end of the stick. He thought George was telling him not to go out of concern that he was interrupting his lunch break, not because a jam-stained individual chewing away was not representing the Museum in the best possible light. So he always replied that he didn't mind his lunch break being disturbed as he was happy to do his bit. Why George never instructed him not to go rather than make a polite request I never really understood.

Jack had also never quite got round to grasping the change in the department's name. Until 1967, the Department of British & Medieval Antiquities incorporated Medieval & Later Antiquities and Prehistoric & Romano British Antiquities (P&RB), which were then separated into two completely different departments. Three years later, when I arrived in M&LA, Jack was still answering the phone with the words, 'Hello, British Medieval and Later.'

Getting to meet members of the public who had brought in objects for identification and opinions was a really interesting part of the job. The way it worked was that the person would give us the object with as much background as they knew and we would take it in to the AK on duty who would then tell us about the object. We would subsequently go back and relay the message to the person who had brought it in. If the person requested some clarification or asked any supplementary questions, we had to go back and go through the process again. I don't know about the visitors but it was certainly very educational for me, as in this way I was able to learn a lot about a wide variety of objects.

I don't know why the AKs didn't see these people themselves; maybe it was a bit beneath them. But it was a change from routine office work and I did get to see some interesting and beautiful objects. There were also some strange artefacts. One day someone rang the bell and Stella went to answer it, but the person said he didn't want to show her the object and asked for someone else. She was a bit put out but I went instead and the man showed me a porcelain plate with a mildly pornographic picture on it of a couple making love. He said he hadn't wanted 'that young girl to see it'. I found the remark quite amusing, not least because Stella was older than me and married and I'm sure would not have been shocked at all. In fact, when I told her why the man wouldn't let her see his object she was most disappointed.

The system in place for the AKs was that they each took it in turns to be on duty for a week at a time, which meant that during departmental public opening hours – 2.00–4.30 – they were supposed to be available at all times to see any objects that were brought in, whether it was their specialism or not. However, they often went walkabout and the trick then was to get one of the other AKs to look at the artefact instead. The most obliging was Richard Camber, who would often stop what he was doing to help out, but the other two were very reluctant to look at objects when they were not on duty. In fact, so reluctant was Leslie that she once refused to look at something even though it was said to be Anglo-Saxon. What we did when we could get no one to look at the objects was to ask if the person would mind leaving it with us for an opinion and we would either post it back to them or let them know when it had been seen so they could call in again and collect it. In the case of the Anglo-Saxon object, the person agreed to me taking it in. I put it in the cupboard for the AK on duty that week to see.

A couple of days later, Leslie came storming into our office demanding to know who had placed the green glass Anglo-Saxon claw beaker in the objects cupboard. I replied I had and she asked why I hadn't shown it to her before. I reminded her of the incident two days earlier and she looked suitably discomfited and said, 'Oh yes. Did you tell me what it was?' I stressed that I had told her that the person bringing it in had thought it was an Anglo-Saxon beaker. Anyway, it turned out that this was one of the best examples of an Anglo-Saxon claw beaker she had ever seen and the Museum subsequently purchased it for the collection. But it was a close thing as the owner could quite easily have taken it away and not left it.

The only other object I remember taking in myself which we eventually bought, was a seventeenth-century lead glazed earthenware plate which Mr Tait went into raptures over as soon as I showed it to him.

Some of the most common objects we had brought in were Russian icons. Richard was the Byzantine and Russian expert. When I showed him one of these icons he would invariably turn it over, smell the wood and almost always pronounce it a twentieth-century fake. Richard's view that nearly everything was fake caused me a slight problem one day when a man brought in not an icon, but a small stone statuette. Richard told me to tell him it was a fairly modern reproduction and that he should take it to the V&A. When I told the visitor this, he said that he had already been to the V&A and they'd told him it was medieval and should take it to the BM.

As well as explaining my new job to me, George told me what hours I was expected to work. We had to work a forty-one-hour week, including lunchtime, so as well as doing the basic 9–5 we had to find an extra hour from somewhere. George told me that everyone in the office did 8.30–5 on Monday and Tuesday and 9–5 the rest of the week. I said I'd rather do 9–5.30 on Monday and Tuesday as it was difficult for me to get in by 8.30. He absolutely refused to countenance this. I argued that it was pointless him insisting I get in at 8.30 two days a week as I would just be late every time. But the point was not open to negotiation. In the end he said, 'Right, we'll go and see what Mr Tait has to say about this.' So off we went.

When we got to Mr Tait's office, George explained the position. There was a long silence, at the end of which Mr Tait just said, 'Well?'

George said, 'Tell Norman he can't do it. He has to get in at 8.30.' Mr Tait leaned back in his chair, deep in thought, and then said, 'Why?'

George was a bit confounded for a moment but finally managed to say, 'Because that's how it works. We've always done it that way.'

Mr Tait sat upright again and said, 'You know, I've always wanted someone here after five o'clock at night. You all go

home and there's no one around if I need anything done later. I think it's an excellent idea for Norman to stay until 5.30 rather than come in at 8.30.'

I'm not sure how George took this undermining of his authority in front of the new boy as he showed no emotion. But there was a follow-up. The following Monday, George left with Peter and Stella at 5 p.m. and I stayed on until 5.30. When I got downstairs to the Manuscript Saloon I saw George hiding behind one of the cases. He was obviously waiting to make sure I stayed until my allotted time. I went over to him and said, 'Looking for something, George?' He was completely flummoxed and started muttering incoherently about some research he was doing. 'Yes, okay George,' I thought. 'Why don't you just admit what you are doing.'

Not long after I arrived in Medieval & Later Antiquities there was a change in occupancy in the buildings across the road from our office. The window at the front of the room looked out directly over Great Russell Street, while the side window overlooked Montague Street. The building directly opposite our office in Montague Street was used as a small hotel when I arrived, but after a few months it was converted into a hostel for students. For a while it seemed to be occupied exclusively by young, attractive Swedish girls who a) never drew their curtains and b) thought nothing of walking around with no clothes on. You could say it was quite an eye-opener for this impressionable young museum clerical officer.

Talking of looking out of windows, the Tutankhamen Exhibition opened not long after I arrived in Medieval & Later. As members of staff we got a private preview to the exhibition before it opened to the public and grew crowded. Once the exhibition did open, from our front window we could see the massive queues that built up every morning of people dying to get in to see this magnificent exhibition. People must have queued for hours to get in. But what struck us as funny was

that from our window we could also see that by about three o'clock in the afternoon there were practically no queues at all and people could just walk in as they pleased.

Over the next few months a number of new MAs made their debut into the department. The first was Martin Howe, who quickly seemed to develop some sort of hero worship for Harry Pavitt. Martin would follow him everywhere, even down to the canteen. Harry was a keen snooker player so Martin took it up as well so he could play with Harry in doubles matches. But he would never take a shot without getting instructions from Harry first. When it came to his turn he would always ask, 'What shall I go for now chief?' When he wasn't holding a billiard cue he was forever rubbing his hands together as he spoke.

Next came Chris Gravett, who was very softly spoken, and unless he was speaking right into your ear he was very difficult to hear. He often used to take Jack Roomes' place in our office, packing objects for dispatch. But, unlike Jack, when there wasn't much to pack he would not go back to the MAs' workshop but stood around talking to us. He had a very lively sense of humour and I'm sure if we could have heard him we would have found him very amusing, but, as it was, we kept having to ask him to repeat what he'd said, and even then we very rarely heard what it was he was trying to tell us. In the end, George got so exasperated that he told Chris to stay round his side of the office and not bother us anymore. Chris actually went on to become an expert in medieval arms and armour, writing well over thirty books on the subject and becoming a senior curator at the Royal Armouries.

Following Chris was Rosemary Tyler. Rosemary had worked at the Museum for a number of years as a CO, but became an MA and transferred to M&LA. When she worked in the Photographic Service she met my old friend Herbert, and they got married. Rosemary was a very friendly sort but she used to come to work wearing a dreadful old yak-skin coat which stunk

to high heaven. She worked in our office sometimes and hung her coat on the stand behind Peter and me. The smell got so bad that we both finally snapped and, one day when she was out of the office but her coat wasn't, we got hold of some deodorants, perfume, air fresheners, etc. from various members of staff and store cupboards, and sprayed her coat with everything we could lay our hands on. We thought it smelled a lot better, but she wasn't impressed. When she got back, she said, 'What's that funny smell?' and went over and sniffed her coat, then burst into tears. We looked as innocent as we could, but, although I felt very bad that we'd made her cry, I couldn't help feeling we'd done the right thing because she never again brought the coat into our office.

As well as the new MAs, the department appointed a new research assistant, John Russell. This was a brand new post and was created to save the AKs from having to take up their valuable time giving opinions to members of the public, as John would be on permanent opinion duty. This could have been good news for both the AKs and us … if only John had been any good at his job. But, although he was a very nice man, friendly and very pleasant to talk to, he was totally useless when it came to offering opinions on objects brought in by the public. His first port of call when anything was brought in was to try and find a similar example either in our own collections by looking through our catalogues or in a reference book in the departmental library. If he found something similar he would give me the volume and tell me to show it to the person and point out what it said about the object. If he couldn't find anything, his stock response was, 'Nothing comparable, ask them if they'd like to leave it and I'll show one of the AKs.'

John also dealt with objects submitted by post. In spite of the extra time he had to deal with such requests he was no better at this. The one classic occasion I can remember was when we received an object which looked like the tip of an iron spearhead and this was, indeed, how John described it,

with the added information that it was probably medieval. He then brought the object and his written opinion in the form of a letter into our room for the MA to pack up and send off. As it happened, Harry Pavitt was in the office and he took one look at the object and said, 'That's the tip of a Victorian railing, John. I think you'd better rewrite your letter.' I often wondered after that how many people who sent objects in for our 'experts' to look at received similar, disastrously wrong opinions from John.

When John arrived we took the opportunity to go through the cupboard where visitors' objects were stored. These were usually things that had been brought in by hand and the person concerned had said they would call back to pick it up. We thought we would see what was there and send out reminders to people whose objects had been there for some time. Whilst engaged in this activity I came across an envelope with a ring and a Nuremberg token in it. The accompanying note was dated 1906. I thought it probably wasn't worth sending a reminder! The problem was that the object wasn't ours so, even if we'd wanted to, we couldn't incorporate it into the collection, nor could we dispose of it, so these objects dating back anything up to seventy years just sat in our cupboard.

My first year back in the main museum building and in the Department of Medieval & Later Antiquities had brought me into contact with a complete set of new and, for the most part, friendly and helpful colleagues in the most wonderful surroundings I could ever imagine. If I'd been asked when I left college, three or four years previously, what job I would like best in the whole world, I would have said working in the Department of Medieval & Later Antiquities in the British Museum. And here I was. For me it was a dream come true.

But there was another side to my museum life: that of trade union activist, which was about to propel me into some long and involved discussions and negotiations over matters which would have far-reaching local and even national implications.

BIRTH OF THE BRITISH LIBRARY & BM PUBLICATIONS LTD

On 18 June 1970, the Conservative Party won the General Election and Ted Heath was asked to form a new government. Within the first few months they announced that they were going to introduce admission charges to all national museums and galleries. Until then admission had been free to the British Museum, ever since it first opened its doors to the public in 1759. As soon as the announcement was made I made an appointment to see Sir John Wolfenden to see what action could be taken to prevent this appalling proposed legislation actually becoming law.

Sir John gave me the good news that the trustees had discussed the matter and were utterly opposed to the introduction of admission charges on principle and would do all they could to prevent them coming into operation. He said that they had already taken it up with the government and that their lawyers had received no answer to the point that Sir Hans Sloane's will made a point of saying that his collection was to be left to the nation on condition it was seen 'freely' by the people. (Sir Hans Sloane's was the founding collection of the British Museum.)

I told Sir John that the CPSA would be organising a staff petition, which I had drafted, and hoped to get as many

signatures as possible to send to the trustees for onward transmission to the government. He gave this his blessing and wished me luck with it. We agreed to keep each other informed about our different forms of protest and to act jointly at all times on what we saw as a fundamental issue which struck at the very root of what we were all about at the British Museum.

Outside the Museum the debate about admission charges raged on in the press and journals (to which I and other members of staff contributed), on radio and television and in Parliament itself (again to which we were able to contribute through briefing our respective MPs). Many legal, moral and practical points were raised and the government did not find it as easy as they must have thought to push the legislation through. We raised 620 signatures on our petition, which was duly submitted.

In spite of everything, the government finally got its way and, just over two years later, on 18 October 1972, the bill received its third reading in the House of Commons. I immediately arranged for a meeting between representatives of the Trade Union Side and the management, at which we told the director we thought the Museum should just refuse to introduce the charges and dare the government to do something about it. Naturally they refused to countenance this course of action and said they had no alternative but to comply.

With the arguments still raging, however, the government decided not to implement the new law immediately and, although ticket booths were erected on the colonnade in December 1972, it wasn't until 1 January 1974 that charging commenced, on which date it was found that, due to sitting outside and not being used for so long, the machinery used to operate the ticket machines had rusted! So it was not an auspicious start for this disgraceful piece of legislation. But, for the advocates of charging the news was set to get much worse very quickly. On 28 February 1974 the Conservative

government went to the country and lost, with the result that Harold Wilson's Labour Party returned to power on 4 March. It was very satisfying to all of us to see that the very first act of the new government was to abolish museum admission charges.

So ultimately, the charges only remained in place for less than three months and have never been reintroduced at the BM. Of course, many people played a big part in delaying and then finally abolishing charges but I like to think the part we had in all was not insignificant as it showed the depth of feeling of the people who actually worked in the Museum.

While all this was going on we faced a number of other major and serious issues. The biggest of these was the move to separate the library departments from the British Museum and set up a new organisation – the British Library.

By the 1950s, due partly to the copyright law, the library was expanding at a rate of something like 1 million books per year. Over the years several plans had been put forward to enlarge the Museum to cope with this ever-growing need for space but, due to pressure from local residents and the local council, schemes to expand the footprint of the Museum into the nearby neighbourhood had been continually turned down. Nevertheless, in spite of having nowhere to put it, the government published a White Paper in 1971 announcing that a new institution, the British Library, would be set up, and that this new institution would incorporate several British Museum departments – Printed Books, Manuscripts, Oriental Printed Books and Manuscripts, the Newspaper Library and the National Reference Library of Science and Invention – as well as several other bodies, including the National Central Library, the National Lending Library and the British National Bibliography.

At about the same time as the announcement was made I was elected chairman of the British Museum Whitley Council Staff Side. The Whitley Council was a system set up

after the First World War in the wake of damaging industrial action and strikes undertaken primarily by railway workers, coal miners and other industrial workers. The idea was to end confrontation by setting up a system under which management (the Official Side) and staff representatives, normally the union (the Staff Side), met together on a regular basis to discuss matters of concern, so that, in theory, the stage of outright confrontation was never reached. The proposal was contained in a report on industrial relations written for the government by the deputy speaker of the House of Commons, J.H. Whitley, hence the name. Although the idea was primarily aimed at industrial workplaces, they never took up the idea and it was left to the Civil Service to set up its own National Whitley Council for non-industrial Civil Servants, along with a network of departmental offshoots.

The British Museum Whitley Council was inaugurated in 1921. By the time I became chairman of the Staff Side it consisted of delegates from five unions. They were the quaintly named First Division Association (FDA) which, as the name suggests, represented the upper echelons, senior managers, keepers, assistant keepers and the like; the Institution of Professional Civil Servants (IPCS), which represented the scientists, photographers, conservators and museum assistants; the Society of Civil Servants (SCS), which represented middle management, EOs, HEOs and SEOs; the Civil Service Union (CSU), which represented the security warders, gallery warders, library assistants, messengers, cleaners and paper keepers, and my own union, the Civil & Public Services Association (CPSA), which represented the clerical grades, secretaries and typists.

There were two more unions at the British Museum: the Transport & General Workers (TGWU), which represented the labourers; and the Society of Graphical & Allied Trades (SOGAT), which represented the highly specialised grade of

labellers whose sole job was to stick the Reading Room shelf marks on the spines of all the books. However, as labourers and labellers were officially classed as industrial Civil Servants, they were not allowed to sit on the British Museum Whitley Council. Being of a somewhat radical bent, the CPSA several times proposed that TGWU and SOGAT be allowed on to the BM Whitley Council, but our proposal was always voted down by the other unions who felt that their presence would somehow dilute the nature of our representations on behalf of the non-industrial staff. One radical suggestion the CPSA did manage to get the other unions to agree to, was that of renaming our side of the Whitley Council the Trade Union Side (TU Side), rather than the archaic Staff Side.

For its part, the Official Side of the Whitley Council was chaired by the director and included one trustee, one keeper, the deputy director, the museum secretary and assistant secretary, the chief executive officer (CEO) in charge of administration and the SEO in charge of personnel.

The Whitley Council used to meet once a year but other meetings could, in theory, be called by either the director, as chairman of the Official Side, or by the chairman of the Trade Union Side, as and when necessary, to discuss a particular problem in line with the original *raison d'être* for Whitley Councils.

Of course, as soon as the announcement was made that the British Library would be established and would include members of staff currently employed by the BM, we met to discuss their proposed conditions of service in the new institution. However, as the BM management would have no say in the conditions of these staff in the future, it was quickly realised that we needed to speak to the government itself, in particular the Department of Education and Science (DES), under whose authority the British Library would be placed.

To further discussions on the new set-up, a consortium was established consisting of BM Trade Union Side delegates plus

representatives of management from the DES, the relevant parts of the BM and the other organisations which were to form part of the new British Library. This was chaired by a senior Civil Servant at the DES, Edward Martindale. Although this body met a few times, all the detailed discussion was undertaken in smaller groups depending on the subject. The more complex matters of principle rather than the day-to-day matters were dealt with mostly by Ron Baker, the Museum's TU Side secretary, and me, with Mr Martindale and whoever he thought the most relevant person from management to accompany him.

As the CPSA branch secretary, as well as TU Side chairman, I was also involved in discussions on the matters that affected our grades, along with our newly elected branch chairman, Mike McGrath. Mike was a member of the Socialist Workers' Party (SWP) and an uncompromising negotiator. I remember one occasion when we obtained what I thought was a good concession from Mr Martindale, but before I could say anything, Mike jumped in and said, 'That's all very well, but how do we know you'll stick to the agreement?' Mr Martindale replied by saying, 'You're not very trusting are you?' Mike shook his head and said, 'It's my job to mistrust management.' Mr Martindale smiled, looked at me and just said, 'He's a boy, isn't he?'

In general, although we were able to come to a number of useful agreements, there was one main sticking point which overrode everything else, and this was that the DES wanted to set the British Library up as a public body, outwith the Civil Service, with its own terms and conditions. We felt very strongly that the British Library should have Civil Service terms and conditions, the same as the British Museum. At the very least we argued that those staff being moved from the British Museum to the British Library should be able to keep their current status. This was a vital issue for us as our pay

and grading and all other conditions, most importantly our pensions, were all agreed nationally. We felt that if the British Library was able to set its own pay and conditions they would inevitably be worse.

After interminable meetings, mostly at the DES offices in Parliament Street, with all sorts of senior officials, we came to an impasse. On 7 June 1973 Ron and I spoke to a mass meeting of something like 750 affected BM staff and explained the position to them. The meeting agreed almost unanimously to refuse to sign British Library contracts and, if necessary, to demand transfers to elsewhere in the BM or the wider Civil Service. Faced with this solid refusal to sign the new contracts, the DES proposed a compromise whereby the British Library would be set up as they originally proposed but that BM staff would be employed on secondment terms, retaining their current conditions with a right to return to the BM if a suitable vacancy became available. This was agreed and for many years the great bulk of the new British Library staff were not contracted to it, but remained British Museum staff on secondment. It wasn't really a very satisfactory outcome for either side, but at least it allowed the new body to go ahead, and on 20 June 1973 the British Library came into being as an independent institution.

As yet there was no new building and the British Library continued to occupy the space the library departments had always occupied at the Museum, but they had to set up all their own administrative departments, such as personnel, stationery, accounts and registry. Security remained in the hands of the BM. Building work where the fabric of the building was affected also remained with the BM, but minor maintenance, e.g. changing a light bulb, necessitated a whole new Library admin department.

Personally, I felt I'd had a lucky escape as had I still been working in Reading Room Admissions or at the NRLSI,

I too would have now been in the British Library, which is not where I wanted to be.

While all this was going on (late 1972), Museum staff received an office notice[1] stating that the Publications Department was to be privatised and the Museum management would soon be entering into discussions with the unions about staff conditions in the new company. We were appalled. This was the first we'd heard of it and yet it was being presented almost as a fait accompli.

Taking our cue from the wording of the office notice, and given the possible serious consequences for our members in Publications, I wrote to the director (Sir John Wolfenden), calling for a meeting of the Whitley Council. To our utter astonishment we received a reply saying that management would not meet us. As I said earlier, the Whitley Council constitution allowed for either the chairman of the Official Side or the chairman of the Trade Union Side to call a meeting. All the local union branches immediately contacted their respective national headquarters to see what our next step should be.

All the headquarters' officers were outraged. We were told this was only the second time in the fifty-year history of Whitleyism throughout the whole Civil Service that a management had refused to attend a meeting called by the Trade Union Side chairman. It was all the more inexplicable because of the wording of the office notice: that management intended to *enter discussions* anyway.

Following the refusal, I called a special Trade Union Side meeting for the usual local representatives and also invited headquarters officers as well. At this meeting we agreed to reaffirm with management our wish to hold a Whitley

1 Office notices used to come out roughly once a week, listing things like current vacancies, staff movements, retirements, etc. Sometimes when there was some important news a special one-off office notice would be issued as in this case.

Council meeting, to inform them that they should put a stop to any further progress towards setting up the company until we had met and to issue a press statement for distribution to the national press, television and radio. Once again the director replied that they would not attend a meeting with us.

The FDA headquarters officer, Gerry Gillman, was almost apoplectic when we reconvened our meeting after receiving this further reply, and said he was going to publicise Sir John's refusal as widely as possible in an effort to shame him to the table. Good as his word, he arranged for an interview on Radio 4's 'The World This Weekend' flagship news programme in which he really laid into the director. He also went much further than anything we had actually agreed as a TU Side, saying that if we didn't get a meeting with Sir John, the staff at the BM would follow a policy of no co-operation, and unless we heard from Sir John immediately the policy would start straight away. In addition, the *Daily Telegraph*, *Guardian* and *The Times* all ran sympathetic articles following our press release and Gerry Gillman's lobbying.

Fortunately, we weren't put to the test on the no co-operation policy as on the day following this broadcast, I received a letter from the director saying management would now meet us. Why they had decided to put themselves through this bad publicity was (and still is!) a mystery to me when it was obvious they would have to meet us sooner or later. In fact, Maysie Webb told me some time afterwards that she and other senior managers had urged the director to inform us of the plans before sending out the office notice, but he overrode them all and personally insisted that it be issued. If this was true, and I have no reason to suppose it wasn't, it showed a remarkable lack of judgement on Sir John's part.

It was agreed our side would be led by one of the full-time officers and that it should be the CSU as they had the most members involved: the bookshop staff, paper keepers

and messengers. Fred Fagan, the CSU's officer responsible for the BM, was deputed. At the full Whitley Council meeting, when it finally took place, the director outlined the proposal and the reasoning behind it, which was that the Publications Department had been making a financial loss for several years and was being stifled by Treasury accounting rules. The trustees wanted the company to be free of constraints as to how it could spend its money and, although one of its main purposes would be to continue to produce catalogues and serious academic tomes, they wanted to be able to produce more popular books and other souvenirs, while trying to do this with the Treasury looking on was almost impossible. They hoped that by privatising the company they could escape the restraints and turn the Publications Department into a properly run commercial company, which would be wholly owned by the trustees of the British Museum. Any profits, therefore, would be paid into the Museum's coffers and help support the work of the BM.

So far so good. This seemed a reasonable idea and one we could support. However, what followed was not so acceptable. They wanted to appoint a managing director (in fact, they had already advertised the position), who would also be a shareholder and therefore entitled to some of the profits; so what the director had outlined previously was not strictly true as not all the profits would go back into the company and the Museum. Beneath the managing director there were to be five senior managers. These top six posts (including the managing director) would not be tied to Civil Service grades and would be recruited directly by the company. For us this was bad enough, but then we were told that although the rest of the staff would keep their jobs, they too would no longer be tied to Civil Service grades as, in the future, the company needed to be free to recruit in the open market in comparison with other publishing companies.

There was one final point about which the curators in particular were not very happy and that was the position of the Cast Service, which currently existed under the aegis of BM Publications and would therefore be privatised along with the rest of the company. The Cast Service, which was stationed in another building in Shepherdess Walk in North London, near the famous 'Eagle' pub of 'Pop goes the Weasel' fame just off the City Road, made casts of popular objects to sell in the BM shop – a lucrative form of income. The curators' concern was twofold. Firstly, by privatising the service it would mean that in future non-BM employees would be handling Museum objects, and secondly, that the curators sometimes needed casts made for study purposes or to send to other museums around the world for exchange purposes. They felt that they would have no say over how a private cast service would prioritise their work, which would naturally look to making profits first and foremost, with the curators' needs coming a poor second.

With all these points to pick up on we were hoping that Fred Fagan would put forward a strong argument on our behalf, but he was hopeless. He rambled on without making any real points at all. As TU Side chairman I was receiving frantic and pleading looks from most of our representatives, so I felt impelled to step in and cut Fred short. I simply said that we needed time to absorb what had been said and asked if we could reconvene the meeting the following day. Surprisingly, in view of the problems we'd had getting the meeting in the first place, the director agreed. Or perhaps it was because of the problems and the bad publicity it had brought. Incidentally, I was very surprised how nervous Sir John appeared to be throughout his opening statement. He was continually fiddling with his hands and kept reaching under the table to pull his socks up.

The TU Side met again a couple of hours later to consider our response. The first thing that came up was Fred Fagan's

woeful performance and it was agreed I should telephone John Sheldon, the CSU deputy general secretary and Fred's line manager, to tell him that we didn't want Fred to attend any more meetings. I phoned him up there and then. When he answered the phone I told him what had happened and why I was phoning. He said, 'I've got Fred in the office here now. Why don't you tell him yourself?' I thought, 'You bastard!' When Fred came on the phone I explained to him that we were unhappy with his performance and asked to speak to John again. John agreed that, owing to the seriousness of the situation, he would come to the next meeting himself.

The following day, after briefing John on our own discussions, he put forward our views very clearly and concisely and was a 100 per cent improvement on Fred. Discussions continued for several weeks and were deferred to a sub-committee, which on management's side consisted of Sir John Wolfenden plus four trustees – the chairman, Lord Trevelyan; the Marquis of Cambridge, Sir Richard Thompson; Denis Hamilton (who was also editor-in-chief of *The Times*), along with the newly appointed managing director, Michael Hoare. They were obviously taking it seriously.

The first concession made by management was that the Cast Service would remain with the Museum and transferred to the Research Laboratory. Eventually we reached the agreement that all staff below the top six would remain BM staff on secondment, but that new staff could be recruited direct, just like the British Library; the managing director would not receive a share of the profits, and we also got agreement that the Trade Union Side would have a seat on the board of the company. In his book *The British Museum: A History*, Sir David Wilson says:

Ludicrously, the place reserved for a staff member on the board of the publications company – intended for a curatorial

representative who could advise on the academic side —
was hijacked, due to supine neglect by the First Division
Association, and a militant clerical officer was forced upon it.

I would take issue with this statement on two counts. The first
is that the place reserved for a staff member was for a trade
union representative, not a curator. If management had wanted
a curator to advise on the academic side they could have
appointed one. Secondly, when Kevin Coombes, the clerical
officer in question, was appointed to the board it was not due
to 'supine neglect' by the FDA. In fact, at the meeting where
we had to vote on a new representative, the FDA turned up
with three members to support their candidate, even though
they were only entitled to one vote, something I had to remind
them of as they all put their hands up. The Trade Union Side
wanted its own representative to be a clerical officer so that
the lower grades could be looked after.

The main sticking point was the position of the five senior
managers. Management wanted them to be recruited and
rewarded in line with what was happening in the publishing
world. For our part, we agreed that they could be recruited
from outside but we wanted them aligned to Civil Service
grades and open for internal promotion and transfer. In par-
ticular there was a BM member of staff, Len Bourton, who
was already a senior manager in BM Publications, who wished
to continue with the new company but wanted to remain
with his current Civil Service conditions. On 27 April 1973
we had our last meeting on the issue. Once again, manage-
ment insisted that they were not prepared to budge on these
five posts and that if Len Bourton wanted to be considered he
would have to give up his Civil Service conditions. We asked
for a break.

Outside, John Sheldon took me to one side and said, 'This
is crunch time. What do you want to do? If we insist on our

position I'm quite prepared to call a strike of our members in Publications and we could kill the company stone dead.' I said I thought we should have one more try to at least get a personal concession for Len and if we could then we should come to an agreement. If not, I said that we should end the meeting and call a special all-members meeting to see what they wanted to do.

When we went back, we started off by reaffirming our original position that all five posts should be open to Museum staff, who, if they wished to stay on current terms and conditions, should be allowed to do so. To our great surprise Sir John agreed immediately and the negotiations came to an end. Len was confirmed in post and, as it happened, there was one other member of BM staff who took one of the other posts, so initially the company had two senior managers on secondment.

Since then, of course, the company has gone from strength to strength, publishing not just hefty catalogues and standard academic reference books, but also popular and children's books as originally envisaged. It now has a number of outlets inside the Museum and a thriving online business selling art prints, CDs, DVDs, clothing and accessories, jewellery, ornaments, replicas, toys and games, as well as books and postcards. The constant deficit of the old days has turned into considerable profit, so much so that the company was able to contribute well over £4 million to the Museum to help towards the building of the Great Court in 1999. But it was all born in a baptism of fire, acrimony and great mistrust.

As if all these major Museum issues weren't enough we, the trade unions, also took a prominent role in the first ever national strike by Civil Servants in this country. From the beginning of 1973, while we were still deeply immersed in discussions on museum charges, the British Library and BM Publications, the government of Ted Heath imposed a pay

freeze on all workers throughout the country. We got caught up in this as our annual pay rise was due on 1 January.

The reason we felt particularly hard done by was because our annual pay increases were determined independently by a body called the Pay Research Unit, which compared the pay of all the different Civil Service grades to the equivalent workers in other public sector organisations and private industry, and then recommended a rise in line with the median point minus an extra amount to take account of our non-contributory pension. The idea, when Pay Research was first set up in 1955, was to take pay negotiations out of the political and industrial dispute arena as both sides agreed to be bound by its findings. However, the government was now, for the first time, refusing to implement the Pay Research findings. This we felt was bad enough, but our real gripe was that because of the way it worked our annual pay rise was always behind everyone else's, as by its very nature it was a catching-up exercise, so to be the first to be caught in the pay freeze felt particularly unfair. It was also the case that this was a time of high inflation (just under 10 per cent) so in practical terms, let alone principled matters of fairness, it meant we were being particularly hard hit.

The upshot of all this was that the National Executive Committees of the CPSA and SCS decided to embark on a course of industrial action, while the CSU, who were not prepared to go quite that far, agreed to take protest action where appropriate. The initial action agreed by the CPSA and SCS was to start with a one-hour protest by all members; that is to say that on 10 January members were to down pens for an hour and, if possible, attend a protest meeting at or near their place of work. This was to be followed by strike action lasting two weeks at selected sites where it was felt we could do the most damage, at port and airport customs posts, for example. If this did not get Pay Research reinstated the unions would call a full, one-day nationwide strike of all members.

We quickly realised the potential of the one-hour protest meeting on 10 January at the British Museum for gaining wide publicity for our cause. The Museum was a nationally and internationally known icon and we felt that if handled correctly we were probably in the best position of any government department to make the headlines. We contacted our respective headquarters and told them we planned to hold our one-hour protest meeting at 10 a.m., the time the Museum opened to the public, and that we intended to hold it at the front of the Museum in full view of visitors. Although not officially taking part in the strike, the CSU agreed to support our meeting as part of their 'protest action where appropriate' remit. This was a vital breakthrough for us as the CSU organised the security and gallery warders, not only by far the largest section of staff, but without them at their posts the Museum would have to remain closed to the public. Our three respective headquarters agreed to send along prominent speakers as they too recognised the publicity potential of what we were planning.

My next job was to write to Sir John Wolfenden and explain to him what we were planning to do. I told him that our action was in no way aimed at Museum management but the unfairness of the government's pay freeze. He replied, thanking me for my assurance about Museum management. And while he didn't exactly wish us luck, he didn't try to stop the protest meeting going ahead. Really, there was nothing he could do about it, especially as his security staff were taking part.

On the day itself we had a massive turnout of staff who filled much of the front courtyard, while the three headquarters representatives, Gerry Gillman (who had just moved from the FDA to the SCS as their new deputy general secretary), Ken Thomas (the CPSA deputy general secretary) and our old friend Fred Fagan from the CSU, myself and other local representatives stood on the steps facing them – at least 600 in

all. I had the job of starting the meeting with a brief explanation of why we were all there and then introducing the other speakers. It was by far the biggest meeting I had ever addressed but I knew it was going to be for the most part a friendly audience so I wasn't too nervous about it.

As it turned out we were absolutely right that, in spite of the many protest meetings being held all over the country, it was our protest that would make the headlines. Later that day, the *Evening Standard* carried a photograph of our meeting on its front page, together with a full-page story about the Day of Protest. In the evening the television news channels showed our meeting; the BBC's clip even showed me speaking. The following day most of the newspapers latched on to our meeting with photographs of the massed ranks of BM staff standing out in the courtyard. It was the first time the British Museum had ever been closed to the public due to industrial action, even if it was only for an hour.

Two weeks later the CPSA and SCS British Museum branches joined the national one-day strike, but because the CSU didn't take part the Museum remained open and our newsworthiness was relegated to a mere footnote that day. It wasn't until December that year, almost a full year later, that the government finally gave us a backdated pay rise under its 'anomalies' procedure.

The summer of 1973 saw another national issue in which we played a prominent part. The fascist Portuguese dictator, Marcello Caetano, was visiting Britain. He was met with protests and demonstrations wherever he went. On 18 July he was due to visit the British Museum. As chairman of the Trade Union Side I wrote to the director asking him to cancel his invitation. Of course, the trustees would not countenance it, so we organised a demonstration outside the Museum gates to greet his arrival. Thousands of people turned up and crammed Great Russell Street. It was, we were told later, the biggest

demonstration of his tour. Less than a year later, Caetano had been overthrown by the people of Portugal. Perhaps we played our part ...

Another demonstration I attended on behalf of the British Museum CPSA branch was the 'Free the Shrewsbury Two' demonstration. Des Warren and Ricky Tomlinson were construction workers and trade union activists who were imprisoned for 'conspiracy to intimidate' whilst picketing in Shrewsbury during a building workers' strike. Along with a number of other members of our branch I went on strike for half a day to join the protest march. Naturally we lost half a day's pay over this. With Ricky Tomlinson now so famous as an actor and earning good money, I have often wondered if I should write to him and claim my lost pay back!

There was one final, major internal issue I was involved in at about this period and that was the proposal to build a whole new block on the west side of the Museum to ease our accommodation problems. The plan was to build an L-shape building incorporating new offices, meeting rooms (including a new board room), new staff and public restaurants and a new exhibition gallery. Colin St John Wilson was appointed as architect and the proposed plans shown to the TU Side for comment. Naturally we were delighted about the proposal so there wasn't much argument from us. The only thing we were concerned about was the fact that there would be no openable windows in the offices as the rooms were all to be air-conditioned. Our question, 'What happens if the air-conditioning fails?' was met with the reply, 'It won't fail.' Needless to say, the air conditioning never worked properly right from the beginning and we eventually got management to replace all the windows with ones that could be opened manually.

The one other problem we had was that before work actually started the government cut the funding for the project, and the 'L' shape turned into an 'I' shape. One of the facilities

we lost was the recreation and games room which was due to be attached to the staff restaurant.

In spite of these minor problems, the New Wing (as it is still known to this day) was a welcome addition and provided much-needed space and modernised accommodation. But it was sad to see the magnificent old Board Room go and also my first office, with its oak cupboard-lined walls and fine balcony. The Reading Room Admissions Office, which had very high ceilings, was divided in two horizontally, with the new upper floor being converted into a new meeting room, funded in part by Lord Hartwell and named the Hartwell Room in memory of his wife Pamela, a former chairman of the British Museum Society. The ground floor part was turned into a bookshop and public toilets. The site where my old desk stood is now in the middle of the Ladies'.

Before leaving the subject of trade union activities, I think it would only be right to mention that we had our fair share of characters at the time as well. The CSU in particular seemed to go in for the somewhat eccentric type. One of their representatives was a French polisher (in the days when the Museum actually provided its own craftsmen instead of buying in contractors), who was well into his sixties. His name was Alf Baster and he had been a Communist Party member all his life. He used to turn up to all meetings wearing the obligatory cloth cap. He would rail against 'the bosses' in no uncertain terms and let our management know exactly what he thought of them and their exploitation of the workers. In the early days of health and safety legislation he would insist that any improvements made to working practices should apply to union members only. Much as I sympathised with this point of view, I didn't quite see how he expected this to be practically carried out. Maybe the guard on the wood-cutting machine should be removed when a non-member went to use it?

His fellow delegate was an Irishman by the name of Michael Horgan. Michael was a mason's assistant and I suppose it was carrying those heavy stone statues around that gave him a big appetite, because he was forever complaining about the amount of cheese in the canteen's cheese sandwiches. He managed to find some pretext for bringing it up at every meeting he ever attended. I thought this was his main preoccupation in life until I discovered that he spent his spare time outside the Museum working single-handedly on a mission to bring about better cultural relations between Ireland and Bulgaria. Why Bulgaria I never did discover, but he was as passionate about this exchange as he was about his cheese sandwiches.

The gallery warders were represented by Johnny Bugg, who was as deaf as a post. He missed everything that was said at our meetings. Because he couldn't hear he would now and then interject with some statement that had nothing to do with the issue under discussion. As chairman I found it difficult to stop him as he couldn't hear me trying to shut him up. He was, as it happens, a great supporter of Michael's campaign for bigger cheese portions but he would often bring this up while we were discussing the conditions for staff moving to the British Library, or our tactics over admission charges.

Eric Verdon was the security warders' representative. He worked at one of our outstations in Orsman Road, Hackney, and was convinced that the Museum management were trying to poison the staff out there with some noxious gas or other. It was a section of the Conservation Department stationed over there that was apparently the cause of his conviction. The real problem with Eric, as far as our meetings went, was that the idea of making a short, to-the-point intervention was complete anathema to him. Once he'd started you got a blow-by-blow account of his latest discussions with management. His interruptions would go something like this:

My members asked me to take up the issue of overtime with management last week, so I went to see the chief warder, Mr Hammond, about it. I climbed the stairs to his office and I knocked on the door. 'Come in,' said Mr Hammond. So I opened the door and went into the room. 'Sit down, Mr Verdon,' he said. 'Thank you,' I said, and sat down on the chair opposite Mr Hammond's desk. 'Would you like a cup of tea?' Mr Hammond asked me. 'Thank you Mr Hammond,' I replied. 'No sugar for me, please.'

And so on. By the time he got to the point of what it was he'd gone to talk to Mr Hammond about, the rest of us had lost the will to live.

At the other end of the union scale we had the FDA representative Roderick Whitfield, an assistant keeper in Oriental Antiquities. I don't really think his heart and soul was in trade unionism. My reason for saying this is because when we had joint meetings between the Trade Union Side and management, Roderick always went and sat on the management side of the table.

Although these were all characters in their own right, they paled into insignificance beside the future CPSA and trade union secretary Kevin Coombes – but he's for a later chapter.

REAL MUSEUM WORK

Back in Medieval & Later I was beginning to get more and more involved in what I considered to be 'real' museum work. Firstly, Mr Tait asked me to help him with his 'Pottery and Porcelain Slip Catalogue'. This was just an easy reference guide to all the post-medieval ceramics he was responsible for. Each entry was written on a slip of paper which was inserted into a small ring binder. My main job was just to copy out information and, although it didn't involve much brainpower, thanks to Mr Tait's enthusiasm and wish to involve members of staff working on his objects, I did get to learn a fair bit about the items concerned.

He then asked me to catalogue the watch papers held in the Horological Students' Room. Watch papers were the original makers' labels which had been inserted inside pocket watch cases at the time of manufacture and now provided invaluable information about the provenance of the watches. This time I worked with the actual objects.

I was also involved in the move of our exhibitions. We actually had very few of our objects on display in the public galleries. We had a small number of clocks and watches and some other objects exhibited in the King Edward VII Gallery, which was about as far away from our departmental offices

and students' room as you could get, and we had some objects exhibited in the Indian Room and the Chinese Gallery, which were located directly above our offices. It was one of the charms of the Museum at this period that galleries and other rooms and spaces still kept the names they had had for years. It had been a very long time since Indian and Chinese artefacts had been exhibited in those particular galleries, but they still retained their names.

Another room whose name bore no relationship to the objects it contained was the Iron Age Corridor. We also had the Egyptian Stone (or Sculpture) Gallery, the Greek & Roman Life Room, the Cycladic Room, the Bridge, the Duveen Gallery and the Nereid Room. These days, galleries are just given soulless numbers (from 1–94 at the last count) or are named after their sponsors, although one or two of the more famous gallery names still haven't given up without a fight, particularly the King's Library (Room 1), but even this is now becoming increasingly known as the Enlightenment Gallery, and the Mummy Rooms (Rooms 62 and 63).

Behind the scenes, many of the rooms were named after keepers and other prominent members of staff who occupied them, or other people important in the Museum's history. For example, there was Budge's and Gadd's, named after two curators from the old Egyptian and Assyrian Antiquities Department, the Willoughby Stairs, and possibly the most splendid name of all, the Cracherode Room, named after the eighteenth-century benefactor, Clayton Mordaunt Cracherode. Other areas were named after their use in bygone days. One example of this was the Stables, which had not seen a horse in it for many a year. There were also the Supplementary Rooms, the Arch Room (happily still widely known as this), the Sanskrit Library, the Fireman's Passage, the Select Passage and the Spider (under the Reading Room). But perhaps the best example of clinging to the past – as a museum should – is the staircase that runs from

the basement to the top of the building near our offices and is still known to this day as the Botanical Staircase, in spite of the fact that the natural history collections moved to their own purpose-built museum in 1883.

In 1970 the Ethnography Department moved out of the Bloomsbury site into its own building, the Museum of Mankind, in Burlington Gardens, freeing up space in the main museum building and allowing our department to rationalise and expand. We took over a number of galleries much nearer to our offices than the King Edward building and completely rebuilt the old Indian and Chinese galleries to fit in with the newly acquired space. Over the next few years we were able to set out our objects in chronological order from the Dark Ages, including a new Sutton Hoo exhibition, round to a modern gallery, displaying twentieth-century material, which took over the space vacated by the Ethnography Department's library. In keeping with Museum tradition of the time, the space that was now officially the Modern Gallery was still generally referred to as the Ethno Library. There were also a number of specialist galleries created: the Medieval Pottery and Tile Room, the Clocks and Watches Gallery and the Waddesdon Bequest Room.

It was during the setting up of one of the new galleries that Harry Pavitt had a run-in with a newly appointed assistant keeper, Dafydd Kidd, who was responsible for European Dark Ages Antiquities. Dafydd had only been in the post a few weeks when he went with Harry to design a case for the new layout. He explained how he wanted it set out, but Harry, who as I mentioned earlier was a master at making Perspex mounts and had many years' experience of organising displays, said he thought that what Dafydd was proposing wouldn't work and suggested a couple of changes. Dafydd simply said, 'Don't argue with me. Just do what I say.' Harry answered that he wasn't arguing, he was just making a couple

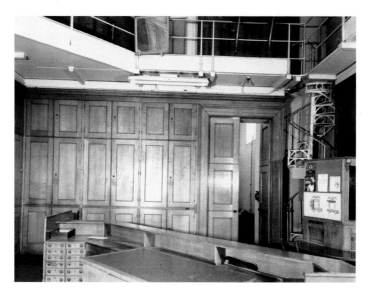

1. My first office, Reading Room Admissions, now sadly demolished. Straight in front of the desk are the cupboards the Archbishop of Canterbury tried to get through and above is the balcony from which Derek Cole threw the box that hit Louis on the chest.

2. George Morris (*left*), BM assistant secretary when I first started; later secretary. Bentley Bridgewater (*right*), BM secretary.

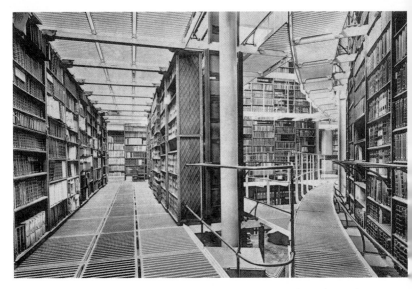

3. Part of the ironworks book stacks in which I spent many happy hours during my first couple of years.

4. The outside of the hut housing the old staff canteen and public restaurant before it was demolished to make way for the New Wing.

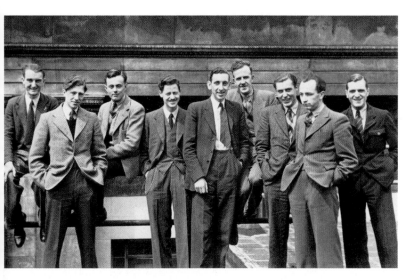

5. Alan Gray (centre, fifth from left) played a big part in my early years at the Museum. Taken at least fifteen years before I started, Freddie Jones (second from left) is the only other face I recognise. He was HEO in the trustees' Works Office when I arrived.

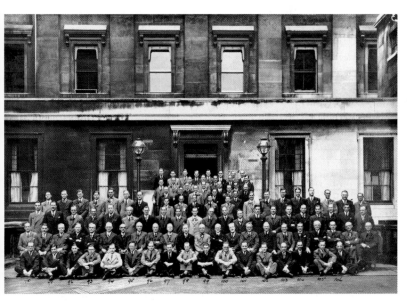

6. Printed Books Staff; taken just before the Second World War. Many of these people were still working at the BM when I started, including Ron Saunders, Bernard Lynch, Jack Bennett, Reg Goode, Arthur Keyte, Jimmy Etherington, Ben Damery and Jimmy Norton.

7. Ron Wallom, who I was friends with for thirty-five years and who should have been a famous rock star.

8. Brian Smith, who helped me get through NRLSI Holborn and who should have been a famous actor.

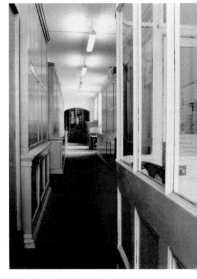

9. The M&LA corridor leading from the door to the general office. About halfway down, in the window bay, was Esther Ochonoger's booth, gone by the time this photograph was taken.

10. The queue for the Tutankhamen Exhibition on the opening morning.

11. The unions' mass meeting held in the forecourt of the Museum on 10 January 1973 to protest against the pay freeze.

12. The west side of the front of the Museum as it looked during my first few years, before the New Wing was built. On the left is the West Residence, where the old staff office was and where I moved to when I was in Welfare. Notice the BT Tower in the background.

13. The same view as the one above, after the New Wing was built.

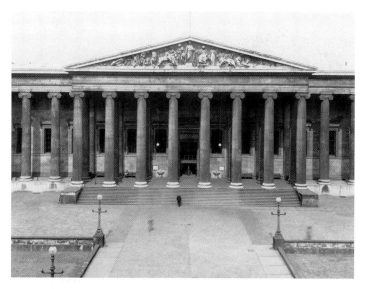

14. When I started work at the BM the outside was absolutely filthy, black with 150 years' worth of London grime, smoke and smog.

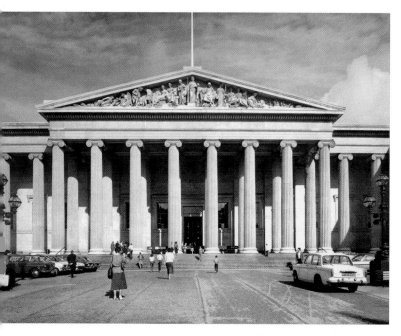

15. During the 1970s the outside was cleaned up; the difference was amazing as can be seen in this photograph.

16. (*Left*) A restored frame and pictorial roundel, one of a pair, showing Richard I in combat with Saladin from the magnificent Chertsey Abbey tiles collection that I worked on.

17. (*Below*) The King Edward VII Gallery in the early 1970s, when it was home to Medieval & Later Antiquities displays.

18. My office in the attic of the old Ethnography Department, formerly Brian Cranstone's office. I had no filing cabinets or cupboards to store anything. That's my excuse for the mess anyway!

19. (*Left*) The entrance to Ronaldo's, where Peter Stocks and I used to go for coffee.

20. (*Below*) A section of the new canteen in the New Wing, where I spent many happy hours!

21. Maysie Webb and David Wilson.

22. Senior welfare officer, Edna Adams: a self-portrait.

23. Sue Copus (*left*) and Mena Williams, my colleagues when I first went to Welfare.

24. Olly Quistorff, head of the Works Support Team (*left*) and Mark Conway (*right*), who took me on my trip of a lifetime.

25. The human dynamo, Terry Giles.

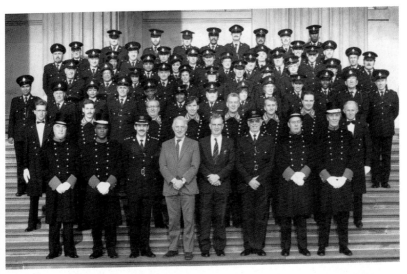

26. Sir David Wilson (front row, fourth from left) with the warding staff in 1988. Brian Williamson (third from left), then deputy chief warder and later head of security; Ken Wright (fifth from left), then head of security; Dick Clarke (next to Wright), then chief warder. Warders in the front two rows are dressed in the Windsor uniforms, worn on special occasions.

27. *Torc* no 136, the edition after Kevin Coombes' reported quote about the double nut flange sprocket, showing how it had become the talking point of the Museum.

28. Rex Shepherd in his role as president of the Cats' Protection Society.

29. The Trade Union Side office some time during the Thatcher era.

30. (*Left*) Union activist Ursula Stone, who proposed helping to solve the Museum's financial problems by asking Pizza Express to have a special 'Museum in Peril' pizza on their menu.

31. (*Right*) Dr Robert Anderson, director from 1992 to 2002, who oversaw the magnificent Great Court project.

32. The Great Court project team. (*From left to right*) Paul Snoddy (museum architect), Chris Jones (client project sponsor and head of administration), Kathy Shakur (project accountant), Anne Beard (personal secretary to the project manager), Reg Cobham (client project manager), Deborah Vogwell (enabling works co-ordinator).

33. (*Left*) The quadrangle around the Reading Room before demolition to make way for the Great Court.

34. (*Below*) The east side of the Great Court taken from the same direction as the previous illustration. All the buildings have gone and the Inner East Road previously out in the open is now under cover.

Admission card

Mr Norman Jacobs

The Trustees and Directors of The British Museum
request the pleasure of your company at a Reception
on the occasion of the opening of

The Queen Elizabeth II Great Court
by Her Majesty The Queen

Wednesday 6 December 2000

Guests are asked to arrive by 5.15pm

Lounge suit
RSVP
The Director's Office
The British Museum
Great Russell Street
London WC1B 3DG
Telephone +44 (0)20 7323 8771/8340
Facsimile +44 (0)20 7323 8480

Reception

35. My invitation to the formal opening
of the Great Court.

36. The famous South Portico.

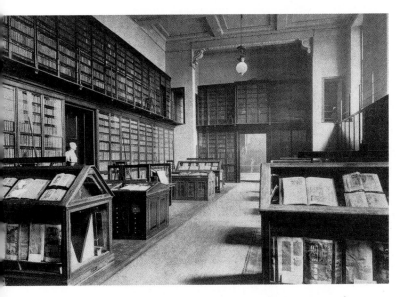

37. The Grenville Library as it was when it was home to the Department of
Manuscripts collections. It is now a BM Company shop.

38. Me (*left*) with my cousin Ian.

39. (*From left to right*) Andrew Burnett (deputy director), Vivian Davies (keeper of Egyptian Antiquities), Brian Wilson (head of administration)

40. Leslie Webster, keeper of Prehistory & Europe, makes the farewell speech at my leaving do. Also in the photograph, behind Leslie are Chris Lazenby (*left*) and Ian Freestone (*right*).

of suggestions, to which Dafydd replied, 'I am your superior officer. Just do what I say!'

Being spoken to like this by a twenty-something-year-old just out of university was like holding a red rag to a bull for Harry, so he looked straight at Dafydd and said, 'You're my what? My "superior officer"? If you know better than me then get on with it.' And he walked off. Needless to say Harry was proved right and Dafydd eventually had to do what Harry had suggested in the first place.

My part in all this reorganisation initially was to work with Mr Tait on his cases, including the Waddesdon Bequest. The Waddesdon Bequest was a collection of nearly 300 precious art objects from Renaissance Europe bequeathed to the British Museum by Baron Ferdinand de Rothschild, MP, when he died in 1898, and was named after Waddesdon Manor, the mansion he built in Buckinghamshire. It was mainly made up of small-scale, rare and precious pieces of the highest quality and included masterpieces of goldsmiths' work, painted enamels, glass and ceramics, sculpture and small carvings in wood. All these exhibitions were arranged in the days before the Design Office took over Museum displays and were organised by the department responsible for the objects. Once again, Mr Tait made the exercise interesting by explaining to me why he had chosen the objects, their importance and so on, so I learnt a lot about the artefacts he was putting on display.

Shortly after our new galleries were opened to the public, the queen was given a private viewing. Two days after her visit, Buckingham Palace rang up to say that Her Majesty had seen three garter plates from St George's Chapel, Windsor Castle, on display and had remarked that they must have been 'nicked', so they wanted to know how we came by them. There was no doubt about the legality of the acquisition of two of them, but no one could find out where the third had come from. It was all hands to the pumps for the rest of the day looking for

evidence we hadn't stolen it. I never did learn the outcome of the search but no one was carted off to the Tower so I suppose we must have satisfied Buckingham Palace that we had come by it legitimately.

Funnily enough, not long after this phone call I had another phone call with a royal connection when Sir Richard Colville rang up. Sir Richard had been press secretary to King George VI and Queen Elizabeth II from 1947 to 1968, and was currently an extra-equerry. He phoned up about eighteenth-century furniture, which was really the province of the Victoria & Albert Museum, but we got chatting generally and discovered we had a mutual liking for Victorian and Edwardian Music Hall. He asked me if I knew a particular song and when I said I didn't he burst into a rendition of it over the phone.

The most interesting aspect of my job came when I was asked to help Elizabeth Eames catalogue our medieval tile collection. Mrs Eames, probably Britain's leading expert on medieval floor tiles at the time, was not a full-time member of staff but was employed by the British Museum as a special assistant to take on the enormous task of looking after and cataloguing the BM's entire collection of something like 14,000 medieval floor tiles, the bulk of which, some 9,000 or so, had been built up by the 9th Duke of Rutland, and had been purchased by the British Museum in 1947. These were housed in eight large mahogany cabinets in the basement of 1a Montague Street.

The tiles dated from the early Middle Ages up to the eighteenth century and had originally been on the floors of abbeys, churches, cathedrals, palaces, mansions, large houses and hospitals. They ranged from very badly made tiles, with plain or very uninteresting patterns, to beautifully made, intricate ones, such as those from Chertsey and Malvern Abbeys. It was a fascinating job and I loved every minute of it. I also loved Mrs Eames' enthusiasm for her subject and her pure delight

when she discovered something hitherto unknown about a tile or the way it had been made. She always called this eureka moment her 'contribution to knowledge'.

I knew absolutely nothing about medieval floor tiles before I started helping Mrs Eames; by the time I finished I must have been one of the country's most knowledgeable people on the subject. In fact, I remember one particular occasion when I was even able to help Mrs Eames solve a problem she had with tracking down the provenance of a particular group of tiles. She had been looking to English tile kiln sites for their manufacture without success when I suggested they were probably continental because of the material they were made from. She immediately said, 'Of course, you're right. Thank you. That's solved that.' My own 'contribution to knowledge'.

The only downside to Mrs Eames, although it rarely affected me personally as I was with her in the basement of 1a Montague Street, was that she sometimes brought her young son to work during the school holidays and would leave him in our general office. Apparently he saw himself as an expert drummer and spent the day beating tattoos on anything he could find, much to the annoyance of George, Peter and Stella.

During this period I became very friendly with Peter and we used to go for coffee together every morning. Instead of going to the canteen we used to go to a cafe across the road called Ronaldo's. Ronaldo's provided a whole new set of characters all of its own, some from the Museum, some from outside. Of the Museum characters who frequented the cafe, the one to avoid at all costs was Iris Phillips, who was a CO in P&RB. She was a fifty-something-year-old spinster who had three main topics of conversation.

The first was her health. We quickly learned that it was a big mistake to say anything like, 'All right, Iris?' when she walked in as she would invariably reply that no, she wasn't all right,

and would work her way through a litany of complaints she was suffering from that day, some of which, the sores on her legs for example, she described in graphic detail. In fact, I think the phrase 'too much detail' was probably coined by someone who had heard Iris talk about her leg sores.

Her second topic was her boss, Maisie Salisbury, the EO in P&RB. Iris never had a good word to say about her and would move on from her health to complain about Maisie's latest misdeeds at some considerable length. Her third topic was her brother, with whom she lived. Just like Maisie, her brother could never do anything right and we heard all about his transgressions. Her colleagues in P&RB were convinced that her brother didn't really exist and that he was just some alter ego of Iris' on whom she could blame things when they went wrong at home. I have no idea whether this was true or not. All I know is that Iris was a real ray of sunshine and our hearts sank whenever she walked in.

At the opposite end of the scale was a woman who worked in Printed Books, whose name we never did know, but she used to meet a male friend in Ronaldo's quite often. We liked to think they were having an affair and it was a secret assignation, but the man could just as easily have been her husband or an old friend of the family for all we knew. We never spoke to her or her friend ourselves but their conversation was often punctuated by raucous laughter which reverberated around the whole cafe. In fact, she sounded just like a kookaburra, which is what we used to call her in lieu of knowing her real name.

Of the outsiders there was the man who sat with us once, looked around to make sure he wasn't being observed and suddenly announced in hushed tones that he was a spy and knew enough government secrets to get himself killed. He knew, he said, that people were watching him and he had to be very careful where he went or what he said. It struck us as

very curious that he was talking to us, complete strangers in full public view, about how careful he had to be. Sadly we only ever saw him once as he was very entertaining.

Another time a man came in who when asked by the waitress what he wanted, simply replied, 'Beans.' The waitress said, 'What?' So he repeated, 'Beans. I'd like a plate of beans, please.' In an exchange reminiscent of the diner scene in the film *Five Easy Pieces*, the conversation then continued like this:

'You can't have just a plate of beans.'
'Why not? I can have beans on toast can't I?'
'Yes.'
'Well, I'll have beans on toast but leave the toast off.'
'I can't do that.'
'I'll pay for beans on toast, just don't put any toast on the plate.'

This was too much for the waitress to comprehend so she went off to get the manageress, who agreed that the man could have a plate of beans if that's what he really wanted.

Our favourite non-Museum people were a group of motorcyclist couriers who used to come in and commandeer a couple of tables. They looked like typical bikers with their long, greasy hair dressed up in well-studded black leathers. The strange thing about them, however, was that their conversation always revolved around the latest ballet they'd seen or art gallery they'd visited, or some newly released obscure Japanese art film. Peter and I dubbed them 'Hell's Connoisseurs'.

Meanwhile, back at the Museum, Rupert Bruce-Mitford returned from his Sutton Hoo 'exile' to reclaim the keepership of the department. He and Mr Tait, who now reverted to deputy keeper, absolutely loathed each other and always took great delight in trying to outdo one another. During the dying days of the Conservative government, Ted Heath introduced a three-day working week as a result of the miners' strike. Although we

remained open seven days a week, restrictions were imposed. Galleries were closed on a rotational basis, and offices were closed early on some days to save heat and light and so on.

At the start of this, Maysie Webb called me down to her office to explain these proposals to me. She said she thought it right to inform the Trade Union Side first and then she would phone all the keepers to let them know. I said I could tell Mr Bruce-Mitford when I returned to the department to save her a phone call. She agreed I could. When I got back I went to see him and told him what Miss Webb had just told me. After I left he stormed out of his office, through the long room occupied by the assistant keepers and straight into Mr Tait's office, where he demanded to know how it was that I, a mere clerical officer, knew the Museum's plans before he, the keeper, did. Mr Tait just looked at him and burst out laughing, which did nothing to ameliorate Bruce-Mitford's temper.

Finally, Mr Tait said, 'Norman is chairman of the Trade Union Side. Surely you must know that Rupert.' One up to Mr Tait! Actually, it was highly likely that he had forgotten that I was Trade Union Side chairman as he was not the least bit interested in the junior and non-curatorial staff. He rarely came down to our office and often just spent all day in his own office, 'entertaining' other keepers, senior curatorial staff and distinguished visitors with what seemed to be a copious supply of alcohol he kept in his room. His elitist attitude meant that hardly anyone in the department had a good word to say for him. This was especially true for our office.

One incident in particular summed up his attitude towards the junior staff. In 1974 our department was undertaking an archaeological dig on an Anglo-Saxon site in Broadstairs, Kent, under the direction of Leslie Webster. Harry Pavitt told me he was driving down there to take some material needed for the dig, so I asked Bruce-Mitford if I could go with him. He said I could, but only if I took the day out of my annual leave.

Talk about encouraging staff to take an interest! So, I took a day's leave to go down, but I'm glad I did as when we arrived the archaeologists had just found a sword still in its wooden scabbard, something which at the time was unique, so it was a very exciting moment on the dig. The other thing I remember vividly about the excavation is the conservation officer, Nigel Williams, getting down into the mud wearing his pink wellies.

Before the one-day strike in 1973, Bruce-Mitford had summoned Peter Stocks and Joy Davey (who had recently replaced George as the other EO in our office) to see him and said, 'I expect my EOs to remain loyal to me and the Museum and not go on strike.' Both Peter and Joy were fully supportive of the strike, so Peter, who was teetotal, replied, 'Well we all have our little quirks, Mr Bruce-Mitford, some people go on strike; other people like to spend all day drinking. That's just how it is.' Both Peter and Joy were on the picket line on the day.

I said that no one in the department had a good word to say about him, but that wasn't strictly true as he was having a not too secret affair with one of the Sutton Hoo research assistants, Marilyn Luscombe. At one time Bruce-Mitford decided to end the affair. Poor Marilyn was distraught and climbed up on to the roof of 1a Montague Street threatening to throw herself off unless he changed his mind. He did eventually divorce his wife and Rupert and Marilyn got married in 1975.

There was little in the way of social activities or get-togethers of staff outside the Museum, except maybe in the two local pubs, the Museum Tavern just across the road from the front entrance, and the Plough just down Museum Street, where people might go immediately after work. I thought it might be a good idea, therefore, if we formed a football team to play the occasional friendly fixture against other similar institutions. With Peter Van Geersdale as our star player, we managed to interest enough people to play a few Sunday morning matches on Hackney Marshes.

The first match we played attracted a few supporters, including Harry Pavitt, Sandy Davison and Mr Tait, who cheered us on from the touch line. We played teams from places like the Royal Festival Hall. But our most memorable match was against the London Festival Ballet. At half time their captain came over to where we were eating our oranges and asked us if we could kindly stop kicking their ankles and shins as they were dancing that evening. We won the match 7–0.

In 1978 I was elected on to the CPSA National Executive Committee (NEC). Because of this and my other union commitments, I spoke to Jack Ryde about having proper time allocated to me to allow me to carry out my union duties. There was a suggestion that I should be moved from M&LA and given 100 per cent union facility time. I demurred at this because although I could certainly have filled 100 per cent of my time on union work, I loved working in M&LA and wanted to continue doing some museum work. I also thought that if I left the department now, when I lost my NEC seat, as I inevitably would one day, I would be sent back to work in whichever department there was a vacancy at the time, which could be anywhere, even the dreaded Accounts Department – a fate worse than death as far as I was concerned.

So between Jack Ryde, the department and myself, it was agreed I would be given 75 per cent union time and 25 per cent official work. To cater for this I was given a special job in M&LA looking after the departmental archives. There were two parts to the archives. The first was the departmental correspondence dating back to the nineteenth century, and the second was a series of notebooks and other similar material handwritten by former keepers, senior curators and other specialists. Neither were indexed or had been looked at for years and there was a general feeling amongst the curators that there was probably much useful information lying hidden in all this

material, if only they knew where to look; so my first job was to get it all in some sort of order and then index it.

I was moved from our general office to what was still called Bryan Cranstone's office, above the old Ethno Library. Bryan Cranstone was the former deputy keeper of Ethnography. His old office, the one I was now about to occupy, was a very large attic room with the only natural light coming through a sky light. All the old departmental correspondence was tied up in brown paper bags in a cupboard in the basement. It was doubtful if any of these letters had been seen since the day they were packaged up and thrown down there. My job was to put them in chronological and alphabetical order in special archive standard box files and move them up to cupboards which lined the balcony of the Ethno Library, so that they were more accessible.

The job was made easier by the fact that when I opened the brown paper packages I discovered that they were already in chronological and alphabetical order, although not marked on the outside, so it was just a matter of getting at least 100 years' worth of brown paper bags in the right order.

There were some curiosities in the way the letters had been sorted in the past. This was especially true of correspondence received from district councils and boroughs in the 1920s and '30s. Sometimes these were filed under the name of the council, which was fair enough. But others were just filed under 'C' for clerk of the council, who had invariably signed the letter, and, even more eccentrically, some were filed under 'T' for 'the' clerk of the council.

The notebooks were housed in a cupboard in the assistant keepers' room and were mainly notes made by former keepers and members of staff while visiting other museums both in this country and abroad. I indexed these by name of the museum visited and the objects described. The biggest find was not a former curator's notebook but a five-volume

diary written by Charles Roach Smith, a nineteenth-century archaeologist, antiquarian and collector who had sold his very important and valuable collection of over 5,000 objects to the British Museum in the 1850s; a collection which provided a great impetus to the establishment of the department I was now a part of. Before this time British antiquities were not thought to be sufficiently interesting to collect, and the Museum concentrated on classical antiquities from Greece and Rome, Egypt and the Middle East. The BM had been lobbied for some time by archaeologists and others to take British antiquities seriously and they found a champion in Augustus Wollaston Franks, who eventually became the first keeper of the new department, but it was in large part thanks to Roach Smith's collection that the department was able to start off with such a large mass of home-grown material.

The more I read Roach Smith's diaries the more I came to like the man, and the more I felt quite angry by the way the British Museum had treated him. His diaries contained not only information about many of the objects now in the Museum's care, but also social commentary on his life and times. He was obviously quite a radical thinker for his day. He was opposed to capital punishment and was not a great fan of Queen Victoria. He also recorded an incident when he visited a farmer in Norfolk who had discovered some Roman antiquities on his land. On walking from the station through the farmer's fields to his house, he noticed that the farm labourers wore very ragged clothes and asked some of them why they were dressed so poorly. They explained that the wages they were paid did not allow them to buy new clothes. When he got to the farmer's house he forgot all about the antiquities and instead berated the farmer for paying such poor wages.

On another occasion, a friend introduced Roach Smith to a man who began to criticise the people of Roach Smith's home town of Strood, but added, 'Of course, Mr Roach Smith,

my remarks apply entirely to the lower orders.' Roach Smith replied that he hoped he could change the man's opinions of the lower orders, 'seeing that I am one of them.'

Indeed, his worst crime as far as the Museum was concerned was that he was not a gentleman but a retail chemist by trade. When he was put up for membership of the Society of Antiquaries in the 1830s, it was the then BM director, Sir Henry Ellis, who campaigned against his admission. In spite of this, Roach Smith knew the importance of his collection and he strongly believed that it should remain intact. He was not a wealthy man and offered his collection for sale for £3,000, which was really only just enough to cover the cost of building it up. He had no desire to make a profit out of it and the collection was, in fact, worth many times that amount. Lord Londesborough, first president of the British Archaeological Association, sent him a cheque for £3,000, but this was immediately returned as no guarantee could be given that the collection would be kept together for all time.

Roach Smith then offered it to the British Museum, who initially turned it down, as many of the trustees were still unconvinced about the desirability of collecting British antiquities; but there was such an outcry that the trustees eventually agreed to approach the Treasury for a £2,000 grant, which is all they were prepared to pay. Although Roach Smith was very upset by what he saw as the BM's parsimonious offer, so strongly did he feel that his collection should be made available to the nation for the sake of the public, future historians and archaeologists, that he accepted the offer, even though it meant making a loss. In fairness to the BM, it should be pointed out that they were in the midst of buying a number of other important collections at the time and there was a bit of a cash flow problem.

Some time after I discovered these diaries there was talk of writing a biography of Roach Smith, together with a catalogue of his collection which was dispersed over a number

of different departments. I was asked if I would like to write a chapter devoted to Roach Smith – the man and his views – while curators from the various departments wrote the catalogue and discussed the importance of the objects he collected. Sadly the book never materialised as I would have loved to have played a part in making his name better known to the public and in some way making it up to him.

Amongst some general papers left by Roach Smith there were also a number of letters from a man called Tisdale, dated between 1789 and 1795. He was a British naval captain serving with the Russians in the war against Turkey. He was captured and imprisoned. Because of this he was thrown out of the Russian navy in disgrace and, in spite of personal appeals to Catherine the Great herself, expelled from Russia. His story was all there in his own letters and I was probably the first person ever to read them since the day they arrived at the Museum with the rest of Roach Smith's collection.

There were a number of staff changes during this period. The most important was the retirement of Rupert Bruce-Mitford in 1975 and the appointment of his successor. Of course, many of us felt Bruce-Mitford's retirement was long overdue, but I think we all realised it was imminent when Peter returned from his office one day telling us that he had been summoned into the keeper's presence and, once inside the door, Mr Bruce-Mitford had demanded to know 'who threw those wires on the floor'. Peter looked around in vain for a tangle of wires on the floor but could see nothing. Bruce-Mitford said, 'Look, there', and pointed to the telephone cable. Peter explained that the telephone cable had been in his room for a number of years and that no one had 'thrown' any wires on his floor.

Naturally, Mr Tait, along with the three assistant keepers, John Cherry, Leslie Webster and Richard Camber, all applied for the job. Until the previous year every keeper of an antiquities

department had been appointed from within the Museum. This tradition was broken in 1974 when Malcolm MacLeod was appointed keeper of the Ethnography Department, so it was by no means a foregone conclusion that Mr Tait, who would normally have been expected to get the appointment as the current deputy keeper, or any of the other three, would get the job. Had the departmental staff been allowed to vote on the issue, Richard Camber would have won by a landslide. The board members were Sir John Pope-Hennessy, the new director; Lord Fletcher, the antiquities trustee; Sir Arthur Drew, the staff trustee; Peter Lasko, a professor at the University of East Anglia and former assistant keeper in M&LA; and Mr Ellis of the Civil Service Department.

After a delay of some two months, the name of the new keeper was announced. It was to be Neil Stratford, a lecturer at Westfield College, London. The reason for the delay in announcing his name was because the board was deadlocked over who should be appointed. It was our understanding that the director and Peter Lasko had refused to appoint Mr Tait at any price, but the two trustees thought he was the best person for the job. None of the other candidates gained any significant support so the discussions went on for some time. In the end, the director, Sir Arthur Drew and Lord Fletcher agreed to support Neil Stratford as a compromise candidate. Peter Lasko refused to vote.

Not long after the announcement was made, Richard Camber told me how bitterly disappointed all the internal candidates were about the appointment, not because they didn't get the job themselves, but because they all knew Neil Stratford and none of them liked him. Richard said that Neil's speciality was Burgundian architecture and that we didn't have any in the Museum. 'Besides,' he added, 'all there is to know about Burgundian architecture can be written on the back of a postage stamp.'

When Neil arrived, because there was no Burgundian architecture in the department, he looked around for something he could specialise in and took a fancy to Russian art, in particular icons, which, of course, was Richard Camber's specialism. This muscling in on his territory didn't help change Richard's opinion of him. As I mentioned earlier, Richard was always the most obliging of the AKs if they weren't actually on duty when it came to looking at objects brought in by visitors. One day, not long after Neil started as keeper, a visitor brought in an icon. As I couldn't find John Russell I showed it to Richard. He just said, 'Show it to the keeper. He's the expert.' I had never seen Richard in that sort of mood before. In the end, though, I can't help thinking that Richard got the best of the deal, as he left the BM not long after Neil's arrival to become a senior director with Sotheby's of New York.

There was also a fair bit of movement at the other end of the departmental staffing. May Seals, the messenger, left and her place was taken by Phyllis Gidley, whose husband Frank already worked at the Museum as a security warder. Phyllis had a low, gravelly voice and was very outgoing and friendly. She did have a bit of a surprising claim to fame, however, in that she was the aunt of the well-known *Carry On* actor, Kenneth Williams. She was always telling us tales about 'our Ken' and letting us know when he was to appear on television: ''ere, our Ken's in a play on BBC tonight …'

Another messenger to arrive during my time was a man called Peter Gidlow-Jackson. He was nicknamed 'the Wolfman' as he was not too fastidious about his appearance and his hair seemed to grow everywhere. We also had a new typist join us, a South African. Whenever Mr Tait called her in for dictation she would rush off to the loo and return some minutes later heavily made up with bright red lipstick on. Mind you, Mr Tait was not above this sort of thing himself. At one time, BBC television produced a series of programmes about the British

Museum with a different presenter talking about each department. Our presenter was the well-known historian and author, Lady Antonia Fraser. We knew when she was due to visit as Mr Tait would arrive dressed in his best suit reeking of aftershave and with his hair cut and suitably coiffured.

In my office, Stella left in 1972 and was replaced by Harry Moore, who was interested in naval history and was forever talking about the 'Phoney-cans', which it took Peter and I some time to work out were actually the Phoenicians. Peter finally got his heart's desire and moved off to Oriental Printed Books. His place was taken by Joan Botfield, who only lasted a short while and was replaced by Deirdre le Faye. Deirdre became well known as an expert and writer on Jane Austen and has had many books published about Austen, a number of which she wrote from inside Esther Ochonoger's old booth in the corridor. I really got on well with Deirdre and we still keep in touch to this day. Although she was/is a Conservative with a big 'C' of the most determined kind and a non-union member, she always allowed me as much time as I needed to pursue my union activities.

The 1970s ended, therefore, with me enjoying life to the full at the Museum, doing 'real' museum work while at the same time getting deeply involved with union activities at all levels, from branch to national. The start of the 1980s was to see the two come into a sudden collision.

'HYPOCRISY AT THE TOP'

After all the major issues of the early '70s, things settled down on the union front for a while. Sir John Wolfenden retired at the end of 1973 and his place was taken by Sir John Pope-Hennessy. The new Sir John arrived with a very bad reputation from the Victoria & Albert Museum, where he had been the director. The staff there did not have many good words to say about him, complaining that he was very aloof and dictatorial. I'm afraid to say our experience was much the same. He was very elitist, did not like to mix with junior staff and was not open to ideas that weren't his own. Out of the six directors I worked under he was definitely the worst. It was not as though he revolutionised the way the Museum worked or brought about any beneficial changes. He had not really wanted to be appointed director in the first place, much preferring the art world to the archaeological world, and seemed to take little interest in the place; consequently, nothing much happened under his stewardship. He was appointed on a five-year contract but fortunately he left after about three years to take up the position of consultative chairman of the Department of European Painting at the Metropolitan Museum of Art, New York, and a professorship at the Institute of Fine Arts.

At a lower level of management, a new head of administration, Cyril Berry, was appointed above Jack Ryde, and a new SEO in charge of Establishments (Personnel), Doug Thomas. Both Cyril and Doug were career Civil Servants who did everything by the book. As it happens, after my initial difficulties with Jack Ryde, we had begun to get on very well and we were often able to sort out problems informally. Jack had worked his way up through the ranks, having started as an assistant at the Museum in 1939, so he understood much more about the way the Museum worked and how to get things done than either of the two newcomers. I think Jack first warmed towards me when he discovered I was interested in cricket, as he was a rabid Surrey supporter and often took time off to go to his beloved Oval.

From our point of view in the unions, Doug was the easiest of the three to deal with as he was a hopeless negotiator and we quite often tied him up in knots. As an illustration of this there was an occasion when Stephen Pewsey, the newly elected CPSA branch chairman, and I went to see Jack and Doug with a list of five items we wished to discuss, including the very contentious issue (at the time) of employing agency typists, to which we were very much opposed. Just as the meeting started Jack received a phone call and was summoned to Maysie Webb's office. As he left he said, 'I won't be long, you may as well carry on without me but under no circumstances are you to discuss agency typists until I get back.'

As soon as he went out, I said to Doug, 'Why do you think he said we shouldn't discuss agency typists?' Doug replied that it was probably because it was such an important issue. Stephen and I agreed it was important and we continued to talk about it, explaining why we were opposed to their employment at the BM which we saw as a bad thing both from our point of view and also management's. In the end, Doug said he could see our point and agreed that the BM should try and end the employment of agency typists as soon as possible.

When Jack returned, he said, 'Where are we then? What's been discussed so far?' Doug looked down at the table like a naughty schoolboy who had just been found out and rather hesitantly replied, 'I think I've done something silly, Jack. I've agreed with the CPSA that we should stop employing agency typists.' Jack shook his head and said, 'Have you? Well you can just unagree it!'

When Sir John Pope-Hennessy left, his place was taken by David Wilson, who had been an assistant keeper in British & Medieval Antiquities in the 1950s but had left to become professor of medieval archaeology at University College London. So, although it wasn't exactly an internal appointment, it was the nearest thing we were ever likely to get to one. He was an archaeologist and a Viking specialist, and his appointment was widely approved because he had a background at the Museum and a real feel for the place.

Unlike his two predecessors he had very definite and positive ideas about how he saw the future for the BM and, although he was quite ruthless in getting his own way, in general he showed interest in the staff at all levels and was more than happy to compliment people personally if he felt they had done a good job.

Despite finding time for everyone, quite soon after his appointment Wilson put forward a very backward proposal, which was to turn the Hartwell Room, one of the meeting rooms in the New Wing, into a common room for senior staff only. We discussed this at a Trade Union Side meeting and even the FDA were not in favour of the idea, so we agreed to write to him protesting about what we saw as a retrograde step. In my letter to him, on behalf of the TU Side, I said that his proposal was taking us back to the Victorian era when gentlemen academics had to be kept apart from hoi polloi. At the next annual Whitley Council meeting, which followed quite soon after my correspondence, the director told me that my letter

was the rudest he had ever received. Nevertheless, the proposal was not pursued.

In July 1980 Stephen Pewsey told me he had come across some confidential trustees' papers which flagged up a number of problems – some being caused by recent government cuts in our grant, others by inherent difficulties within the Museum – and had compiled a dossier made up of copies of some of these trustee papers plus other relevant documents and his own comments.

The two main problems highlighted by the cuts in our grant were, firstly, that the poor upkeep of the building was having an effect on the objects in our care, in particular in the Department of Prints & Drawings, where the roof leaked whenever it rained and buckets were being placed around the Students' Room to catch the rainwater coming in, with the obvious threat this posed to the collections themselves. Secondly, the effect the cuts were having on staff, with the main example being the reduction of the size of the New Wing and the fact that the air conditioning did not work properly (as outlined in Chapter 6 above).

The inherent difficulties within the Museum were emphasised by a request from the Comptroller and Auditor General's Office that the Museum account for all the objects it was holding in trust for the nation and what system was in place to keep track of their movements. The BM had carried out a sample check of 3,600 entries from the Coins & Medals departmental register and found that seven were definitely missing while a further 154 could not be traced but were not necessarily lost. This showed a 99 per cent certainty that between 380 and 2,020 coins were lost and that many more could not be identified definitely.

Stephen's dossier also pointed out the fact that while cuts in our grant were having a serious effect on the collections, the staff and the public, the trustees and director were enjoying

certain perks at the taxpayers' expense. For example, the trustees held frequent luncheons and other in-house functions at the Museum which did not stint on the food provided and were 'liberally supplied' (to quote the dossier) with wine at £8 a bottle (equivalent to about £24 at 2010 prices), and that the director had a 'Personal Entertainments Allowance' of £2,000 per year (£6,000 today). In addition, the dossier highlighted that the director was having a double garage built onsite by the Department of the Environment, while at the same time a motorised hoist to lift disabled people up to the colonnade had been cut from the programme due to cost. It was particularly because of this latter juxtaposition that Stephen had entitled the dossier: 'Hypocrisy at the Top'.

We decided to send the dossier to CPSA headquarters, which was campaigning nationally against the cuts in public expenditure introduced by the Conservative government. As a result, Clive Bush, the CPSA's press officer and editor of its national journal, *Red Tape*, invited us to headquarters to talk about the dossier, which he thought could be useful ammunition to show the public what effects cuts in government spending were having on even relatively small government departments like the British Museum. While we were there, the president, Kate Losinska, walked into his office and Clive explained why we were there. He suggested holding a press conference and giving copies of the dossier to the press. Kate readily agreed to this and said she would like to be at the press conference herself.

Two days later, Stephen and I returned to CPSA headquarters to meet the press. As well as Clive and Kate, the assistant general secretary, John Raywood, and the senior vice president, George Holah, were present at the press conference. The reporters were mainly from the 'quality' press, *The Times*, *Guardian*, *Daily Telegraph* and the *Financial Times*, plus a representative of the Press Association. Clive introduced the dossier

and the press asked a few questions. Given the furore in the press in 2009 over MPs' expenses, it is a bit ironic looking back that one of the journalists said he didn't think they would make too much out of the expenses issue as people might start looking at journalists' own entertainment accounts.

The following morning when I arrived at work, Joan Botfield said, 'What have you been up to? The phone's been red hot this morning. Everyone wants to speak to you, including Maysie Webb, who wants to see you straight away.'

The only newspaper I could get hold of immediately was *The Times*, as someone in the office had a copy. As I was later to discover, most of the newspapers – quality and tabloid – ran the story, including the *Morning Star* who, somewhat predictably, headlined their piece, 'Museum in danger of losing its marbles'. All of them quoted Stephen and me by name. *The Times'* headline was 'British Museum chiefs called "inept" by union'. I read it through and realised things were going to be quite bad for us as they had slanted the article differently to the way we had intended. They said we were criticising BM management for losing 2,000 coins and putting valuable prints and drawings at risk, when our emphasis at the press conference had been to attack the government for not providing the funds to repair the roof or provide enough staff to look after the collections properly. The newspapers had, of course, asked the BM to comment on our allegations but, interestingly, they did not refute them. Their line was that some of the documents we had released were confidential and they were not, therefore, prepared to discuss them, but at no time did they say we were wrong about our main facts.

I called Stephen and said we should go and see Maysie Webb, but he refused to go, so I went to see her on my own. She demanded to know why we had gone to the press without first raising these matters with BM management. I said the papers had misrepresented what we had said and that

our aim had been to highlight the problems caused by the government cuts in public expenditure and not that the BM management was 'inept'. That being the case, I said, we did not see the need to discuss it with management first. She was wholly unconvinced by this argument and brought up the director's garage, which several of the papers had mentioned, and asked why that had been made public. The meeting finished with her saying that she would have to consider what action to take next.

The other unions demanded a meeting of the TU Side to discuss the matter, which was arranged for the next day. Other members of the CPSA branch committee also met and let us know that they did not approve of our action, especially as we had not discussed it with them. The person leading this attack on us from within our own committee was David Hofman, a Trotskyist supporter of the Militant tendency. It seemed very curious to me that this normally outspoken revolutionary should take the 'hated' Thatcher government's side against his own union officials. An emergency meeting for all members was called and we were told we had to be there.

The following day started with a statement in the *Guardian* from Kate Losinska saying she knew nothing about the press conference and demanding an inquiry into how it came to be held at CPSA headquarters without proper authorisation. Although I was dismayed I was not surprised as I had had many dealings with Madam President before and this was typical of her. The fact that she had personally authorised the press conference and had been present at it seemed to have slipped her mind. When the going got a bit tough she always blamed other people for the problems. As *Private Eye* put it at the time: 'Nothing like having a union president standing right behind you with a knife in her hand.'

With the CPSA seemingly deserting us, Stephen and I now had to face the BM Trade Union Side and our own members.

At the TU Side the other unions lined up to criticise our action in going to the press without first discussing the matter with them. I offered my resignation as TU Side chairman, which was accepted.

I then did the same at the CPSA members meeting, but, much to my surprise and relief, the members overwhelmingly rejected my offer and I was asked to continue as branch secretary. It was quite a humbling experience to know that I still had so much support from my own members even though many of them did not agree with what I had done.

On arriving for work the next day, I went to the Trade Union Side office, only to find Jack Ryde, Barbara Hughes (Doug Thomas' successor) and Nipper Read already there. Nipper Read was, of course, renowned as the policeman who had 'nicked' the infamous Kray Twins. He was now the security adviser to the National Museums and Art Galleries. Jack Ryde and Nipper Read were searching through our filing cabinets and cupboards while Barbara Hughes, a senior executive officer, was busily engaged rummaging through our two wastepaper baskets. What they were looking for I had no idea, and why they needed to involve someone like Nipper Read was even more of a mystery.

Literally a few seconds after I arrived, Martin Freeman, the SCS branch chairman, turned up. He was aghast. He demanded they get out of the room. He said the papers in this room belonged to the TU Side and the individual unions and were confidential. Jack replied they were looking for the trustees' papers we had used in the dossier. Martin told them to get out and make an appointment if they wanted to come into our room. Without any further argument they left. Martin was absolutely seething and he phoned the other unions and they agreed to call yet another emergency meeting to discuss this breach of confidence. This incident was something of a turning point for Stephen and me as all the trade union officials

were so incensed about the management's action that their anger was now directed at them rather than us.

Eventually both Stephen and I were charged by the Museum with the disciplinary offence of 'bringing the Museum into disrepute'. After a very perfunctory hearing in front of Cyril Berry we were both found guilty. The decision was made by the director on Cyril's recommendation. I decided to appeal against his verdict but Stephen accepted it. My main ground for appeal was that according to paragraph 9912 of the Civil Service Pay and Conditions of Service Code:

> A civil servant who, as an elected national, departmental or branch representative or officer of a recognised trade union, is publicising his union's view on an official matter, which, because it directly affects the condition of service of members of his union as employees, is of legitimate concern to them and needs no specific permission [from his department].

I also appealed on procedural grounds that the disciplinary hearing had not followed the correct rules.

The appeal was held in front of three senior members of management, chaired by Cyril Berry. I was represented at the appeal by the CPSA full-time officer responsible for the Museum, Richard Regan. I knew Richard quite well and didn't hold out much hope that he would be of any help. And so it proved. Before we went into the meeting he asked me if I knew who would be taking the minutes of the hearing. I said I thought it highly unlikely that anyone would take notes of the meeting as it was normal Museum practice not to. He said, 'We'll have to insist then. If they turn down your appeal we will need to see the minutes in case we wish to take the matter further.' I asked him what we would do if they refused to take any notes. He said, 'We'll walk out.' When the appeal hearing started, Richard asked if any minutes were being taken. Cyril

Berry replied that they were not. As I started to get up to leave, Richard simply said, 'Okay,' and the appeal continued.

Once again, the final decision was in the hands of the director based on the recommendation of the appeal board. Not surprisingly, he turned down my appeal. His main argument was that by publicising in the national press that objects, particularly in Prints & Drawings, were in danger from leaking roofs, it would make people reluctant to donate or leave objects to the Museum and thus we had brought the institution into disrepute.

A little while later, after joining in the general condemnation of our behaviour, the FDA published a report, which also gained widespread coverage in the press, about the lack of government funding for museums called 'A Stitch in Time', which amongst other things said that the British Museum building was in need of urgent repair and that staff cuts were limiting public access to the collections. It went on to say that the Museum still had to replace areas of roofing damaged in the Second World War. 'At the same time,' it said, 'one of the most important collections of prints and drawings in the world was housed in overcrowded conditions, without temperature and humidity controls.' Although this report should have had the same effect of 'bringing the Museum into disrepute', I never heard of anyone facing disciplinary charges for compiling and making it public.

From a natural justice point of view, the whole procedure was completely unfair and I discussed with CPSA headquarters what our next step could be. The fact was that the director was now upholding his own initial judgement on an issue in which he had been personally involved in the first place. To me he seemed to be acting as plaintiff, judge and appeal judge. CPSA took the matter up with the National Trade Union Side secretary, Brian Sutherland, who agreed with me that it was all wrong and offered to come and speak to the director in a

personal capacity. In addition, Beryl Antony, the only CPSA branch committee member who had supported Stephen and me throughout, and who was a member of the Liberal Party, offered to set up a meeting with Liberal MP Clement Freud to see what he could do. When I met him I told him everything that had happened and, although he was not fully supportive of the way we had gone about the issue, he did agree that natural justice had not been carried out.

In the end, I decided to have one more attempt myself and wrote a letter to the director outlining my feelings about the way he had handled the whole case. He replied that he would send all the papers to Sir Arthur Drew, the trustee responsible for staff, to review. I knew what the end result of that would be and sure enough, to absolutely nobody's surprise, Sir Arthur upheld the director's decision.

Although I could have taken the matter further, I decided it probably wasn't worth the time and effort I was spending on it, so I accepted the decision. My punishment was to be put down a point on the incremental pay scale for the whole of 1981. In those days every grade had an incremental pay scale lasting anything from three to ten years, so that until you reached your maximum point you received an annual pay rise outwith the Pay Research general pay rise. I was already on the maximum so I was put down a point to one below the maximum, a loss of £248.84 before tax (£746.52 at today's value) over the whole year.

While all this was going on at the BM, Clive Bush, at CPSA headquarters, had been absolutely incensed by Kate Losinska's statement that she did not know who had authorised the press conference. He wrote a very strongly worded letter to the general secretary, Ken Thomas, in which he laid out the true facts and no more was heard of the president's proposed inquiry. As it was now accepted by CPSA headquarters that the press conference had been held officially under their aegis, Clive Bush

recommended that they should make up the shortfall in my salary for 1981. It was agreed and I received this in the form of a lump sum cheque for the full amount of my gross salary, that is, without deducting any income tax. So for the year of my punishment I actually took home more money than if I'd not been put down an increment. Not a bad result in the end!

After all the fuss had died down, *The Times* ran an article headed 'Computer will list British Museum riches'. It began:

> The British Museum's department of prints and drawings does not know exactly how many works it has in its collection. The number is between two million and three million pieces of paper. The department has never counted them. This might seem to support the criticism of mismanagement in the museum that was published by members of the Civil and Public Services Association. But the situation is symptomatic of an organisation which, short of money and space, is slowly tackling the task of controlling its enormous collection … The museum is about to start recording all its riches by computer.

Writing this, and looking back on the whole episode, I think it is easy to say we undoubtedly made a mistake in the way we went about it, but it was done with the best of intentions to bring attention to the fact that cuts in public expenditure were possibly harming the collections of the best museum in the world. Of course, we should really have steered clear of the personal accusations about the director's garage and trustees' expenses and concentrated on the main thrust of our argument; and the title of the dossier was the biggest mistake of all.

The computerisation of records, begun after our press conference, has been an enormous success and the whereabouts of all objects is now known and tracked, while the creation of a

dedicated works department after the demise of the Property Services Agency in the 1980s enabled the BM to target funds where they were most needed. Within ten years the situation had improved beyond all recognition, thanks in the main, I have to say, to David Wilson's drive and determination to put things right. After the previous two directors he was like a breath of fresh air, or, more appropriately, a hurricane-force wind.

In the year following all this excitement I became involved in what could have been a very unnerving experience, although it didn't seem so at the time. In 1981 the CPSA was engaged in another long pay battle, this time with the Conservative government of Margaret Thatcher. In late May representatives of all the branches in Holborn and Bloomsbury met together one evening to discuss how we might further the cause in our area. I went along as the British Museum representative.

It was here that I met Denis Nilsen, who was the representative of the Department of Employment Job Centre in Denmark Street. Nilsen was later arrested in 1983 having become one of the most notorious serial killers of all time, murdering at least fifteen men and boys between 1978 and 1983. So in 1981, when I met him, he was still fully active in his gruesome trade. Bizarrely enough I can remember his macabre contribution to the meeting which came when we were discussing what action we could take next. He said, 'I'll volunteer to go and kill Margaret Thatcher.' Naturally we all thought this was a big joke. Little did we know ...

9

JOURNEY OF A LIFETIME

Until I lost my seat on the CPSA national executive in 1985, my museum life was mostly made up of union work and the M&LA archives. When I did lose my place my union facility time was cut to 50 per cent and I returned to the general office. Because of the nature of CPSA politics at the time it seemed unlikely I would regain my seat in the near future, and what with my second son being born in 1985, I decided it was time I thought about promotion. I had always turned down the chance of promotion before because it would have meant leaving the CPSA.

The first executive officer post that became vacant after I made that decision was that of welfare officer. I thought this sounded like something I could do, as much of my time as CPSA branch secretary had been taken up in dealing with personal cases, and I imagined it would be much the same for the welfare officer. I decided to apply for the job and to my surprise I got it. So after sixteen and a half years it was farewell to Medieval & Later Antiquities and hello to Welfare.

As soon as I walked through the door of my new office on my first morning, the senior welfare officer and my immediate boss, Sue Copus, said, 'I've got a job for you. One of the security warders died over the weekend. Can you phone his

widow, express our condolences and ask if there is any way we can help.' It was an abrupt wake-up call that the job was not like a union branch secretary's after all, nor was it anything remotely like the one I'd just left in Medieval & Later Antiquities.

My first action as the Museum's welfare officer, therefore, was to phone the man's widow. I really had very little idea how one was supposed to talk to someone who had lost her husband only the day before, but I did my best. Because the warder was Jewish, the funeral was the next day and I agreed to go along to it with the deputy chief warder, Brian Williamson, and a couple of the man's closest colleagues. On the way there we stopped to buy some flowers. Just as we got back in the car I remembered that Jewish funerals do not have flowers, so one of the warders took them home to his wife instead.

After the funeral service was over I spoke to the widow and asked if there was anything I could do to help. She told me that her husband hadn't left a will so could I help her sort out the financial side. I agreed but had no idea what this would entail. Back at the office I read up about letters of probate and the procedure for dealing with an intestate – something which stood me in good stead, as in the next five years as welfare officer I would deal with a further five deaths of serving members of staff.

It wasn't a pleasant part of a welfare officer's duties, though there were occasions when I felt that perhaps I had been able to help the bereaved families in some small way. After one member of staff died and I had done what I could to help, I received a letter from one of the man's daughters, in which she said:

I am writing to express our grateful thanks for all the help you have given us since daddy died. I know there must be many demands on your time and perhaps we have taken

more than our fair share but you have never hinted it. Certainly for my family you have been such a tremendous source of comfort and kindness and always with little regard for the length of time you have taken. Although I would have written anyway, I feel I must mention that mummy particularly requested that I write to you since she more than any of us has suffered at this time and I know she truly values your support. To this end I am enclosing such a small token of our appreciation at mummy's request [a box of chocolates]. She never indulges as a rule but whenever she does these are her favourites. She specifically requests that you take them home to your family and tell them that they come with kind regards from a family who feel that you are worth your weight in gold.

It found it a very humbling and moving experience reading that letter and was just so glad I had been able to help the family through a very difficult time. As much as I had enjoyed my role in M&LA, it made me feel as though I was now doing a worthwhile job that touched the lives of other people and made a real difference.

The Welfare Office itself consisted of just three people: Sue, myself and our clerical support Mena Williams, who had the unique grade in the Museum of 'clerical officer with typing'. Sue had her own office while Mena and I shared one. We were situated on the ground floor of 42 Russell Square.

The British Museum itself occupies a square plot of land in Bloomsbury bounded by Great Russell Street to the south, Bloomsbury Street and Bedford Square to the west, Montague Place to the north and Russell Square and Montague Street to the east. All the properties along the roads of the square were owned by the Museum and many were leased out as shops, houses and hotels, but some were retained by the BM and used as offices, with back entrances and access direct from the main

Museum site. Number 42 Russell Square was one of these. It was, however, in a very poor state of repair. We actually had two scaffold poles *inside* our office holding the ceiling up.

I did find the job a little difficult at first, as I had had no training and we had to cope with all sorts of problems brought to us by individual members of staff; some were work related but many were not, and I found myself having to deal with marital and other personal relationship problems, financial troubles, alcohol addiction, bereavement, housing difficulties and so on. The current school of welfare thinking was that we were there to help people help themselves, as opposed to the old familiar style of welfare officer who was the mumsy type willing to take over someone's problems and sort them out for them. Sue was definitely of the modern school and expected me to be too. Not that I could have been very mumsy however hard I tried. To this end the Civil Service Department had set up a training course in counselling for welfare officers.

The course consisted of three one-week residential sessions at the Civil Service Training College at Sunningdale, looking at general counselling and specific aspects, such as debt counselling. The chosen method of counselling was that proposed by Carl Rogers, an American psychologist whose theory mainly consisted of the counsellor reflecting back in different words to his or her client what they had just said. So, for example, if the client says, 'I feel dreadful today', the counsellor might reflect this back by saying something like, 'So, life's getting you down, eh?' By doing this, the therapist is communicating to the client that he is listening and cares enough to understand, and it will hopefully enable them to look at what they are feeling and doing in a different way. There was a bit more to it than that, but that was basically it. We were warned, however, that there might come a time when you should actively intervene and not just reflect, as the following example made clear:

Client:	I feel dreadful today.
Counsellor:	So, life's getting you down, eh?
Client:	Yes. I feel like ending it all.
Counsellor:	You feel like committing suicide then?
Client:	(moving to the open window and standing on the ledge) I'm going to jump.
Counsellor:	You feel so bad you want to leap out of the window?
Client:	Yes, here I go.
Counsellor:	Yes, there you go.

During the second week we covered bereavement and grief counselling. Part of the training entailed making us think about ourselves and how we would feel if we lost a loved one. It was a very heavy session and most of those being trained finished up in tears. Afterwards, two of the female members of our group disappeared into the ladies' toilet where they had a good cry. Two women on a different course, who were already in the toilet, saw them. One said to the other, 'They look like they're on a difficult course. I wonder what it is.' The other replied, 'I think they must be on the Internal Audit course.'

The BM also paid for me to do a year-long evening class course on counselling at Essex University. We covered many different methods of counselling therapies and it was here that I realised why the Civil Service had chosen the Carl Rogers method of counselling; it was because it was the least threatening and the one least likely to cause any damage if used by fairly inexperienced welfare officers.

During my time as welfare officer I discovered that some people just seemed to be born unlucky. If something could go wrong for these people, it did. One of our security warders, for example, came to see me on a fairly regular basis over a number of years. He had money problems, housing problems, marital problems and, finally, he had work-related problems

which eventually led to him leaving the BM. About a fortnight after he left he turned up in my office again and told me that he'd managed to get a new job as a nightwatchman. I said I was glad to hear that something had gone right for him at last. He said, 'Not really. On my first night there my wife made me some sandwiches to take and by the time I got round to eating them they'd gone off.' As I said, for some people anything that could go wrong usually did.

Another of the world's unluckiest people was someone who went off on long-term sick leave. I visited her at home several times and every time I saw her she related yet another bad experience that had happened since the last time I'd seen her, each one worse than the last. It was while visiting her to take her to the Civil Service Occupational Health Service (OHS), so they could assess her fitness to continue work or consider whether she should be retired on grounds of ill health, that I had one of my most memorable Museum experiences.

As the OHS was in central London and she lived at Stratford it was agreed I could take the Museum car with its driver, Mark Conway, to give her a lift. After returning her home, I asked her which was the quickest way back to the Museum. She told us to turn left at the bottom of her road and then gave us very precise directions on the route to take. When we reached the bottom of the road, Mark promptly turned right. I said, 'She told us to turn left.' Mark replied, 'Yes, I know, but I know a quicker way.' After a splendid journey of something like 15–20 minutes through parts of London I never knew existed, we finished up at exactly the same spot from which we had started, but this time heading in the direction we had been told to go in the first place.

We continued for a while following the directions we had been given when we came to a traffic jam, so Mark turned off the main road up a side street. I asked him if he knew where he was going and he replied that there must be a way round to

miss the traffic. We drove round some back streets for a while, once again finishing up in exactly the same place where we had turned to avoid the traffic.

The adventure still wasn't over. Driving into Dalston we neared Ridley Road, which was a street market road. Again Mark said he knew a way of avoiding the market and promptly turned into a narrow side street with cars parked on both sides. About halfway along there was a delivery van parked in the middle of the road, but Mark's consummate driving skills enabled us to very slowly edge past the van. Upon emerging from this hazard we continued up the street only to find … a dead end. As there was no room to turn round, Mark had to reverse all the way back. Only he couldn't because the van now had its cab door open, leaving no room to pass. The driver was nowhere to be seen so we just had to sit and wait for his return. Eventually we were able to get back to the main road. This quick detour had taken us something like 20 minutes to negotiate a street less than 100 yards long.

There was one more highlight awaiting me on this journey of a lifetime and that was when Mark, unknowingly, drove me past my old school, Parmiter's, in Bethnal Green.

On my return I immediately wrote to Mark's boss to ask if I could hire him for a Magical Mystery Drive every Tuesday as this exciting and eventful journey had been the highlight of all my years at the Museum. Sadly my request was denied. Over the years I got to know Mark quite well and, in spite of his driving eccentricities, he became a good friend as he was a really decent sort who would do anything for you.

About two years after my arrival in Welfare, Sue Copus was moved on to Personnel, where she became the Museum's training officer. I was put on temporary promotion but was ineligible for permanent promotion because in those days you had to be in post for four years as an EO before you could be considered.

When I took over Sue's clients I realised that perhaps she wasn't always as 'non-mumsy' as she professed. One day I went to visit one of her regulars at home who was on long-term sick leave. When I got there the person said, 'I've got the shopping list ready.' I said, 'Pardon?' She said, 'Sue always used to get my shopping for me.' She was most disappointed when I explained that I'd come to see how she was and that it wasn't part of my job to do her shopping for her.

Seeing members of staff on long-term sick leave was a big part of the Welfare Office's job. We had to liaise with the member of staff, Personnel and, if necessary, the OHS, who made the final decision on whether someone should be retired on ill-health grounds. In those days it was fairly easy to get ill-health retirement. The doctor responsible for the British Museum was Dr Peter Constable. He once said to me, 'If someone says they've got a bad back, who am I to say they haven't?' He would normally grant ill-health retirement if it was asked for. By the time I left the Museum in 2004, ill-health retirement had become a rarity and it was very difficult to put up a case good enough for it to be awarded.

Another aspect of the work of the OHS was to give general advice on working practices insofar as they might affect the health of employees. Dr Constable caused a stir in Personnel once when he described the British Museum's approach to staff in one particular department as 'neo-fascist'.

It was during my three months as senior welfare officer that we had to move offices, because 42 Russell Square was to be completely refurbished to house the newly formed Architectural & Building Services Department (A&BS). Brian Wilson, who had succeeded Cyril Berry as head of administration, told me we were being moved to yet another outbuilding, to one in Coptic Street, a few minutes' walk from the Museum front entrance, and not in any way attached to the main Museum building. I objected to this on two grounds:

the first was that it would make it more difficult for members of staff to simply 'drop in' without informing their managers where they were going. It was usually the case that personal problems were highly confidential and people who came to see us often did not want their managers to know.

The second was that it would be more difficult for me to get to the canteen on a regular basis. This wasn't as flippant as it sounds, and there were two good reasons why it was important for me to spend time in the canteen, apart from the obvious. The first was that it was where all the gossip took place and it was important for the welfare officer to know how the staff were feeling about the different issues that arose. It was the best way possible of keeping my finger on the general pulse of the well-being of the Museum and the staff. Secondly, it was a way of meeting people informally to discuss any problems they may be having and perhaps find solutions before they got out of hand.

To my amazement, Brian accepted both of these reasons and a few days later informed me that he had found two rooms in the West Residence for us. By an astonishing coincidence, both of the rooms had previously been occupied by Alan Gray. The space we were to use as our main office was the one in which I had been interviewed twenty-two years previously. The other room, which we were to use as our confidential counselling room, was the one I had been interviewed in for my transfer to M&LA.

Shortly after we moved in, Edna Adams was appointed as the new senior welfare officer. Edna had also started at the Museum in 1967, just a few months after me. She had worked in the Accounts Department and Personnel. Her approach was undoubtedly of the old school. She was most definitely of the mumsy type who would take over any problems you had and sort them all out for you. At least, she gave the impression she would. She did not go in for all this new-fangled counselling

business and helping people to help themselves. Some of our regular clients, and we had a few, were in their element with this return to the old ways. One in particular, who had been coming on and off since, well, before I was first employed as the welfare officer, became even more regular once he realised that Edna was going to do everything for him.

The first time I met him was very early on when he came to see Sue. After he'd left her office he came in to see Mena and me and said, 'I've just had a confidential talk to Miss Copus about a very personal problem.' I asked him if Sue had been able to help and he then went into great detail about his confidential personal problem to both of us. When he left our office he bumped into one of the electricians, who was changing a light bulb in the corridor outside. As he closed our door I heard him once again launch into his confidential personal problem, telling the electrician how helpful we'd been. I don't know how many more people heard about his problem on his way back to his workplace, but I suspect it was quite a few.

By the time Edna arrived he was having housing difficulties and he asked Edna if she could write a letter on his behalf to the council. He explained he wasn't very literate and he was sure Edna could explain the problem a lot better than he could. Edna, of course, agreed to do this and spent some time drafting a letter for him. When she showed it to him, he looked at it and said, 'In this first bit, I think you should say …' He went through the whole letter making numerous alterations. So much for not being very literate himself! Edna took it all in good part and changed the letter as he wanted.

She was indeed a lovely lady, but her outward gentle and caring appearance belied the fact that she was as tough as old boots and not afraid of anyone. This was made clear to me on her very first day when she took on the head of security, Ken Wright, and won. Ken had a fearsome reputation as a dictatorial authoritarian who ruled the security staff with a rod of

iron and was most definitely not to be messed with. A short time before, there had been an inspection of the Museum by the local fire service. They had found a fire escape door locked and had asked Ken why. He said it was because there were Museum objects in the room on the other side. The fire brigade said he had to keep the door unlocked in case of fire. He refused. The fire chief asked, 'What will happen to people in here if there is a fire?' Ken replied, 'They'll just have to fry.'

On Edna's first day she received a request from a gallery warder for welfare support in allowing him to park his car in the Museum car park, which was at the front of the Museum. The director was trying to limit the amount of cars parked on the forecourt and by this time only two categories of staff were allowed to park there; the first were the security warders because they worked night shifts and had to travel in at times when there was little or no public transport. The second category were those allowed to park on welfare grounds. Parking permits were issued by the Security Office and, until Edna's arrival, it was recognised that Ken Wright had the final say and could turn down a welfare recommendation if he felt so inclined.

Edna phoned Ken and told him that she was recommending this particular warder be given a parking permit as he had difficulty walking and she thought he needed to drive in. Ken said that if he had difficulty walking he shouldn't even be working as a gallery warder, let alone be able to park his car on the forecourt, and he declined to issue him with a permit. Edna said that when she said she was recommending a permit on welfare grounds, she did not mean it was open to challenge by someone who had no qualifications in welfare. 'Mr Wright,' she said. 'You will issue the parking permit at once. I am sending the warder up to see you now.' And just put the phone down. The warder got his permit.

Over the next couple of years there were several run-ins between Edna and Ken Wright but she emerged triumphant

on every occasion and became the warders' heroine. Edna was afraid of no one and on some occasions took on her immediate boss, Barbara Hughes, as well as others higher up the chain, invariably coming out on top. Her mumsy image to the staff belied a very tough and clever lady indeed.

Edna's only downside, as far as I was concerned, was that she was an absolute believer in astrology and considered that whichever star sign you were born under had a bearing on the type of person you were and how you would behave. I even heard her on the phone one day saying to someone who had rung up with a relationship problem, 'Well, what do you expect, dear, he is a Sagittarian.'

As well as dealing with individual cases, we had a remit to look after the general well-being of the staff and to keep an eye out for any 'trouble spots'. In 1989 both Edna and I felt we were seeing a disproportionate number of staff from the new Architectural & Building Services complaining about their working conditions and their treatment by some of their managers. Because of this we asked Chris Jones, who had just taken over from Brian Wilson as head of administration, if we could look into the structure and working practices of the whole department and produce a report. He agreed and we arranged interviews with individuals and groups in A&BS.

One person we were not looking forward to interviewing was the head of the building maintenance section, Bill Lawrence, as he had a reputation for endlessly keeping people talking. Apparently the record interview with one of his own members of staff stood at over four hours. At the appointed time, Edna and I left our office to go and meet him and told Laura (Laura Davies, our new clerical support who had taken over from Mena) to ring Bill after one hour if we were not back and tell him that we were both needed urgently in the office.

We found him to be a very pleasant individual who spoke with a soft West Country burr, but true to form he chattered

on, giving long-winded answers to our questions, changing the subject without warning and then returning to the original topic. We could see why interviews with him normally took hours and were glad we had primed Laura to get us out by telephoning us.

After exactly an hour Bill's phone rang while he was in the middle of one of his rambles. To our horror he continued talking and made no attempt to pick the phone up. At last I said, 'Shouldn't you answer that, Bill? It might be important.' He picked it up and said, 'Okay, yes, okay', and put the phone down. He then carried on talking to us. Edna and I looked at each other but we couldn't let Bill know we knew it was Laura. We seemed trapped. Eventually after about five minutes Bill said, 'Oh, by the way, that was Laura on the phone just now. She said you're both needed back in the office.' A great feeling of relief overwhelmed us and we stood up immediately. Edna said, 'Thank you, Bill, it's been very interesting. Thank you for your time.' We made for the door, then out to the passage and down two flights of stairs to the exit. Bill followed us all the way, still talking until we finally escaped the department.

Our report on A&BS found that the main problem was the lack of direction and encouragement for the junior staff. When the department had originally been structured the admin team consisted of an HEO with two EOs and several COs. By the time the department was actually formed the HEO post had been upgraded to SEO and given wider responsibilities, leaving him unable to keep a close watch on the two EOs, who, in our opinion, were both poor staff managers and needed much closer supervision and direction. One of our recommendations was to reinstate the HEO admin manager post. After further discussions with the department and central Museum management, our recommendation was accepted.

The previous year I had been successful on a HEO annual promotion board. The Museum had instituted a new promotion

procedure so that instead of boards being held as and when a post became vacant, they now held annual boards with three or four people being promoted to a grade rather than a specific job, so that when a job became available in that grade they would slot into it straight away.

At the board on which I sat, one of the board members, Dyfri Williams, later keeper of Greek & Roman Antiquities, asked me what I would do with the Reading Room once the British Library finally moved out to its own premises. I knew that two proposals had been put forward: one was to central-ise all the departmental libraries in the Reading Room, and the other was to house the Ethnography departmental library which now included the library of the Royal Anthropological Institute in it. I mentioned both of these possibilities but said I didn't think either of them would work as, firstly, I couldn't see the departments willingly giving up their libraries to which they currently had easy access, and secondly, I thought the Reading Room was such an iconic symbol of the British Museum that it would be wrong to turn it into a library for just one department (Ethnography), however large it was. At the end of my answer, I added, 'I don't suppose that's much help really, is it?' Dyfri told me not to worry, adding that no one in senior management had any idea what to do with the Reading Room either, so they were asking applicants on this board just in case they came up with any good ideas.

The upshot of the board was that I was promoted to HEO. So when the new post in A&BS was created, I was slotted into it. Therefore, as luck – for good or ill – would have it, I now had the job of implementing the report I had written as wel-fare officer.

INVISIBLE GREEN RAILINGS

Until the 1980s, the British Museum building itself was looked after by central government, firstly by the Ministry of Public Buildings and Works (MPBW) and then by the Property Services Agency (PSA). The Museum had its own small team of administrators who liaised with MPBW/PSA, plus a number of craftsmen, including locksmiths who had to be BM employees because of the nature of their work.

A couple of the people who worked at the Museum in the old MPBW and PSA times were Clem Horton and another man universally known as Mushy. I never did know his real name. Clem was a general maintenance man on twenty-four-hour standby in case of emergencies. At one time he actually had a flat onsite so he could respond quickly if he was needed. And he seemed to be permanently needed. In fact, he earned so much overtime as a result that he became the highest paid person in the Museum. Questions were even asked about his take-home pay in Parliament.

Mushy was never happier than when he was romping about in the sewers getting covered in filth and muck, to put it politely. He used to boast how he knew his way round every inch of the sewers under the Museum, which, incidentally, included the old Holbourne section of the River Fleet. What

he did down there is anyone's guess, but if there were ever any blockages, Mushy was there with his plunger like a rat up (or should that be down?) a drainpipe.

In the late 1980s, the government began to break up the PSA as part of its public expenditure cut back and made each government department responsible for its own estate and works management; hence the creation of a whole new department, the Architectural & Building Services, at the British Museum.

A&BS was divided roughly into three main sections. The first was the architectural section which looked after significant new projects – new galleries or major rewiring projects, for example. The second was the Works Office which looked after maintenance and small works. The third was the accommodation section, which looked after the estate, the allocation of rooms and provision of furniture, along with all the cleaning and labouring services. We were situated at 42 and 43 Russell Square, although the head of our section, Ken Stannard, occupied an office in the New Wing, almost as far away from his department as could be.

By the time I took up my post as the new HEO in late 1992, one of the EOs we had criticised in the Welfare Report had moved to another department, while the other had been moved elsewhere in A&BS. A newly promoted EO now headed up the admin support team for the building management section.

The first thing I did was speak to all the staff for whom I was now responsible, which numbered eleven in total, a big increase from when I was welfare officer. The new EO, Erwin Quistorff, known as Olly, had been promoted from CO in the Photographic Service. On talking to him I could see he was completely different to the two EOs I had previously met. He was sharp, intelligent, knew exactly what he was doing and, in complete contrast to his predecessors, appeared to be an excellent staff manager. This was confirmed when I spoke to the AOs who worked for him. (Clerical officers and clerical

assistants had just been renamed administrative officers (AOs) and administrative assistants (AAs).) Olly was in charge of the Works Support Team, whose job was basically to take requests for maintenance and small improvement works from departments, pass them on to the technical officers and then pay the invoices for any work undertaken by outside contractors. Originally all this had been tracked by handwritten records, but not long before I arrived the section was computerised and became one of the first parts of the Museum to have computers.

The AOs working for Olly included Geff Cooper, who I had known for many years. He was about my age and was one of the nicest people you could ever hope to meet. He was willing to do anything for anyone. His most remarkable asset was his ability to remember telephone numbers. If you needed someone's number it was usually quicker to ask Geff than look it up in the telephone directory. Another member of the team I had known for some years was Graham Austin. Poor Graham was a nice enough bloke but he had an enormous chip on his shoulder and reckoned that both Barbara Hughes and Huw Evans (one of the HEOs in Personnel) had it in for him, for a reason that I never discovered, and that because of this he was resigned to the fact that he would never be promoted. In that respect he reminded me of Jack and Bernard from my very early days at the Museum.

Diane Talbot-Lamonte was the AA support to the team. She was married to one of the gallery warders, Buddy Lamonte, and was most noted for the number of pies she consumed during the day.

After speaking to the Works Support Team I then spoke to Trish Gibbs, who was now the only AO working directly for the other EO, Hannah Reeves. Her job was similar to that of the Works Support Team but as support to the architectural section. Trish didn't have a good word to say about anyone, especially Hannah.

Next up was Hannah herself, one of the EOs we had criticised in the Welfare Report. She came to my office and spoke to me about her job for what seemed like hours. When she had finished I had absolutely no idea what she'd been talking about. She had definitely been speaking English – I recognised the words – but it was as though they were put together in some random order and not designed to make any sense. I later discovered that Hannah had another interesting characteristic, which was that she was the Mrs Cropley of A&BS. *Vicar of Dibley* fans will know what this means, but what it meant to us was that whenever we had a small celebration – birthday party, leaving do or some such – Hannah would turn up with some strange concoctions to add to the food. Most times she took away as much as she'd brought, apart from the samples she'd eaten herself.

My next call was to the Works Stores, as I was responsible for that too, and spoke to the two store men. Their main topic of conversation was that they both felt their jobs were undergraded and that they should be promoted. Lastly I saw the departmental typist, Ros Isaie, who seemed a pleasant enough young lady; but then I was yet to see examples of her typing.

After doing my rounds I went to see my new boss, Martyn Tillier, the SEO, whose main responsibility, apart from being the line manager for all the administration staff, was the Museum estate itself, dealing with all the leased-out properties and our own outstations, of which there were three at this time: Orsman Road in Hackney, which housed parts of P&RB, Ethnography and Conservation; a store in the old Post Office Savings Bank building at Blythe Road, Hammersmith, which we shared with the Victoria & Albert Museum and the Science Museum; and the Museum of Mankind in Piccadilly. The main concern I expressed to him was my complete inability to understand what Hannah had said to me as I thought this must be, in some way, my fault. He brushed my concern

aside saying, 'I wouldn't worry about it. Hannah's a lovely lady but no one can understand what she's talking about. It's not just you.' I wasn't sure whether this was comforting or not, seeing as I would have to work with her.

After meeting my own staff I then went round getting to know the rest of the department. The Works Office itself was divided into two sections, building fabric and utilities, both under the overall control of Bill Lawrence. My first stop was to see John Johnson who was the higher professional and technical officer (HPTO) in charge of the fabric side. John made Eeyore seem like a confirmed optimist. His view of life and his work seemed to be that if something could go wrong, it undoubtedly would. A barrel of laughs he most certainly was not.

Under him were five professional and technical officers (PTOs), all of whom were long-time BM employees. Two had been locksmiths, two joiners and one, Rod Kidman, a museum assistant. On my initial wander round the offices to meet my new colleagues, the very first thing Rod did was to show me his college certificates which he had framed and placed above his desk and, in case I'd missed it, orally reinforced the point that he had come first in his class.

I then moved on to the utilities part which was under Len Packman, another HPTO. Len had transferred over from the PSA when it was broken up. Below him were three PTOs, Phil Sturgeon, Kevin Rogers and Rick Mears, all of whom had also transferred from the PSA. Phil and Kevin were both quite young and had worked together at the PSA, where they had become good friends. They were very friendly, helpful and extremely competent at their job, although Kevin's whole physical demeanour and appearance seemed for some reason to exude an air of complete incompetence, but this was only a facade. Phil spent some time in my first few weeks showing me round parts of the Museum I had never come across before, such as the boiler rooms and the switch rooms, which

was very helpful to me as I was then able to understand where problems might arise and the work involved in putting them right. I found myself on good terms with Phil and Kevin and they became my new 'canteen partners' on most days. Rick Mears was older than both and, without being too unkind to him, often had to be helped out by them.

Kevin's competence was put to good effect when we decided to completely refurbish the Works Support Team Office. Initially the project was jointly managed by Rod Kidman and Rick, but it soon became apparent that under their joint management the whole project was going to take far longer to complete than seemed reasonable, Rod's certificates notwithstanding. In the end, we took both of them off the job and replaced them with Kevin, giving him sole charge of the project. Once he was on the job things got done quickly and efficiently and the new office was ready in next to no time.

A new PTO was appointed shortly afterwards, Huw Rees, a fiery Welshman. He was a top-class rugby referee and although only small in stature, I could quite understand how he managed to keep large, hulking rugby players in order. Being from the South Wales Valleys, Huw's political views were very close to my own and we became good friends.

Below all the PTOs in both sections was a whole host of basic grade tradesmen and women, electricians, joiners, carpenters, locksmiths, plumbers, painters and so on. The most interesting group was the electricians, led by Dave Edmunds, who seemed to spend more time offering watches, trainers and other goods for sale than he did replacing light bulbs. One of his colleagues was universally known as 'Lurch' for his obvious similarity to the character in the old television series, *The Addams Family*. Another interesting character was Malcolm the plumber. He was a well-built gentleman who had great difficulty in getting into the small spaces plumbers often had to work in. There were also two window cleaners

who hardly ever seemed to clean any windows above ground level, as health and safety rules dictated that there had to be two of them working together if they needed the ladder to get to upper-storey windows, which they frequently did. What with annual leave, sick leave and sometimes special leave, it was quite often the case that only one of them was on duty on any particular day, so the higher windows had to remain unwashed.

The architectural section was headed by Chris Terrey, who had taken over from Chris Walker after the latter's retirement. The project officer for the major electrical projects was Keith Gofton. Keith was a great one for thorough, exhaustive and exhausting preparation before starting on any practical work. There seemed to be endless meetings and paperwork before so much as a screwdriver was turned. He would produce reams of reports, graphs and charts (pie, bar, line, column, step, dough-nut, range, circular, vertical, horizontal … it didn't matter what sort, Keith loved them all). His favourite task was producing milestones. He drove his PTO, Gordon Dewar, to distraction with all this. Gordon just wanted to get on with the job but was often frustrated by Keith, who insisted that he get the paperwork right first.

Gordon was a good friend of Phil and Kevin's, and through them I got to know Gordon well, in the end probably more than I did Phil and Kevin. He was about the same age as them and built like a rugby player, which, indeed, he was. He had a good sense of humour but, when we met in the canteen, he often had to get his latest frustrations with Keith out the way first before he could calm down and join in the banter. Whenever anything went wrong, he would shake his head sadly and sigh ruefully, 'It'll all end in a meeting.'

As might be imagined, Keith was a very serious sort but a bit unworldly. His teenage son was a Manchester United sup-porter and the first Christmas I was there, Keith tried to find him a Manchester United football shirt for his present. Unable

to do so, he bought him what he thought was the next best thing: a Manchester City shirt. Keith couldn't understand why his son wasn't happy with the present, nor why Gordon, Phil, Kevin and I found this story so funny.

There were two HEOs in the accommodation section: my old friend from Director's Office days, Ron Wallom, and Eileen Myhill. As we were his three senior administration managers, Martyn called us all together shortly after I arrived and said we would have regular admin team meetings so we could report on what was happening in our area, discuss any problems we might have come up against and plan for future work. This sounded like a good idea, but the first meeting was the one and only admin team meeting we ever had in all my eight years in the department.

As well as getting to know my new colleagues I also came across a couple of people from my early days at the Museum who I hadn't had anything to do with since leaving the Stationery Department and Reading Room Admissions back in 1969. The first was George Morris, who was now museum secretary. About a month before he retired the Museum appointed his successor, Claire Parker, so that she could work with him in a handover period and get to know the ropes. After she'd been there a couple of weeks she phoned me up and said she would like to discuss redecorating her office when George left. She asked me to meet her outside the office so we could go and have a look at it. I took Ben Lilley with me, who was in charge of the painters and decorators, and we duly met outside the office. She said that she would like us to take a look inside the office and see what we thought about redecorating and get an idea of the dimensions. However, she said that George was in there and she didn't want to offend him by making him think that she couldn't wait to get him out. She suggested we go in and pretend to look at one of the light bulbs, which was not working, and take a crafty look

round while we were there. So, she knocked on the door, put her head round and said, 'George, I've got a couple of people here from Works to look at the lights,' and showed us in. The room was decorated in 1950s-style wallpaper, in keeping with the fusty, old-fashioned museum air George still seemed to exude in spite of all the changes that had taken place over the last forty years.

While we were looking at the light and trying our best not to look as though we were studying the walls or weighing up the dimensions of the office, George got on with some work and completely ignored us. As we went to leave, he looked up and said, 'Oh, Claire, while they're here, why don't you get them to look at redecorating the room? I'm sure you don't want to be stuck with my old-fashioned ideas after I've gone.' It was nice to see that George hadn't lost the dry sense of humour from all those years ago when he'd brought back Lenin's signature.

The second old acquaintance was Gordon Barber. We hadn't spoken since my enforced move to NRLSI, Holborn. He was now the SEO in the Design Office, which we naturally had a lot of dealings with due to gallery refurbishments and work that affected the public areas generally, so Gordon and I had to converse frequently. Fortunately there was no problem and everything from my younger days was forgotten. Talking of the Design Office, our proposed works often clashed with their idea of corporate design and good taste. Len Packman in particular seemed to be locked in continual battle with one of the senior designers, Geoff Pickup. One incident had to go to arbitration and be decided at the highest level, and that was the refurbishment of the Front Hall lift. To comply with the new Disability Discrimination Act (DDA), Len proposed putting a bar with the controls on around the lift at waist height so that a wheelchair user could access them. Sadly this did not fit in with Geoff's idea of a well-designed wall and he opposed the

idea. After several meetings, letters and emails, the matter was referred to central museum management who took the view that the DDA must come first.

And so for a while things drifted along quite happily. Olly had things under control in the Works Support Team, Hannah was doing whatever it was she was doing, I was catching up with old acquaintances and enjoying my canteen life with Phil, Kevin and Gordon, when suddenly, we were hit by a human dynamo in the shape of Terry Giles.

It had been decided by the powers that be to separate A&BS into two distinct divisions and to create a completely new department from the Works Office section to be called the Building Management Department (BMD). Terry arrived from BT to head up this new department.

Right from the start he created waves at the Museum. The BM was very backward in introducing office computerisation and there were still very few computers around the place. Terry had come from BT, where computers were the norm rather than the exception, and he was appalled by the lack of IT, so he went out and bought a standalone desktop computer from the departmental budget and put it into the small general office we had upstairs where it could be accessed by himself, Bill Lawrence, Hannah, Trish and me most easily, but by anyone who wanted to in general. In practice only Terry and I used it. However, when it came to the attention of the head of the IT section, Ted Neville, it was as though anarchy had broken out in the hallowed halls of the British Museum. He demanded that we stop using the computer as only he, Ted Neville, could authorise the use of new computers. Terry wrote to Chris Jones and said, 'Either I can put the computer in the cupboard, write off the money spent and never use it again, or I can use it to make my department more efficient. Your choice.' Chris wrote back saying we could continue to use it but in future all requests for new computers had to go through the IT section.

A few days later, Ted came over to look at our heresy. At the time, what few computers the Museum did have operated on the old DOS system; ours was the first to operate Windows – Windows 3.1 to be precise. I said to Ted that Windows was a much better system and he shook his head, saying, 'I don't think so. Windows will never replace DOS.' I looked at him with some scepticism and asked him what computer he had at home. The head of our IT section replied that he didn't have one at home and couldn't see himself ever getting one.

A little while after this episode, Ted Neville, the man who wouldn't have a computer at home, caused outrage amongst the curatorial staff by writing to them and suggesting that when they buy computers for their own use at home they should make sure they were compatible with the Museum's computer system, such as it was at the time. Apparently his preferred option was for them to buy Wyse/Primeword-compatible equipment which would set them back about £1,900 as opposed to the £400 needed for a cheap Amstrad. After receiving a strongly worded letter from the IPCS, no more was heard of this suggestion.

Within the next few years computers were introduced throughout the Museum and it soon became commonplace for everyone to have one on their desk. However, some people were able to adapt to this new technology quicker than others. This was apparent one day when one of the PTOs for some reason decided to take a look at the *Daily Star* web page on his computer. On hearing someone opening the door to his office he tried to close the page quickly but couldn't manage it. Fortunately it was only Kevin, who tried to help him close the page, but they only succeeded in initiating a string of pornographic pop-ups on the screen.

Meanwhile, the Terry Giles revolution continued. Part of his plan for BMD was to make it more proactive and not just wait for departments to send in requests. To this end he organised

John Johnson, Len Packman and myself into a team and we were to go out and find problems and jobs that needed to be done. John and Len were to spend part of their time inspecting the fabric and utilities to see where repairs and modernisation were needed, while I was to start a regular round of visits to departments to discuss their mid- to long-term 'wants' lists, as well as their immediate concerns. In this way, Terry was able to draw up a properly budgeted, rolling three-year plan of work rather than just react to circumstances.

Having come from a more commercially minded institution, Terry didn't quite cotton on to the more settled expectations of Museum staff. For the first time, probably ever, the '90s was a time of some uncertainty at the Museum with regard to the idea of a job for life. The unmentionable word 'redundancy' was being whispered in the corridors of power and rumours began to spread to the shop floor. Terry returned from a meeting of senior BM management to address a meeting of all BMD staff to tell them that he had 'good news' for them: their jobs were all secure for at least a year. He was completely unprepared for the reaction to this statement. In his mind this was indeed good news, but to BM staff, used to the idea of a job for life, it could only mean one thing, that after a year they would be made redundant, and many of them expressed their feelings in no uncertain terms. Afterwards he called me to his office to say how shocked he was by the reaction. Where he came from, telling people their job was safe for at least a year was cause for celebration. I explained to him as best I could the difference between the BM and BT. He took the point and never made that mistake again.

Apart from that initial faux pas, Terry proved that as a staff manager he was undoubtedly one of the best the Museum had. Possibly his greatest asset in this area was the fact that he could discern the strengths and weaknesses of his staff and play to those strengths as much as possible by allowing people

to do what they did best, delegating responsibility where he felt comfortable and giving extra training where necessary to resolve the weaknesses.

Terry also liked to push his staff to see what they were capable of and was quite prepared to trust them to take on work outside their normal sphere if he felt they could cope with it. This happened to me not long after Terry's arrival, when John Johnson retired. For the most part, project management of building fabric projects was delegated to the PTOs until a replacement for John could be found. But there was one project which Terry knew had the chance to show BMD off to the rest of the Museum as well as the general public, and that was the repainting of the Museum railings and front gates, the first thing that any visitor saw when they approached the Museum's main entrance.

To my complete surprise he decided to allocate management of this project to me. I had never done anything like this before in my life. In fact, my wife thought that just giving me the job of Works Office manager in the first place had shown that the British Museum had a great sense of humour, as my attempts at maintenance and small works at home were legendary and gave DIY a whole new meaning: destroy-it-yourself. Actually giving me a complete works project of my own to manage made her reconsider the idea that the BM had a good sense of humour, and she now thought it was far more serious than that – the Museum had fundamentally taken leave of its senses. Nevertheless, I felt that if Terry was prepared to take the chance, I was certainly prepared to do my best.

The first problem was that the Museum is a Grade I listed building, which meant I had to match the colour of the railings exactly. The railings may look black but in fact they are painted in a colour known as 'invisible green'. So the first thing I had to do was find a company that made such a colour. Once I'd done this, the next problem was liaising with our

painters and the Museum's Public Relations Department over the poster cases which were attached to the railings. Obviously they had to be taken down, but equally obviously the Public Relations Department wanted them down for as little time as possible, so I had to work out a rolling programme to allow for the posters to be taken down one or two at a time while each section was painted.

It was this aspect of the work that caused me the most problems as sometimes the painters took longer than estimated and Public Relations got very impatient, even threatening on a couple of occasions to put the poster cases back before the painters had finished the section. This was, of course, completely unreasonable and they eventually saw sense, but I realised then that maybe this was why Terry had asked me to handle the project – because of my trade union negotiating skills.

Terry himself was a workaholic. He would come in early and leave late and his secretary, Dee Hillen, used to dread his going away on holiday because this was the time he did the most work. He would use his time, usually in France, to write up reams and reams of paper for reports on all aspects of BMD work. We always knew when Terry was about to go on holiday because Dee would go to the Support Team Office to ask for a couple of 100-leaf A4 pads. Although she could relax a bit while he was actually away, she had to work overtime on his return to type up his reports. Terry himself worked all hours and days under the sun, but he never expected his staff to do the same. He was quite happy for us to do our conditioned hours and never once put demands on us to work extra hours if we didn't want to.

Terry's success with the department was obvious to everyone and senior Museum management decided to expand the department to include not only Keith Gofton's section of A&BS, but also the whole of Security, including the gallery and security warders. Terry now had responsibility for well over

half the Museum staff. He instituted a regular monthly meeting for the heads of all the individual sections: Len Packman, Peter Newman (John Johnson's replacement), Ron Wallom, Keith Gofton, Brian Williamson (now head of security) and myself. In keeping with his belief in delegating responsibility, we all took it in turns to organise the meeting – that is, arranging the room, the agenda, the reports, the minutes and the refreshments. The meetings were always held at 9 a.m. on the appropriate day.

There were varying degrees of cynicism amongst the group about Terry's management style and the need for these regular team meetings. Keith loved the idea, of course, while Brian was the most cynical. The first time it was his turn to organise the gathering he arranged for one of the gallery warders to act as doorman to the meeting room and dressed him in the traditional Windsor uniform which was worn only on very special occasions, for example when the queen or other distinguished visitors came to the Museum. He also arranged for coffee, croissants and Danish pastries to be served by two more of his warders. Everyone else had just arranged coffee and biscuits. This over-the-top staging was Brian's way of putting two fingers up to Terry's management style; although the Danish pastries were very nice!

One side effect of taking over Security was that we got caught up in emergency planning and bomb threats. This was the period of much IRA activity, of course, and one day the Museum received a phone call from a woman with an Irish accent. The conversation went like this:

Caller: I've got a bomb and if you don't pay me £5,000
 I'm going to blow up the Museum.
Operator: Where are you?
Caller: If you don't believe me, I've got the detonator
 here in my hand. I'm going to do it.

Operator: Where are you?
Caller: I'm in the phone box in the road. If I don't get
 the money I'm going to blow the lot of you up.
Operator: Which road?
Caller: You don't expect me to know that, do you?
The caller then hung up.

Although this was obviously a crank call, we did receive a
number of threats that had to be taken more seriously and, on
occasion, the Museum was closed and the staff and public evac-
uated. During one of these evacuations, with staff and public
pouring out of the front gate, I witnessed a man trying to get
in. The warder on the front gate stopped him and explained
there was a security alert and he couldn't come in. The man
replied, 'I'm a trustee.' The warder said, 'You'll be just as dead
as anyone else if the bomb goes off', and refused to let him in.

At about this time the Museum set up an Emergency
Planning Committee, chaired by Chris Jones and made up
of senior Museum management, including Brian Williamson,
and senior keepers. I was appointed secretary of the commit-
tee. Our brief was to plan for the aftermath of an emergency,
whether it was a bomb explosion, a bad fire, floods or what-
ever. We organised an Emergency Control Centre in one
of the Museum offices and held several exercises. For some
reason there was a persistent rumour going round that Brian
Williamson was a Jehovah's Witness. To try and disprove this
notion, one of the scenarios dreamt up by Brian for an exercise
was to have a group of visiting Jehovah's Witnesses decimated
by a bomb blowing up in the Front Hall. It was an interesting
set-up but did nothing to dispel the story.

We put a lot of effort into ensuring our planning was
immaculate, but it always seemed to me that if ever there
was a real emergency we would never be able to put the plan
into operation, as the Museum would be taken over by the

emergency services, most notably the fire brigade and the police, and we wouldn't be allowed within a mile of the place. I suggested that we should have our Emergency Control Centre off site so that, in the event of anything ever happening, we would at least have somewhere which could act as an information point for staff. One of the local hotels kindly allowed us use of one of their rooms should the worst ever happen.

Back in the department, Terry, who was well versed in various theories of management and loved going on, and sending all his managers on, different courses and seminars, asked Len, Peter, Keith and me to investigate different management theories, models and systems to see which of them we should introduce into the department. We were on the verge of deciding on ISO 9001, which set out a requirement for continual and planned improvement of its quality management system. This was in line with Terry's favourite saying: 'If you always do what you always did, you'll always get what you always got.'

In the end, however, Terry decided we should go for the Investors in People (IiP) award as this was more staff orientated. To this end he set up an IiP steering committee drawn from all sections and levels of staff. I was to act as secretary and team co-ordinator. Once again there was plenty of cynicism about this but there is no doubt that along the way we did introduce a number of things that showed the staff they were appreciated and not just treated as cogs in a wheel. Probably the best example of this was setting up training courses for the cleaners and labourers and awarding certificates at the end of them. Many of them had no educational qualifications and had never received a certificate in their lives. They were very proud of their certificates and it gave them a real sense of worth, which was good for them and, of course, good for the Museum.

Another positive outcome of the IiP process was the introduction of a departmental newsletter, which I edited. This

was a monthly double-sided A4 magazine which contained news of what various parts of the department were up to; new appointments, retirements, promotions, exam successes and so on. It brought a real cohesion to the department, which, although composed of many disparate elements, could see that, in Terry's best loved term, we were a team all working to the same end. It also gave publicity to individuals who were successful in internal and external exams, which gave them a good feeling that their efforts were being noticed.

In spite of the new spirit of team building, there remained, for some reason that I never really got to the bottom of, an enmity between the carpenters and the labourers, with the carpenters forever playing practical jokes on the labourers. An example of this happened one day when my cousin Ian, who was a labourer, needed to use one of the toilet cubicles. While he was there a voice shouted, 'Ian, are you in there?' He replied, 'Yes.' The next thing he heard was laughing and then a loud hammering noise. The carpenters nailed three planks of wood across the door, trapping him in the cubicle. It was half an hour before he was released.

Another time the carpenters decided to fill the locker of another labourer, Dave Prince, with a bin of sawdust. When he opened it, the sawdust fell out and covered him from head to toe. Dave seemed to be a particular target of the carpenters as on another occasion he was tied to a four-wheel barrow with one of the long toilet hand towels that pull down from a dispenser and left outside the Security Office with a ransom note on him, which read: 'To release this man, hand over £500.' Wayne, another of the labourers, was held on top of one of the carpenters' benches while another carpenter hammered nails through his boots, nailing him to the bench by his feet.

But it wasn't just the labourers who felt the full force of the carpenters' practical jokes. Harry, who was one of the window cleaners, used to keep a garden gnome outside the Portakabin

which he used as his office. The carpenters blacked its eyes out with tape and put it on the roof. They then sent a ransom note with a picture of the gnome attached, asking for £25,000 in used notes. Harry failed to see the funny side, but the carpenters found it all hysterical.

As I mentioned above, my cousin Ian worked at the Museum. In fact, two other members of the Jacobs clan worked there as well. Another cousin, David, worked, and still does at the time of writing, as a messenger and my Uncle Joe, Ian's father, worked as a gallery warder. During his interview he had been asked if he knew anyone who worked at the BM. He said he didn't. He told me afterwards that he thought if he mentioned me he wouldn't get the job!

At about this time there was a feeling around the Museum in general that communication was quite poor, both vertically, to and from the centre, and horizontally, between departments, and there was a feeling that 'they' didn't listen to the staff – 'they' being central management. To try and overcome this, Chris Jones set up a small committee composed of representatives from different disciplines and different grades to look at how communications might be improved. With my experience as BMD's IiP project co-ordinator I was chosen as a member of this committee. After listening to the views expressed at a couple of meetings I produced a paper to focus the committee on a number of issues.

Among my proposals was the suggestion that, firstly, the Museum needed a new post of internal communications manager; secondly, the Museum should produce a weekly newsletter along the lines of BMD's newsletter to replace office notices; thirdly, there should be regular meetings between representatives of departments so that news of what each department was working on or involved in could be disseminated throughout the Museum; and fourthly, the BM Handbook should be completely revised, updated and

reissued. The BM Handbook had first been produced in the 1970s. This was given to all members of staff and set out the main terms and conditions under which we worked. It was, however, written in 'Civil Servicese' which made it quite difficult to understand and, in any case, had not been updated for at least fifteen years.

As part of my paper I gave examples of where I had been involved in introducing similar ideas – BMD News and our own BMD team meetings, for example – to show that they worked. I found out some time later that after reading my paper, Chris Jones contacted Terry Giles and told him that it had the effect of not only writing out a job description for a new post but also doubled as an application for it.

Most of my proposals were accepted by the committee and subsequently by Chris, although he felt the internal communications post would only take up 50 per cent of someone's time. Shortly afterwards, a new SEO post in Personnel was advertised – 50 per cent of the time to be responsible for internal communications, and the other 50 per cent as line manager for the welfare and training sections.

Naturally I applied for the job and, to my great delight, I was successful. Not only did this mean that I had now been successful every time I had gone for promotion – three out of three – but it was also the third time I had got a job for which I had been partly responsible for creating the opportunity to apply for in the first place – Medieval & Later, A&BS and now Personnel.

II

FINANCIAL DIFFICULTIES & REDUNDANCIES

When I left the Welfare Office for A&BS it became possible for me to be involved in the union again and I was elected chairman of my new union, the SCPS (formerly the SCS), though I never got involved to the extent that I had been before. As welfare officer it had been, of course, inappropriate to be active in the union. My last major act in the CPSA before I became welfare officer was to take part in the campaign to prevent museum charges being introduced again. After the failure of the Ted Heath government's proposals in the early 1970s to bring in compulsory charges, the Thatcher government tried a different tack and instead passed legislation enabling museum and galleries to introduce charges if they wanted to. One of the first to introduce a charge was the Victoria & Albert Museum.

On the day charging began a protest was held outside the V&A, which included some prominent people from the worlds of politics and the arts, including former and future arts ministers Baron Jenkins of Putney and Tony Banks, and the Oscar-winning writer Colin Welland. I was there along with a few colleagues from the British Museum. Obviously we did not stop the V&A bringing in charges but we made our point and there was a good deal of news coverage of our

protest. BBC News featured short interviews with Tony Banks and Colin Welland with the V&A director, Roy Strong, who I thought was absolutely pathetic. He did not justify the decision to introduce charges, instead he just railed against what he called the 'rent-a-crowd' protesters outside, giving us no credit at all for feeling very deeply about the issue. He seemed to think it was all some Trotskyist plot just to get at him personally. As if we cared.

All the large national museums except one eventually went along with charging. That one exception, I am very pleased and proud to say, was the British Museum. Our trustees and the director, David Wilson, took a very firm stand against charging on principle and were often to be found at the forefront of the public argument. (In fairness, I should point out that the three major art galleries, National, National Portrait and Tate, also refused to bring in charges.)

Soon after the V&A protest I took up my post as welfare officer and gave up my union activities. For at least the previous fifteen years I had always been thought of around the Museum as the 'Union Man', but that accolade now passed to Kevin Coombes, one of the greatest characters I came across in my thirty-seven years at the Museum. Before giving up the union I had worked with Kevin both in the CPSA and on the Trade Union Side. He became CPSA branch secretary in 1984 and then TU Side secretary shortly afterwards. There is no doubt that Kevin worked tirelessly on behalf of the members but his approach was somewhat reminiscent of the proverbial bull in the proverbial china shop. It soon became apparent to everyone that Kevin's dictionary was missing the word 'compromise'.

I can still vividly recall two negotiations with management we undertook together. The first was after the CPSA annual conference had carried a motion calling for the making of tea and coffee for their boss to be removed from the job description of personal secretaries. Kevin and I went to see

Brian Wilson to ensure this was implemented throughout the Museum. While we were in discussion, Rita Talbot, Brian's secretary, looked in and asked us if we'd like tea or coffee. Before I could say anything, Kevin looked up and said, 'No, we don't, and you shouldn't be asking.' Shame really; I was gasping.

The second was when we were discussing another matter with Brian. Suddenly there was a loud beeping sound. We all looked at each other wondering what it was. Brian said, 'Maybe it's the fire alarm', and went out to investigate. As soon as he had left the room, Kevin reached inside his jacket pocket and took out a small cassette recorder. The beeping sound had been the warning sound from the machine to say that the tape was coming to an end. I looked at Kevin in some amazement. He said, 'I thought I'd better record what Brian was saying so he can't get out of any agreement we make. You can't trust that bastard.' He just managed to turn the tape over and put it back in his pocket before Brian returned.

After my promotion, Kevin's first solo act in his private battle came when the CPSA was involved in a dispute over the introduction of new technology. Until the 1980s, practically all typing work was carried out either by typists or personal secretaries. With the introduction of word processors it became possible for the originators of various documents – letters, reports, minutes and so on – to type them out themselves. The CPSA were very unhappy about this as, of course, it could lead to a loss of jobs amongst typist members. Kevin set out not so much to negotiate the introduction of word processors and other forms of computerisation as to stop them altogether. When a couple of word processors appeared on the desks of Personnel staff in their general office, Kevin took this as a personal challenge and immediately went to the office and pulled the plugs out of the wall, much to the annoyance of his own members working there, who felt the word processors were making their lives easier.

Incidentally, when the very first word processor was introduced into the Museum, an IBM rep came along to give us a demonstration. The machine was set up in the typing pool and he went through all the astonishing things this new machine could do compared to a manual typewriter, such as use many different fonts and sizes, copy and paste, create borders and all the other things we now take for granted but were quite amazing then. When he finished he asked if there were any questions. The superintendent of the typing pool, Sylvia Daniels, who was not noted for being the sharpest tool in the box, said, 'Yes, can it do double spacing?'

As Kevin got further into union work his own personal form of direct action began to get up the noses of more and more of the Museum's managers, and even officers of other unions, and he would probably have felt there was something missing from his life if he didn't have at least five or six personal vendettas going on simultaneously.

The strange thing about Kevin was that he looked so meek and mild, a bit like an older version of the Milky Bar Kid. His other main passion in life was motorbikes and he could bore for England on the subject. By the late '80s, the CPSA branch newsletter, now called *Torc*, which had had something of a chequered life since its first publication in 1968, was under the editorship of Ian Burch. Ian had taken it by the scruff of the neck and turned it into a 'must-read' magazine for the whole of the Museum, not just CPSA members. It also had a big following around the country in other government departments. It was a mixture of more serious union and political articles along with humorous articles, gossip and satirical articles about well-known Museum personalities. It was a local *Private Eye*.

One of the most popular features was the 'quotations page' in which Ian would print quotes from various people around the Museum; some were true, some were completely made up. In the January 1987 issue, Ian published '20 Sayings of Kevin

Coombes'. These were all made up – as I should know! Many of them were on the subject of his vendettas against various members of management. Just one of them referred to his motorcycle mania and read, 'The double nut flange sprocket on my twin carb has gone.' For some reason the 'double nut flange sprocket' caught the zeitgeist of the time and everyone around the Museum started talking about this completely fabricated component of a motorbike. As I discovered later, it also became the talking point of many branches nationally and the British Museum was identified with the double nut flange sprocket up and down the country. I never did find out what Kevin thought of this new-found fame. But, even up to the time I left in 2004, older members of staff remembered the double nut flange sprocket, and seventeen years later it would still occasionally crop up in conversation.

Meanwhile, Kevin continued in his private war on management. As mentioned earlier (Chapter 6), he was appointed a director of BM Publications Ltd. Not long after he was appointed, the TU Side health and safety representatives asked BM Publications if they could carry out a health and safety inspection of their premises. They agreed to an inspection of the parts of the company that were actually on BM property, the bookshop and postcard gallery, for example; but they demurred over the issue of inspecting their offices, which were situated in one of the perimeter properties in Bloomsbury Street. As a director of the company, Kevin took it upon himself to invite one of the safety reps to come and have a look round with him. They found several things wrong, such as fire doors locked, trailing wires and no proper storage for flammable materials. Kevin informed the company's safety officer of their findings. A few days later he went back and, in normal Kevin fashion, seeing that nothing had been done, immediately telephoned the Camden fire prevention officer.

The next day he went to see Hugh Campbell, the managing director of BM Publications, and explained the problems. He then told Mr Campbell that he had contacted the fire prevention officer. At this point, Mr Campbell interrupted him and the conversation continued like this:

Mr Campbell: Yes, about that. I take grave offence at your phoning the fire officer without speaking to me first.

Kevin: I don't know about you taking offence, but the company might be committing an offence. I told Mr Killick [the company's safety officer] about the problems last week and nothing's been done.

Mr Campbell: You had no right to do what you did …

Kevin: I'm not having this. I'm leaving.

Mr Campbell: You're a pain in the arse, do you know that? You only became a director so you could stir up trouble.

Kevin: Can you tell me the procedure for calling an emergency board meeting?

Mr Campbell: Mr de Banzie [the company secretary] will tell you on your way out.

Following the visit of the fire prevention officer, Mr Campbell informed Kevin that he was not allowed to set foot on company premises again. This must have been the first and only case of a director not being allowed to set foot in his own company.

After several years of this type of thing, BM management eventually had had enough of Kevin and they found a pretext to sack him. A new typist complained that Kevin had harassed her by trying to get her to join the union. It was a ridiculous accusation as the typist in question was about three times as

big as Kevin and no one could imagine her being harassed by anyone, let alone Kevin. In any case, Kevin had only met her in the canteen to ask her to join the CPSA, as he was perfectly entitled to do. But it was just the opportunity management were looking for. Of course, Kevin threatened the Museum with unfair dismissal and a compromise settlement was finally agreed and Kevin left the Museum in 1991 after eleven very eventful years.

There was one other union rep who made a name for himself around this time: Rex Shepherd. Rex was a labourer and a branch official of the Transport & General Workers Union (TGWU), but it wasn't for his activity in either of these fields that he was known. Rex became famous throughout the Museum as the 'Cat Man'.

The British Museum had been home to large numbers of feral cats for as long as anyone could remember. They lived in the basements, occasionally making forays into the light. By the 1970s there were so many that it was felt something needed to be done about them. There was a suggestion that Rentokil should be brought in to exterminate the lot. However, it was recognised that the cats performed a useful service in keeping the rat and mice population down, so Maysie Webb decreed that the Museum should keep six cats as 'official Museum cats', with money being made available from Museum funds for their well-being, while the RSPCA should be called in to catch the rest and arrange for them to be re-housed.

It was at this point that Rex stepped in and took over responsibility for the six lucky cats – Susie, Maysie, Poppet, Pippin, Pinky and Pompom. He set up a staff committee with himself as president and dedicated himself to looking after them. He used the official money to make sure they had proper sleeping arrangements and food, which he put down twice a day in two specially designated cat feeding areas. At Christmas he used to go round the staff with a collecting box

to 'get the cats something special for Christmas'. He usually collected between £100 and £200. The more he got involved the more seriously he took it, even to the extent of coming to work every day in a pseudo-RSPCA uniform, complete with peaked cap, gold braid and stripes on his arm.

Rex was also called in to deal with other animal problems at the Museum. On one occasion, a pigeon flew into the Museum and seemed trapped in the Reading Room. Some of the more cynical members of staff suggested shooting it, but Rex was called in to coax the pigeon down and free it. It was a successful undertaking and the pigeon flew happily out the front entrance.

Leaving aside double nut flange sprockets and cats, there had been many changes going on at the Museum when I returned to become chairman of the SCPS, and even more during the decade that followed, partly due to outside government pressures and partly due to a new outlook by Museum management itself.

As far as government pressures went, the Thatcher government had forced changes on the Museum by continually, year on year, cutting back on public expenditure and reducing our grant. As Chris Jones said to me once: 'Okay, the first year the grant is reduced, you can find some fat to cut. The second year, okay. By the time it gets to the twelfth year you are cutting deeply into core services or having to find other ways of raising money or both.' There was no let up either when the Labour government came into office in 1997, as for the first two years they kept to the Conservative government's spending plans. By 1999 the Museum was in the worst financial trouble it had ever been in.

In addition to the general problems caused by underfunding was the fact that the British Library was gradually moving out, with the pace accelerating throughout the '90s. This had an extra adverse effect on the Museum's finances for two

reasons. Firstly, the British Library was paying rent for the space it occupied; as they moved out this rent decreased more and more, meaning our income dropped, finally to nothing. Secondly, the Museum had to do something with the spaces being left, which meant spending money on renovations and refurbishments. Even with this loss of income and extra expenditure involved the government still refused at first to provide any help to cover the shortfall.

In 1992 David Wilson retired as director and his place was taken by Dr Robert Anderson, the director of the National Museums of Scotland. Dr Anderson was as ideologically opposed to the introduction of Museum charges as David Wilson had been, so from that point of view he was certainly seen as a good choice by the staff at the BM. Most, if not all, the other major candidates were already directors of charging museums and, to their great credit, in spite of the growing financial crisis, the new director and the trustees continued to firmly oppose the introduction of charges, believing unconditionally in the principle of free admission. This in itself caused further unexpected problems in that charging museums were classed as businesses and could claim VAT back on building works and other projects, but because we didn't charge and therefore weren't a business, we couldn't.

There were two other financial pressures on the Museum. The first was that we had three outstations. All of these added extra costs to the Museum which we wouldn't have had if we'd been able to show and store everything on one site. The second was that many of the galleries were badly in need of refurbishment and bringing up to modern display standards.

To help overcome these problems two things happened: firstly, the British Museum Trust was set up to try and raise money to support the Museum; and secondly, the Museum itself paid much more attention to marketing than it had done before. To a large extent the Museum had relied on its name

to pull in customers, but now it was seen that we needed to put on more 'blockbuster' exhibitions, which would have an admission charge, and advertise more widely.

Towards the end of the 1980s, the Museum hosted a large dinner for almost 1,000 guests in the Duveen Gallery and the Nereid Room. The queen and the Duke of Edinburgh were the guests of honour, but, more importantly, the guests who came were the sort of guests who could afford the asking price of £1,000 for the dinner, and it was hoped there would be more where that came from. The dinner worked wonders and soon the Museum had a number of generous patrons willing to sponsor new gallery developments. Amongst the first were Sir Joseph Hotung, who gave £2 million to refurbish much of the King Edward VII Galleries, and two Americans, Raymond and Beverly Sackler, who paid for a series of major refurbishments to the Egyptian and Western Asiatic galleries. This, however, wasn't without its minor problems for the office staff in Western Asiatic Antiquities and us in BMD, as the Sacklers would frequently drop in unannounced to have a look at their galleries and complain when they saw lights not working. It became something of a priority for us in BMD to make sure the lights in those galleries were inspected regularly and replaced immediately if it was noticed they were out.

Although these sponsorships were very welcome, there was some naivety in the early days of big gallery sponsorships. A&BS and the Design Office put the money to good use in redesigning and rebuilding the galleries and putting on first-class displays, but they forgot to add in the cost of the supporting infrastructure work, as this was behind the scenes. This fell to BMD to put in and fund and made a bit of a mess of Terry Giles' carefully worked out three-year plans. Later, after intense lobbying by Terry, the funds raised were allocated on a whole gallery basis, not just the showy parts; so, for example, the electrical wiring behind the walls had to be budgeted for

in the sponsorship deal and Terry's three-year plans were back on track.

Galleries were one thing, but the effects of the cut in grant were felt very keenly amongst the staff. During the '90s there was a whole change in ethos at the Museum and the emphasis changed from the old Museum I had grown up with, the one where curators, conservators and scientists worked away behind the scenes writing catalogues, putting on displays, answering queries from the public and so on, to one where marketing and up-front activity became all important. It was no longer good enough to expect the public to come to us, we had to go out and sell ourselves to the public, both to bring the punters in and to hook a few sponsors. Departmental keepers were now expected to spend some of their time wining and dining instead of studying, and a whole new marketing department was created. This in itself caused a great deal of resentment amongst the academic staff, and even the general administrative staff, as it was seen that those in marketing generally received higher salaries than the rest of us did. We were told it was the 'going rate' and that they were essential to the continued running of the Museum, as they were vital in helping to make up the shortfall in funds. For their part, the curatorial staff pointed out that without their work there would be no museum to sell. It was a very touchy subject in the '90s.

Amid all the gloom there was what one can only call a lighter moment when the new CPSA branch secretary, Ursula Stone, put forward her plan for solving the BM's financial crisis. For a number of years Pizza Express had featured on its menu Pizza Veneziana, the cost of which included a discretionary 25p donation to support the charity Venice in Peril. As there was a branch of Pizza Express less than 100 yards from the front gate of the Museum, Ursula proposed asking them to create a new British Museum pizza, with 25p from the sale

of each pizza going to the 'BM in Peril' fund. Not surprisingly, management never pursued this proposal.

Instead, in 1996 the Museum commissioned a report by a former deputy secretary at the Treasury, Andrew Edwards, to look at ways of saving money and/or increasing income. The report when it came out was very disappointing for most of the staff and management as it seemed to be thinly disguised propaganda for introducing admission charges. Otherwise, it warned, we would have to cut one-third of our staff, reduce our opening hours and close many of the galleries.

Fortunately, the director and the trustees didn't fall for it and reaffirmed they had no intention of introducing admission charges. They did, however, institute a programme of voluntary redundancies, and asked members of staff to apply for redundancy which would be granted if it was felt the person (and the job) could be spared. Such was the unease about the future that about 50 per cent of staff enquired about the possibility, though many of those had no real intention of leaving and were just interested to see what they would get if they did go.

In 1997 the new Labour government was elected, but there was no ease up in the Museum's financial difficulties. The British Museum was not the only famous public institution to be going through a cash crisis: the Royal Opera House was going through a similar experience which brought it to the brink of bankruptcy. The new culture secretary, Chris Smith, seemed to live in dread that a second big institution, namely us, would go under during his watch, but there was still to be no extra financial help. Instead, his solution was to appoint a managing director who would take over financial control.

The person chosen to 'save' the Museum was Suzanna Taverne, a former investment banker and director of various large newspaper corporations. Smith's move was not received with any great enthusiasm by most people in the Museum. They viewed having two directors as a recipe for disaster,

because while Suzanna Taverne had responsibility for the finances, Robert Anderson continued to run the Museum's curatorial and associated activities.

It was during this period of financial crisis and worsening staff morale that the British Museum became involved in the biggest undertaking it had been engaged in for over 150 years.

'AN AWE-INSPIRING TRIUMPH': THE GREAT COURT

This massive undertaking culminated in the opening of the Great Court in 2000. After the British Library had been set up as a separate institution in 1973, it was obvious that it would have to move out of the British Museum site to a building of its own. After a number of false starts and proposals that never got off the ground, building work on the new British Library site finally got under way in 1982 on the old goods yard at the back of St Pancras station in North London. In 1984 the Museum laid out its plans for redeveloping the Library areas within the main building. One of the main objectives was to bring back the Ethnography collections, which had more or less been completely divorced from the Museum for almost fifteen years, with the main exhibition areas being at the Museum of Mankind and the reserve collection at Franks House in Orsman Road, Hackney.

When the British Museum was originally designed in the 1820s, it was envisaged as a four-sided building around a 2-acre central open courtyard with large portico entrances from the main building on each side. However, by the 1850s it was apparent that the Museum's Reading Room was much too small to fulfill its purpose and it was agreed to build a new Reading Room in the centre of the open quadrangle. This had

an entrance corridor through to the Front Hall of the main Museum building, which was enlarged, necessitating the demolition of the South Portico.

Over the next 130 years or so, because of the ever-growing pressure on space in the main building, the remaining open area around the new Reading Room began to fill in a very piecemeal way with temporary, semi-permanent and supposedly permanent buildings of all shapes and sizes, including the ironworks book stacks, offices and other work areas – such as the locksmith's workshop, colloquially known as 'Hobbit's Kingdom' – with no coherent plan. By the 1990s this higgledy piggledy development of buildings in varying styles and of different eras just looked a complete mess. There was also still a fair bit of open space remaining, including the Inner East Road, a handy cut through for staff from the front to the back of the Museum. It was this area that now had to be reinvigorated.

The British Library departments occupied much more than just the Reading Room. As far as gallery space went, there was the King's Library and the Bridge (which displayed the maps), as well as the Manuscript Department's galleries on the ground floor, the Grenville Library and the Manuscript Saloon. In addition, there was all their storage space as well as their students' rooms and offices, which included, amongst others, the North Library, the Anteroom, the Sanskrit Library, the State Papers Room, the Map Room, the Music Room and the Copyright Receipt Office.

So there was plenty of space to plan for. But, of course, the most sensitive issue in all of this was what to do with the inner courtyard and the Reading Room, as it was such an iconic part of the British Museum. It was famous throughout the world as the place where leading scholars of the nineteenth and twentieth centuries had studied, and it could not be turned into just another gallery. Something special had to be done with it. It was also right in the centre of the Museum; there was

opportunity and danger and the Museum had to make the right decision.

The first plans produced for the conversion of the Library space were piecemeal and the original idea was to turn the Reading Room into the library for the Ethnography Department, as I mentioned during my HEO interview (see above, Chapter 9).

It didn't take Robert Anderson long after his appointment to express dissatisfaction with the current proposals to deal with the vacated space. He made it clear that he was very unhappy about both the piecemeal approach to its development and to the idea that the Reading Room should be used to house the library of just one department, however big and important it was. So he asked the trustees to look at the plans again. This time it was agreed that the majority of the space left should be seen as a whole scheme, and a design competition was held to find an architect with an 'imaginative' view of what to do with it.

In all, 132 practices entered, including the two leading architects of the time, Norman Foster and Richard Rogers, though Norman Foster had originally written to the Museum to say that he would not enter an open competition.

By this time I was working in A&BS and I can remember the main drawing office of the architectural section being stuffed full of plans and little models showing how the space could be used. The original 132 firms were whittled down to 22 and then 3, Norman Foster, Rick Mather and Arup Associates, were chosen as finalists. In the end, the trustees decided to go for Norman Foster and his Great Court idea, as he was an internationally renowned architect who had built prestigious buildings all over the world, including the HSBC building in Hong Kong; the Stansted Airport terminal building; the Joslyn Art Museum in Nebraska, USA; the Carré d'Art, Nîmes, France and the Commerzbank Tower in Frankfurt, Germany.

By 1998, most of the books and manuscripts had been moved out to the new British Library at St Pancras, which had opened in 1997, and the enabling works for the Great Court scheme could begin. BMD were very much involved in these works and some of my time was now taken up with helping to organise the removal of 20 miles of book shelving and the masses of office furniture left behind. Once this had been completed, recognising that BMD would be responsible for the area once it was built, we became further involved in the project by appointing a 'completion manager', whose job it would be to ensure that the Great Court's electrical, heating, water and drainage systems were compatible with the rest of the Museum, and that all the necessary operating instructions were available and handed over once the project had been completed. It was expected that the instructions would fill 400 lever arch files.

For BMD there was also the question of cleaning. The main problem was how we would manage to keep the glass roof clean. The glass dome roof was to be an important feature of the new building and was to be made up of 3,312 individually made panes of glass with no two made exactly to the same dimensions. Cleaning the outside looked like it might be a logistical nightmare; cleaning the inside, given that one of the conditions of the Millennium Lottery Grant was that the public opening hours had to be 6 a.m. to 12 midnight, was even worse.

When the new job of completion manager was announced, Terry Giles approached Len Packman, Peter Newman and me and asked us each individually if we'd consider taking it on. I thought painting the railings was one thing, but making sure that the electrical wiring was in the right place to connect to the rest of the Museum was quite another and, for the sake of the Museum, I declined Terry's kind offer. Len Packman eventually took on the job, though I did get involved in

dealing with the logistics of indexing and housing the 400 lever arch files.

Once the actual building work started, the most difficult thing about the whole operation was that the Reading Room and the adjacent space was right bang in the centre of the ground floor of the Museum, yet somehow the project had to be carried out without closing the Museum. All the entrances to the area from the rest of the Museum were boarded up and for almost two years no one, except those working on the site, saw what was going on. I do remember, however, walking through the East Basement one day and finding a small opening looking out on to the courtyard which had just been knocked through for some reason. I looked through and saw the Reading Room standing in splendid isolation. Everything around it had been demolished and the courtyard was completely empty. It was a magnificent sight. Apart from the people working onsite, no one had seen this view since the 1850s. It was one of those moments that once more made me feel what a privilege it was to work at the greatest museum in the world. When I went back a few days later the hole had been covered up, and with work starting on the courtyard, that view would never be repeated.

After the boarding up, the next thing staff and visitors noticed was the arrival of a crane on the forecourt to lift out all the rubble from the demolition of the buildings in the courtyard. It was 46 metres high with a reach of 75 metres, the longest of any crane in Great Britain, as it had to reach right across the south wing of the Museum into the courtyard. Although staff had been warned about its arrival for many months, I don't think anyone was really prepared for the sheer size of what was to become a dominant feature of the Museum for over a year. One night, not long after its arrival, two people were arrested following an attempt to enter the Museum by climbing the crane. They were spotted by security

warders who chased them right up to the top, where they were apprehended by Don Adams, one of the supervisors, and escorted into the waiting arms of the Holborn police.

The whole Great Court project scheme cost £97.9 million and not one penny was received from the government. In many ways it was fortunate that the necessity for redeveloping the Library areas coincided both with the creation of the National Lottery and the millennium, as £30 million came from the Lottery Millennium Commission and a further £15.75 million from the Heritage Lottery Fund. The rest of the money was made up by some very generous donations from individuals and organisations, and smaller grants from members of the public and charitable foundations.

By the middle of 1999, about a year before the Great Court was due to open, I had moved to Personnel as internal communications manager and was involved in organising a programme of what was called 'Cultural Change Issues'. It was felt that there would be such a fundamental change at the heart of the Museum that there needed to be a complete retraining of the staff to understand the impact of the Great Court. Paul Snoddy, the BM architect in charge of the project, Tony Finnemore, the training officer, and I were given the remit to come up with the design for training sessions for the staff, as well as producing a booklet for everyone. In all we organised twenty-six half-day training sessions for up to fifty staff at a time in the Hartwell Room, with the booklet to take away, plus fifty 'walkabout' sessions for up to twenty staff at a time to familiarise themselves with the Great Court and the new facilities it provided, including the new galleries, lecture theatres, education suite, information desks, shops, restaurant and coffee shop. These 'walkabout' sessions were undertaken in 2000, once it was safe to gain access to the area.

Although the whole project progressed well and the planned-for opening in 2000 was well on target, a problem

arose with the renovated South Portico. As mentioned above, this component of the original quadrangle building had been demolished in the nineteenth century and was now being restored. The walls around the courtyard had been faced with Portland stone by Robert Smirke, the BM's original architect, and the expectation of the Great Court design team was that the new South Portico would be rebuilt in that same material. European tendering rules did not, however, allow for a specification for Portland stone as the sole usable material. Instead, the Museum was required to specify the use of 'Portland stone or a suitable alternative oolitic limestone'.

Nevertheless, none of the companies who tendered for the work offered anything other than Portland stone, and indeed, when the contract was let to Easton Masonry, the successful bidder, Portland was identified as the stone to be used. The Portico was partly constructed when an anonymous tip-off was passed on to the Heritage Lottery Fund, which was financially supporting this component of the Great Court project, that an alternative stone was being used. Easton Masonry at first denied that this was the case, but eventually acknowledged that it was indeed true.

The Museum now faced a considerable problem about the right action to take in the context of its overall project. The first issue to be addressed, and rapidly, was whether the stone being used, Anstrude Roche Clair, was fit for the purpose. It was quickly confirmed by geologists and engineers that Anstrude was another oolitic limestone which in composition was completely suitable for the job. But this was far from being the only relevant issue. It was clear that in colour the Anstrude stone was not the perfect match to the Portland stone of the adjoining courtyard walls. But then again, new Portland stone would not have matched the long-weathered original Portland stone anyway. Nevertheless, the Museum was considerably disappointed that the wrong stone was being used, and at having

been cheated by the contractor. There was great disappointment also at the Heritage Lottery Fund, English Heritage and at Camden Council, the responsible planning authority.

The debate over the issue understandably extended over a long period and this gave the Museum a further problem in that to stop work on the South Portico construction would heavily damage the Great Court programme and budget. The continuation of building was, therefore, allowed pending the decision on the stone. Eventually the various authorities accepted that the Anstrude stone could be used, although formally lodging their disappointment at the occurrence. So the Museum went ahead to complete the South Portico in the Anstrude Roche Clair stone, adjusting payments to Easton Masonry to take account of the effects of the change.

Although it was now accepted that building could go ahead, the *Evening Standard* seemed to take the whole affair as a personal affront and demanded the resignation of Graham Greene, the chairman of the trustees. They returned to the issue time and again, featuring it as front-page news and twice running double-page spreads personally attacking Graham Greene and the thirteen trustees who they saw as responsible for this 'dereliction of duty', as well as running many smaller pieces and editorials. In more than one report they described the Portico as being 'dazzling white' that 'stood out from the Portland Stone that surrounds it'. This was complete and utter nonsense. When the Great Court was finally opened to the staff, I, along with many others, took a look at the South Portico to see what all the fuss was about. You could hardly notice any difference, and if you didn't know about the controversy, the idea that it was different to the rest of the building wouldn't even have entered your head. Camden Council was also unhappy about the whole affair and well into 2001 was threatening to order the BM to pull down the South Portico and rebuild it, which would have been a com-

plete nonsense. Fortunately common sense did eventually prevail with them.

Although the finished project was not officially opened until 6 December 2000, it was open to staff a month or so earlier. The first time I saw the Great Court it took my breath away. As someone who could remember what was there before it was just mind-bogglingly staggering. Never before had we been able to see the Reading Room without all the attached book stacks and buildings, and yet, here it was, standing in the middle of a wide open space so that its full proportions could be seen and admired. But what struck me most was the information desk, the circulation space and the coffee shop on the right-hand side, all now under cover of the new glass roof. I could remember when much of this was in the open and you could walk down the road, past Hobbit's Kingdom.

The sensitive issue of what to do with the Reading Room had been solved by creating a modern information centre, the Walter and Leonore Annenberg Centre, with a collection of 25,000 books, catalogues and other printed material, which focused on the world cultures represented in the Museum.

It wasn't just what had been done to the Reading Room and the space around it at ground-floor level; there was also the Centre for Education, the lecture theatres, the dedicated schools area and a new gallery at the lower-ground-floor level, the new gallery on the mezzanine floor and a new terrace restaurant on the upper floor. The British Museum could now provide the first-class facilities that the world's best museum had sadly lacked before. Furthermore, there was a circulation route at ground-floor level for the first time since 1857; the public could now get from the main entrance to the back entrance, without having to climb any stairs, by walking through what was now the largest covered public square in Europe.

This whole incredible rebuilding of the centre of the Museum had taken place without having to shut the Museum for one single day during demolition or construction – an amazing achievement in itself.

It wasn't until the euphoria of the first few days was over that the reality of what the Museum had inherited struck home. With the maintenance now handed over to BMD, Len Packman and Terry Giles noted down a snagging list consisting of no less than 15,000 items, from lifts that didn't work to lights that had minds of their own (or no minds at all) to loos that didn't flush. The fire brigade turned up and all but closed it down because of the number of faults they found. Then a sewage pipe burst over one of the lecture theatres and a waste pipe burst in the kitchen. Terry remained unfazed. First he bashed up the consultants to make contractors finish their jobs properly, then, when he'd had enough of the consultants, he bashed up the contractors direct. Eventually the 15,000 snagging items were cleared and the Great Court was really finished to become the living heart of the British Museum, an awe-inspiring triumph made possible by Robert Anderson, the trustees, the generosity of many benefactors and all those Museum staff, architects and contractors who worked so hard to bring it about.

LAST IMPRESSIONS

My new job as internal communications manager started on Monday 6 April 1999. On the previous Friday afternoon I went over to Personnel to see where my new office was. On my arrival Jenny Kelly, who was to be my secretary, showed me the room. As well as my desk and chair, there was a filing cabinet, some bookshelves and a locked cupboard. I asked Jenny what was in the cupboard. She said, 'I can't tell you. It's confidential.' I said, 'What do you mean you can't tell me?' She said, 'It can only be opened by Personnel staff and you're still in BMD. I'll open it on Monday.'

When she did open it on Monday I must confess it was a great disappointment as it only contained a few personal files that had queries on them that needed sorting out. The filing cabinet contained, amongst other things, the personal files and annual report files of all the Personnel and central management staff, including the director's and, curiously, my own. It meant I was the only person in the whole Museum who was able to see his own files. Harking back to my early days and my first run-in with management, I wondered what Daphne White would have thought of that. I also wondered what Jack Ryde, the man who once banned me from setting foot in Personnel, would have thought of my new post of SEO

occupying more or less the same position that Elsie Ding had held in my young days.

My file made very interesting reading, especially the notes that had gone back and forth between various members of management when I had been involved in union negotiations. There was one small piece of correspondence that explained something I had been curious about relating to a request I had made back in the 1970s for special leave. Union officials were allowed up to twenty-five days of special paid leave per year – forty if you were on the NEC – to go to union meetings and courses. I had once asked for one day's leave for a Friday and a further one day for another meeting on the following Monday. I was told I would have to take four days. I went to see Alex Newton, who was then a HEO in Personnel, and asked him why. I told him they were two completely different meetings in different parts of the country and if I was wanted over the Saturday and Sunday I would be available. He seemed to agree with me and said he would confirm my request for two days. A couple of days later he did a complete volte-face, writing to me to say that I had to take four days. In my file was a note from Alex to Barbara Hughes giving her the gist of our conversation and his recommendation that I should have two days' leave. She had written back saying that under no circum-stances was he to agree with me and I had to take four. This was the same Barbara Hughes who was now my boss.

As with all my new jobs, I spent the first morning getting to know everyone. Barbara I already knew very well as we had sat on the opposite side of the negotiating table many times. I also knew Jenny well from my frequent visits to Personnel. As 50 per cent of my time was to be line manager for the Training Office and the Welfare Office, I went to meet the heads of these two sections. Tony Finnemore, with whom I had worked on the Great Court staff training, was head of training, while Sue Copus was back as head of welfare, following Edna's

retirement. This meant, of course, that Sue, who was once my boss, now worked for me. As well as Tony and Sue there were two other HEOs in Personnel: David Wraight and Huw Evans. Again, I already knew both of them well. The EO in the general office was Josie Avey and there were five AOs, one of whom was Chris Lazenby. In charge of all of us was Chris Jones as head of administration. Between his office and mine were the two secretaries, Jenny next to me and Rita Talbot next to Chris, with interconnecting doors between the four offices.

Jenny was also Barbara's secretary and because my office was actually next door to Jenny, while Barbara's was three doors away, she hinted that we ought to swap places, and at one point even contacted Terry Giles to see if the labourers could come over and move our furniture round. Terry, who seemed to think I was 'his man' in Personnel, a sort of fifth columnist working on behalf of BMD, contacted me and told me to stand firm and stay where I was as he felt she was trying to remove me from close contact with Chris. When he pre-varicated about sending over anyone to help move us, Barbara dropped the matter. Actually I wouldn't have minded. She had a much bigger office than I did.

As I settled into my new job I found Barbara an excellent manager to work for. She didn't let any of our previous history get in the way of us having a good relationship now and was always very helpful and supportive. The first job I tackled was updating the staff manual. I discussed my ideas with Barbara and Chris and we decided to have a three-part progres-sion. There would be a simplified handbook issued to every member of staff, a more in-depth manual covering the main conditions of service issued to each department and then the full monty in great detail and in formal language available in Personnel, which, of course, we already had.

The handbook would not just cover rules and regulations but also contain useful information, such as the opening times

of the canteen, staff discounts available in the BM Company's Bookshop and so on. In my original draft copy I included a number of cartoons illustrating some of the points as I thought this would lighten it and make it a bit more readable. When I finished my first draft I sent it to the heads of departments to get their reaction. There was almost universal hostility to the idea of using cartoons. They felt it would 'lower the tone' and would not be taken seriously. Although I strongly disagreed with this view, I reluctantly agreed to remove the cartoons and the handbook was eventually published without these fine additions.

While I was working on the handbook I also started considering ideas for a staff newsletter. I obtained similar publications from other organisations, including some other museums. I was invited to a keepers' meeting (these were held regularly so that keepers could discuss Museum-wide issues together) to explain how I saw my role of internal communications manager progressing. I took along to the meeting some of the newsletters I had gathered from other institutions and passed them round saying these were just some ideas I was looking at for our newsletter. When I had finished, Antony Griffiths, keeper of Prints & Drawings, waved one of the newsletters around and said, 'You're surely not thinking of modelling our one on this?' I said it was a possibility and asked him why he was unhappy with it. 'It's printed in columns,' he said.

First of all my cartoons had to go, now it seemed columns weren't serious enough either. I soon realised that my idea of making communications more accessible to everyone was going to face an uphill struggle with those in charge.

Sadly, before I could get very far with my communications, Barbara was diagnosed with cancer and went off sick. As I was the next senior person in Personnel I had to stand in for her and I began to get involved more and more with 'real' personnel work and my communications remit was sidelined. This

is something I had not really wanted. It comes hard for an active union man to become part of management! I even had to start meeting union representatives, though I don't think they minded too much about meeting me rather than Barbara.

Suzanna Taverne started her new job as managing director about one month after my move, on 4 May. Not long afterwards, she asked to see me to talk about my ideas for improving communications. This was the first time I had ever been asked to meet the director – or in this case the managing director – as a manager and head of a section (even though I was the only one in it), and explain what I was doing and my ideas. So it was quite a big occasion for me.

We arranged to meet at ten o'clock one morning. I normally arrived at work just before nine. On this particular morning my train (I commuted from Clacton-on-Sea to Liverpool Street) pulled into Chadwell Heath Station and stopped. There was then an announcement saying there would be a delay as the overhead wires were down. There was no indication when we might get going again. We waited a little while, until one of my fellow travellers (about four or five of us always met up and journeyed together) said she knew a bus we could get from Chadwell Heath to the City, so we agreed to do this. The bus we got did indeed go to the City but went via every housing estate between Romford and central London. It took forever. I finally arrived at the Museum at about 11 a.m. I went straight up to see Suzanna and apologised profusely. Fortunately, she was all right about it, as, indeed, it wasn't my fault, and she managed to find a bit of time for a truncated discussion about internal communications.

Suzanna was particularly interested in internal communications because there was some bad news that needed to be relayed to the Museum staff, which was that, due to the financial crisis now engulfing the Museum, there was going to have to be a big round of redundancies and, unlike last time, some

of them would be compulsory. After all my years of being Trade Union Side chairman, I now found myself as part of the management team that had to meet the unions at a special Whitley Council meeting to explain the bad news. It was a very strange experience.

Along with the bad news of compulsory redundancies, we did have a bit of ameliorating good news, and that was that some extra jobs were going to be created, mainly in Marketing and Customer Services (where else?), as a result of the opening of the Great Court and its new facilities, and many of these would not be advertised externally to give those being made redundant a chance to apply. We were asked, in Personnel, to prepare a draft office notice to explain what was happening with a list of the new jobs on offer. The four HEOs and I sat around trying to think up a snappy title for the office notice, one that would put the best possible spin on what was not the greatest of positions to be in, despite the offsetting good news. It was Huw Evans who came up with the slogan 'Opportunities 2000', which I amended slightly to 'Opportunity 2000'. Opportunity 2000 became the Museum buzzword for the next six months or so and was on the lips of practically everyone as we pushed through one of the biggest – if not *the* biggest – staff reorganisations the Museum had ever seen.

As far as the redundancies went, we asked the keepers and heads of departments to come up with a list of posts they felt their department could function without, as once a redundancy was declared it meant the post could not be filled again. It would then be their responsibility to break the news to the individuals concerned. Some were quite happy to do this, others asked for a member of Personnel to be present at the meeting. I went along to one of these meetings and it was not a pleasant experience, especially as the person being made redundant had been at the Museum for something like twenty years and I knew him very well. Many of those made

redundant did, of course, apply for the new jobs, but few were successful and it was a very gloomy period for the Museum.

Following Suzanna Taverne's appointment, the senior management of the Museum was restructured and a number of current heads of departments were transformed into directors who now formed the management board of the BM. So as well as the director and managing director, we now had Chris Jones (director of administration), Anthony Blackstock (finance director), Carol Homden (director of public services and Marketing) and John Mack as head keeper. There was one new directorial appointment to make and that was director of personnel. The person selected for this post was Ian Black. His advent at the Museum was to cast a long shadow over my working life. On his arrival he changed our name to the more fashionable Human Resources (HR). This was the fourth name the department had had since I started at the Museum. It had been the Staff Office, Establishments, Personnel and now HR.

After changing our name, the next thing he did was to move Barbara out of her office and take it over himself, putting her into a much smaller room. This was a universally unpopular move. But as things turned out, it became obvious that in the popularity stakes, Ian began as he meant to carry on.

He was not the easiest of people to work for, and that's putting it very mildly. He had a very loud voice and I was going to say he didn't suffer fools gladly, but I think it would be more precise to say he didn't suffer anyone gladly. His language was not the most delicate I have ever heard and he would lose his temper at least once every five minutes (or so it seemed). I found it extremely difficult to hold a rational conversation with him as he would fly off the handle at the slightest provocation, although hardly ever at me personally. But if, for example, I had any difficulties with a keeper, I might, before I knew better, go and ask his advice. The conversation would invariably go something like this:

Me: I've just been speaking to Mr X and I've tried to tell him that he has to explain 'y' to his staff.

Ian: (going red) Mr X is a ******. He's totally incompetent. Just tell him he's got to do it.

Me: Well, it's not that easy because …

Ian: (his voice getting even louder) You just ******* tell him. He's hopeless.

Me: Well, I can try but I don't think he's going to listen.

Ian: (now looking as though he's about to explode) He's ******* useless. He's got no idea how to manage staff.

And so on; nothing helpful about how to deal with the situation, just a tirade of abuse.

He also started regular weekly team meetings for his managers. These were much the same as the one-to-one meetings and consisted mainly of an outburst of abuse aimed at anyone and everyone, especially the keepers. It struck me very early on just how insensitive Ian was. All of his managers had been at the Museum for over twenty years and yet it didn't seem to occur to him that all these people he was roundly abusing as being incompetent, useless, hopeless and so on, were, if not exactly personal friends of ours, at least colleagues we had known and respected for a long time.

Poor Jenny bore the brunt of his brusque manner. Naturally, he commandeered her as his secretary. Barbara was still off sick most of the time, though she did manage to put in as much time as possible, but with hardly any help now from Jenny. I was still 'allowed' to make use of her if Ian didn't need her. But he just drove her to distraction. Nothing was ever his fault. If a file was mislaid, it was bound to be Jenny's fault because she was 'incompetent', even though we might subsequently find the file in Ian's drawer or cupboard – 'Someone must have put it there.'

After about five months of it, Jenny got a transfer to another government department. On her last day she was sorting out her things, removing her personal possessions and making sure she left everything in order for her successor. In the middle of this, Ian called me into his office and asked me to tell Jenny to come in as he had a letter he needed to dictate. Why he didn't ask her direct I'm not really sure, but anyway I told Jenny what he had said. In all the time I had known Jenny she had always come over as a very demure, proper young lady and I had never once heard her raise her voice or swear, even mildly. This time her response to me was, 'Tell him to sod off. I'm getting packed up.' So, I went and told Ian that Jenny was packing and didn't have time to come in for dictation. As you can imagine, there was an immediate explosion.

'You tell her if she doesn't come in here now I'm going to sack her.'

I said, 'You can't sack her. She's leaving today.'

Going a deeper shade of red, he said, 'You just tell her ...'

'No, Ian,' I said. 'You tell her. It's ridiculous.'

And I walked out. He never did tell her himself – or sack her.

Jenny's successor, Halina Karpowicz, was an altogether different proposition. She was a real character and wouldn't take any of Ian's nonsense. If he accused her of losing a file, she would go straight to his desk and take it out in front of him, throw it on his desk and walk out. I once sat in on a memorable meeting between Ian and Halina when he decided he wanted to change the filing system because it had obviously been set up by some 'totally incompetent person, probably Barbara'. When he had finished explaining how he wanted it done in future, he looked at Halina and said, 'What do you think?' She just sat there saying nothing. Ian repeated, 'What do you think?' Halina just shrugged her shoulders. 'Well, do you think you can manage it?' was his next attempt. Again Halina just shrugged her shoulders. Ian, of course, was

getting redder and redder and looked like he was about to have a coronary.

At this point, Halina said, 'Is that all?' got up and walked out the room. Ian looked at me and said, 'What's the matter with her?' By this time I was trying hard not to burst out laughing and wanted to get out as quickly as possible, so I just said, 'It's okay, I'll have a word with her', and left. Halina never did implement his grand plan for the reorganisation of the filing and he never seemed to notice.

For me, Halina was an excellent secretary and had a strong personality. She was a great cricket lover and had a crush on Justin Langer, the Australian opener. But her couldn't-care-less attitude did worry me at times. In 2002 she decided to go on holiday to Iraq and couldn't see what all the fuss was about when she was told it could be dangerous. What was even more worrying was that she went again in 2003, just a few months after the Second Gulf War had ended and the insurgency was in full swing.

Barbara's illness and Ian's arrival meant my own position changed drastically. As I have already said, apart from continuing to compile the new handbook, I really had little to do with internal communications anymore, and in addition Ian took on immediate line manager responsibility for Welfare and Training. Barbara left soon after and sadly died from her cancer within a couple of months. When we got news of her death, Ian asked me if anyone would be going to her funeral on behalf of the Museum. I said I thought a lot of people would go as Barbara was very well known and liked. 'Only,' he added, 'if no one is going then I'll go myself.' To me this was just another example of his insensitivity. I said, 'Don't you dare go to her funeral. People haven't forgotten that your first act was to throw her out of her room.' He didn't go, but I and many other colleagues did.

With Barbara no longer there her post was done away with, and I became next in line to Ian, or, as he kept putting it when

we met other people, his 'number two'. It was not an enviable position. Our first meeting together with the unions took place to discuss their proposed pay claim for 2000. They put forward what I considered to be a very reasonable case on how they saw the position. They took into account the Museum's financial situation but wanted some extra money to be found for the lower paid members of staff. After they had put their views forward, Ian asked for a break to consider them. Outside he asked me what I thought. I said I thought they sounded very reasonable and they were a good basis for discussion. He shook his head and said, 'Well they might be, but we can't be seen to be agreeing with the unions. We'll have to go back and say "no".'

Over the next couple of years Ian managed to make himself universally unpopular with his own staff, with the unions, the staff in general around the Museum and even his fellow directors. In 2002 another round of redundancies and reorganisations was announced. This time there was more central control over which posts were to go rather than allowing heads of departments to decide as in 1999. A list was drawn up and discussed with the unions. When the final redundancies were agreed each keeper and departmental head was given the job of announcing the news to his or her department. Ian called us all together in our general office to read out what was to happen to HR. After a few minor bits and pieces he finally announced the news we had all been praying for. The post of Human Resources director was to be made redundant. There was no time scale given and, indeed, he managed to hang on for over a year, but much of this was on 'gardening leave' while he looked for another job. With his departure, Chris Herring, the new finance director, was given nominal control of HR, but in practice the management of the department fell to me and one of the HEOs, David Wraight, who was a master of pay and pension calculations.

I became the chief negotiator for HR with the unions and we drew up a number of policies in co-operation, such as new discipline and sickness policies. In addition, I seemed to be in continuous discussions with Security over alterations to their working conditions and hours. Every time a small change was proposed the union demanded financial compensation. And they usually got it because the Museum couldn't risk the Security staff going on strike.

I also spent a lot of my time chairing appointment and promotion boards. As far as the appointment boards went I couldn't believe the number of candidates who had made no preparation at all, even those applying for a job as a museum assistant on our Information Desk. Several of the candidates admitted never visiting the Museum and not knowing much about what it contained. One applicant we had for an Information Desk job who had done his homework was a policeman and we asked if he'd ever been involved in any difficult situations. He told us that he had been one of the police officers on duty at the Iranian Embassy siege in 1980 and was now looking for a quiet life.

Another post I interviewed for was that of museum assistant in Prehistory & Europe (the re-merged Medieval & Later and Prehistoric & Romano British Antiquities departments). One of my fellow interviewers was Catherine Johns, a senior curator in the department. On one of the applicant's CVs she had said that she enjoyed watching the television programme *Time Team*. Catherine picked up on this and asked her what she liked about it. After the applicant had replied that she enjoyed watching the archaeology etc., Catherine said, 'So you think it's a good thing, do you, to rush through an excavation without proper time to evaluate the findings and having to work to a deadline where you could easily miss important finds?' The poor applicant was totally thrown by this display of hostility towards the programme and mumbled something about how she didn't really approve of *Time Team*'s methods after all.

A further aspect of my job was to represent the Museum at employment tribunals and Civil Service appeal boards, though in actual fact I was only called upon to do this once. There were a couple of cases of dismissed members of staff threatening tribunals but in both cases the Museum decided to come to a compromise settlement, even though in my opinion we had an excellent chance of winning. There was one case that did go to the Civil Service appeal board (the Civil Service's own mechanism for settling 'unfair dismissal' cases) and was, in my opinion, the weakest one we had, but for some reason senior management were determined to go through with this one.

The Civil Service appeal board consisted of three members: one from management, one from the unions and one neutral. The members of the board elected their own chair. On this occasion the chair happened to be the union representative, John Sheldon; the same John Sheldon who had led our discussions back in the 1970s on the privatisation of BM Publications. When he saw me he said, 'Norman Jacobs representing management? I never thought I'd see the day.'

Back in the office, Tony continued in his role as training officer, while Sue joined Huw as a strictly HR manager after Welfare was outsourced to a private company. Huw was a bit old fashioned in his approach and did not get on well with new technology. He never really got to grips with those new-fangled computers and was forever asking David, Chris Lazenby and me how to do something on the computer, even after it had been explained to him dozens of times. He did have an interesting way of leaving messages on voicemail, however. Sometimes I would get a message that said something like, 'Hello, this is Huw here. Please ring me back and say "Roast Beef".' So I would and Huw would say, 'Ah yes, I wanted to talk to you about …', whatever it was roast beef reminded him of.

The newsletter eventually came about but was introduced by Helena Kicinski, who had recently been appointed to the new post of external communications officer. It was felt that as she would be dealing with all external communications she would be in a better position to know what was going on at the Museum as a whole, and therefore perfect to edit the newsletter. Ironically, in view of my meeting with the keepers, it was given the title, *The Column*, and was four sides of A4 printed in a four-column format.

One of my other ideas set out in that original internal communications paper had been introduced before I even arrived in HR, and that was the weekly briefing meeting at which representatives from every department would meet up to say what was going on in their area. It usually fell to me to represent HR at these meetings, after which I always produced a summary of what had been discussed for HR staff to read. The best meeting I can remember was when the director outlined the arrangements for the presidential visit of George W. Bush. The following is how I reported it back to HR:

George W. Bush is visiting the Museum tomorrow [19 July 2001]. This will be the first ever visit by an American president. Security precautions will be phenomenally high. The view of American security is 'the more guns the better'. There will also be two Chinook helicopters full of marines flying over Russell Square 'in case we have to adopt the military logistical option'. The southern part of the Great Court will be closed during the visit. All windows on the 2nd and 3rd floors of the New Wing must remain shut during the visit and staff passes must be worn. Staff should also comply with any request by security or visitor services.

The president will visit the Reading Room, where he will be shown Mark Twain's signature amongst others. He will also be shown some items from the collections,

including some George III coins to remind him who was boss in the 18th century. If anyone would like to see the president during his visit, part of the south-east corner will be roped off, and you should get in touch with Marjorie Caygill [the director's research assistant] if you wish to take advantage of this viewing area. Chris Jones asked if this was a reward or a punishment. Marjorie replied that whatever you think of his politics he is the most powerful man in the world and that personally she was to the right of him anyway. Mr Bush had agreed to visit during his time in Britain to help boost tourism.

Thankfully the visit passed off without us having to adopt the military logistical option.

The 'experiment' with having a managing director did not work out. The idea of having two directors with no one person fully in charge was confusing, as many in the Museum said it would be when the idea was first mooted, and Suzanna Taverne left on 31 December 2001, leaving Robert Anderson once again in sole charge. Robert himself retired midway through 2002. It had been a very difficult period for him, with the ever-growing financial deficit, but he did leave behind a museum in better shape to face the future than at one time seemed possible and, of course, his lasting legacy was the building of the Great Court.

Robert's place was taken by Neil MacGregor, director of the National Gallery. Neil had a more outgoing personality than Robert and came to us with a good reputation both in terms of getting things done and his relationship with the staff. Apart from the ongoing financial difficulties, Neil was faced with two other big issues, which were eventually merged into one. The first was that 2003 would mark the 250th anniversary of the British Museum and we would be expected to mark the occasion with some big celebrations; the second was what to

do with the one remaining large British Library public space, the King's Library.

This was originally built to house the collection of over 60,000 books formed by George III and given to the nation in 1823 by his son, George IV. When the library was donated there was not enough space to house it in the original British Museum building (Montague House) and it was this that gave the impetus to the construction of the present building. In fact, the King's Library was the first wing of the new building to be erected and is therefore the oldest part of the Museum still in existence. It was almost as iconic as the Reading Room and it was imperative the British Museum make the right decision about what to do with the space.

Again, it was Robert Anderson who had started the ball rolling on this, but it was now down to Neil to finish it off. What had been agreed was to convert the King's Library to house a new permanent exhibition entitled 'Enlightenment: Discovering the World in the Eighteenth Century', and was designed to show what the world was like 250 years ago when the Museum was founded. The new senior keeper, Andrew Burnett, was heavily involved in the planning and execution of the work involved, and the opening of the gallery in 2003 to mark the anniversary was another magnificent achievement for the BM.

In 2004 the newly converted gallery won the Crown Estate Conservation Award from the Royal Institute of British Architects. The judges said: 'The restoration of the room, and its conversion to an exhibition about the history of the Enlightenment and of the early collections of the Museum itself, have revealed it in its full glory as one of the finest rooms in London.'

Just before the opening of the Enlightenment Gallery, towards the back end of 2002, there was another management reorganisation with a new director of resources being appointed,

Dawn Austwick (formerly the project director at Tate Modern), and, together with Andrew Burnett, they became joint deputy directors, forming a sort of triumvirate management at the top. I found all three of them very likeable and very approachable. In fact, I had known Andrew for a long time as he too had been a union representative many years ago. In my position as effective head of staff relationships at the BM, I worked closely with Dawn in particular and found her to be very down to earth (which included some very down-to-earth language at times) with a sensible approach to staff management.

Towards the end of 2003, the Museum decided to appoint a new head of HR. Although I didn't hold out much hope of getting the job I applied for it anyway. I knew that I was up against it, as I was sure the Museum would want someone younger than me with all the appropriate qualifications. In spite of my senior position in HR I had no actual qualifications and had just worked my way up through various administrative posts in the Museum. I knew this was not how the world worked these days. Nevertheless, I thought I had nothing to lose as if I didn't get it I would be no worse off than I was. As I suspected I did not get the job, which went to an outsider, Martin Moore, who had all the right qualifications and even wrote for well-known, nationally respected HR journals.

The first thing Martin did on his arrival was to talk individually to all members of HR staff to ask them what they did and how they saw their future. This was something I had been thinking long and hard about, especially now that I seemed to have got as far as I was ever going to get. The Museum had changed out of all recognition from the organisation I had joined in 1967, as it had to, and I had played my own part in a number of those changes. It was still, in my opinion, the world's leading museum but there was so much emphasis now on marketing and sponsorship that I couldn't really get to grips with this modern way. When Martin asked me how

I saw my future, I said, 'Quite frankly, Martin, I see my future in retirement. I just think it would be best for me and best for the Museum if I left, and let someone else take over who is more in tune with the way things have to be.'

He said that having looked at the structure of HR he would want to make a number of organisational changes and, although he did not want to push me out if I really wanted to stay, he said he was sure he could arrange for me to leave on compulsory redundancy terms, which is the best financial way to leave the Civil Service. I thanked him very much and that was that …

Except for one final little act of rebellion on my part that took me back to my union days. It was a tradition at the Museum for leaving dos, especially for long-serving members of staff, to be held at lunchtime, sometimes in a nearby hostelry but quite often in the Museum itself. Dawn Austwick had decreed that these should stop and that, in future, these sorts of functions should take place outside working time. I told Martin that I had been at the Museum for thirty-seven years – I was, in fact, the seventh most senior member of staff in terms of time served when I left – and that I wanted my leaving do to be held in the Hartwell Room at lunchtime in the traditional manner. He said he would speak to Dawn about it. She came back and said that in view of my long service, she would agree to a sit-down dinner for twenty specially invited guests at lunchtime. I told Martin I couldn't restrict my invitations to twenty as I knew literally hundreds of people around the Museum and wanted to invite some former members of staff as well. He said that Dawn wouldn't agree.

I took no further notice of him or her and, together with Chris Lazenby, we organised my leaving do in the Hartwell Room at lunchtime to which I invited everyone I could think of, past and present, including Dawn and Martin, who both turned up in spite of their views on such celebrations. I asked

Leslie Webster, now the keeper of Prehistory & Europe, to make the farewell speech as, in spite of the number of departments I had worked for in my time at the Museum, I still considered Medieval & Later to be my home and the department I had most enjoyed working for. A number of ex-members of staff turned up, including Hugh Tait, Brian Smith, Chris Down and Jenny Kelly. Somehow I forgot to invite Ian Black.

It was both a happy and sad occasion for me. I had enjoyed my thirty-seven years at the Museum. There had been a lot of ups and downs, with many more ups than downs, but I felt the time was now right to go. Another thing that convinced me it was time to go, as I said in my farewell speech, was that whenever the unions threatened to take action nowadays my new colleagues on the management side of the table would shake their heads and mutter that it was like going back to the bad old days of the 1970s. As I had been the Trade Union Side chairman throughout the '70s this was like saying it was back to the bad old days of me. Somehow I felt I wasn't altogether in sympathy with this line of thought!

The British Museum has a unique character all its own, not to mention numerous characters of its own, many of whom I had met in my thirty-seven years. I had been involved in many events, both serious and light-hearted, and I hope I have managed to convey in this book some of what it was like to be inside that great institution in the latter part of the twentieth century. I have nothing but affection for the old place and the people who worked and still work in it, and I hope that in the future it and they continue to go from strength to strength and that admission to the greatest museum in the world will remain forever free.

... the inventory and those included, and
... meeting the A Number of new members of staff
... indicated my indigene flag with it to go Snuffle Clatel Town and
... Keith Someboy I forgot to leave the black A

... continue to go from strength to strength,
... and that admission to the greatest adventure the world can offer
... whatever that means.